DragonWorld

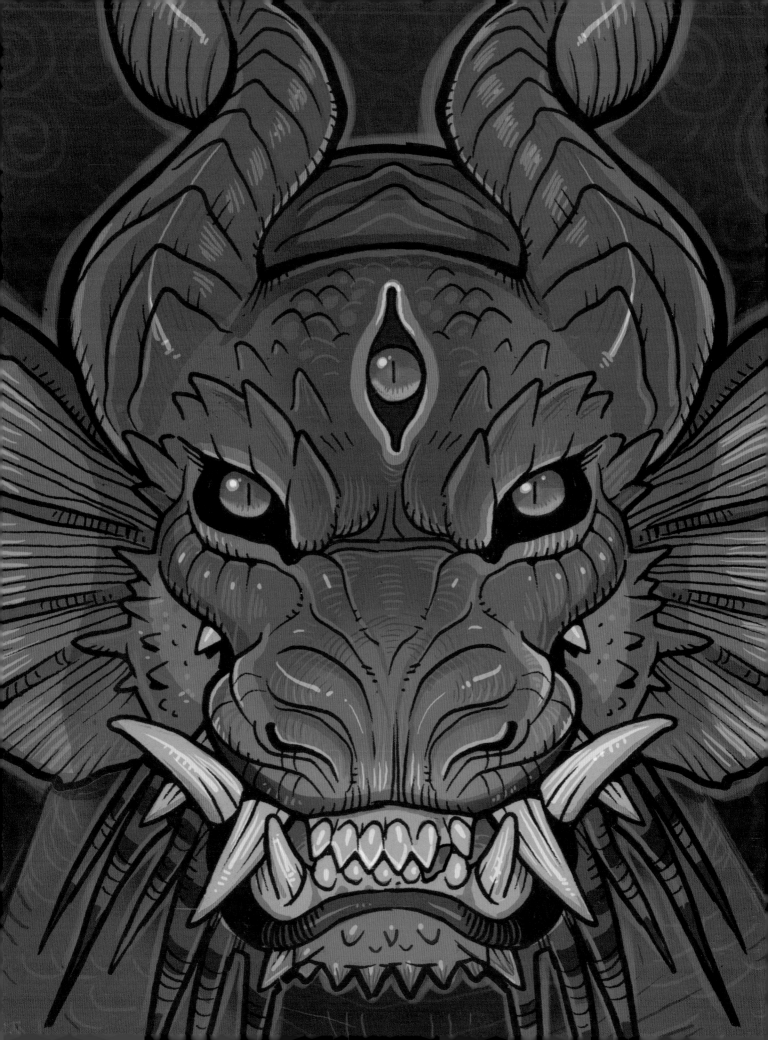

DragonWorld

120 Dragons with Advice and Inspiration from 49 International Artists

edited by Pamela Wissman
and Sarah Laichas

IMPACT
CINCINNATI, OHIO
www.impact-books.com

Dragon Card 1
Melita Curphy | missmonster

Contents

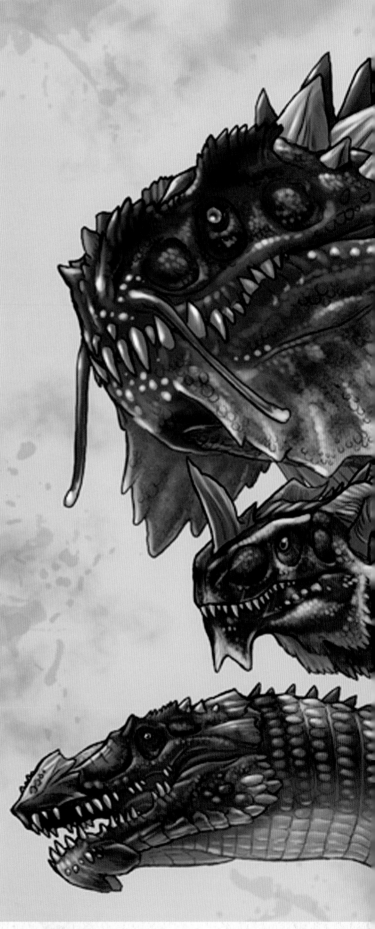

Dragon Exhibit Case
Juan Calle | Onikaizer

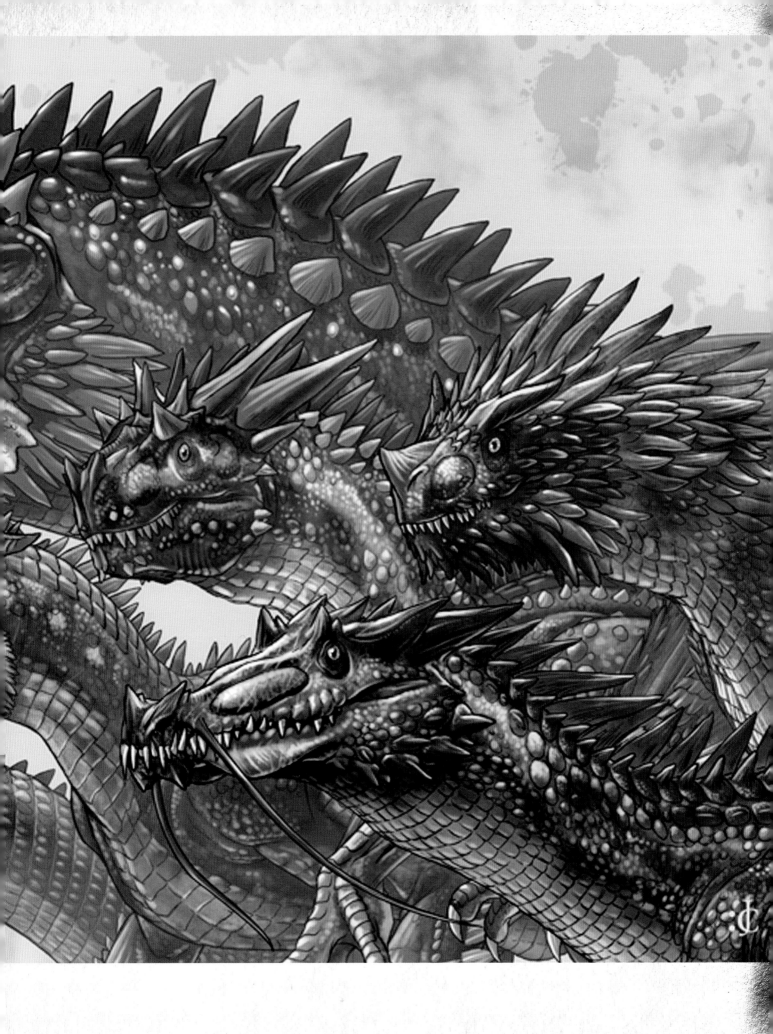

Introduction

Of all mythological creatures, dragons are arguably some of the most massively cool and popular ever. Of course, there are classic European and Chinese interpretations of dragons, but in the end, as subjects for fantasy art, dragons are open to any interpretation. Whether thought of as wise creatures or evil monsters, they typically have great powers of destruction, wreaking havoc associated with such acts as breathing fire and causing floods, which makes them all the more endearing when depicted as gentle. If you can befriend one, the world will open up to you, you can fly, you can pursue your quest with the assurance that your beastly friend will have your back.

The classic dragons in this book can be described as strong, proud and dignified. Some are depicted with companions, appearing as generous, honest, sensitive and loyal friends who inspire confidence and trust. There are humorous, bumbling and eccentric dragons. Many incorporate the traits of other animals, humans and, yes, even food.

Some of these pieces are finished paintings, while others are quick little doodles or rough sketches that serve as a place to work out ideas, deal with life or just have fun, wonderfully capturing the spirit and life behind their creation. Their styles are so varied, many unexpected. Enjoy exploring the many ways that artists love to create dragons.

Thank you to all of the wonderful artists presented here who so generously participated, as well as editor Sarah Laichas, designer Guy Kelly and the production staff at F+W Media. You are all such pleasures to work with.

Pamela Wissman

Pamela Wissman
Editorial Director
IMPACT Books

Dragons and Wolves
Ginger Cooley | cooley

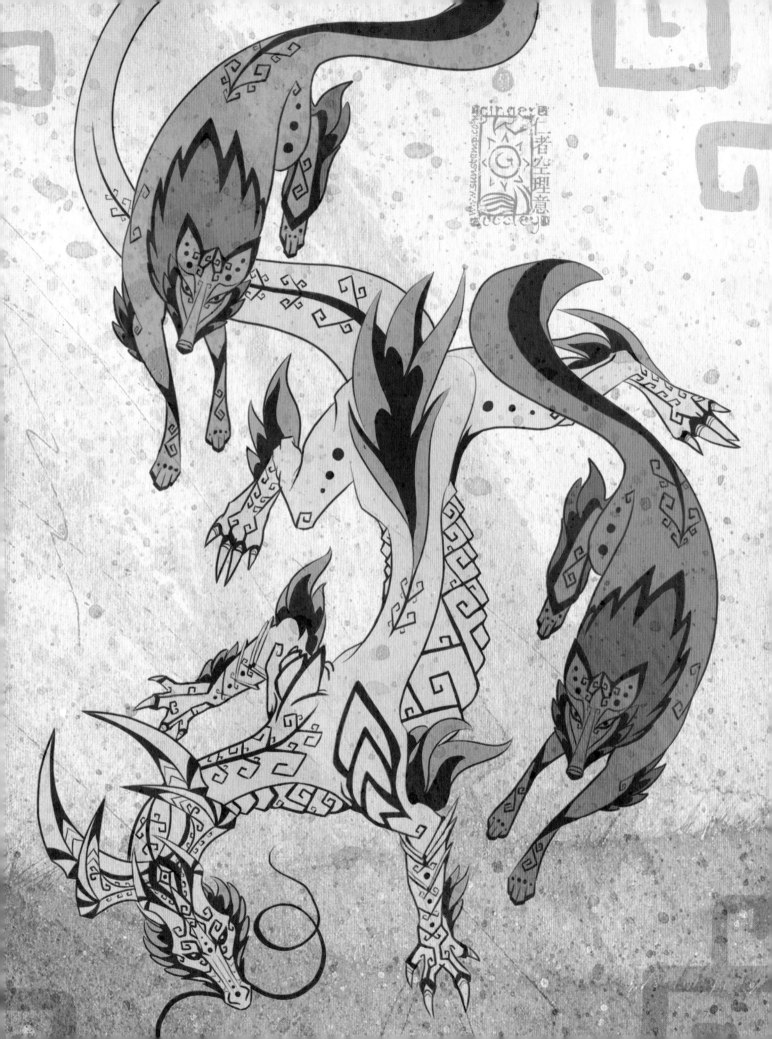

Aaron Pocock | **aaronpocock**

What qualities do dragons exemplify that inspire you?
Dragons are typically proud, fierce, protective, brave and strong, solid in thought and deed. The reason they are so popular is that we humans see these qualities and would like to embody more of them.

What creative license do dragons provide that other subjects don't?
The design opportunities for creating a dragon are virtually endless. You begin with a basic, acceptable framework, but can take it almost anywhere from there.

Is there a story behind your pieces?
Not really. These drawings are a free work. I do find, however, that I paint and draw certain things that reflect what's going on in my life at any given time. These past few years have necessitated that I integrate certain parts of myself that I'd prefer remained hidden. Maybe my drawings reflect that somewhat.

Does your dragon incorporate qualities of other animals?
I believe this fellow has rather devious tendencies, such as the traditional storybook version of a fox.

What personality traits does your dragon possess?
Guile, speed, intelligence, cunning and determination. He looks pretty resourceful to me.

What materials did you use to make this piece of art?
Graphite for the original drawing and Adobe® Photoshop® for the finished inks.

How long did it take you to make this piece?
From rough, conceptual sketch to finished art, around 4½ to 5 hours.

What can dragons teach us about life and art?
Dragons have been teaching us for thousands of years that we all have an abundance of personal power. Societal living has a way of making those things hard to see and to grasp. Dragons embody all those things we long to attain.

profile of a
Dragon Artist

deviantART name: aaronpocock

Location: Brisbane, Australia

Hometown: Reading, England

Date joined: May 27, 2008

Websites:
pocockart.com
aaronpocock.wordpress.com

Hobbies: art, illustration, books, reading, travel, astrology, music, movies

Favorite dragon: Smaug

Favorite quote: What goes around, comes around.

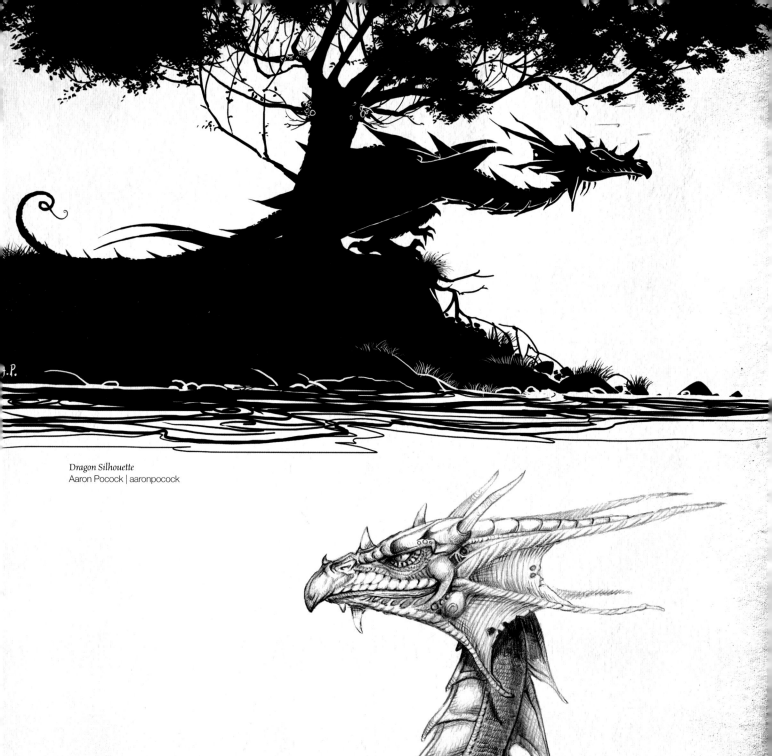

Dragon Silhouette
Aaron Pocock | aaronpocock

Dragon Head
Aaron Pocock | aaronpocock

Julia Chubarova | **AlviaAlcedo**

What qualities do dragons exemplify that inspire you?
Freedom, power and nobility.

What creative license do dragons provide that other subjects don't?
Dragons are an unusual art object—you can draw them as you want, but also according to descriptions shown in worldwide mythology.

Do your dragons incorporate qualities of other animals?
Reptiles, big cats, wolves and birds.

What personality traits do your dragons possess?
Contemplative and peaceful.

What materials did you use to make these pieces of art?
For *Tropical Crystal Dragon* and *Sakura Dragon*: craft paper, colored pencils, and black and white pens. For *From Waves*: blue pastel paper, colored pencils, and black and white pens.

How long did it take you to make this piece?
Tropical Crystal Dragon: 4 days (about 14 hours)
Sakura Dragon: 2 days (about 8 hours)
From Waves: 1 day (about 4 hours)

How does your art shape how you see the world?
My dragons grow up with me. My art is my answer to the world.

What can dragons teach us about life and art?
They help us to feel the harmony of life.

profile of a
Dragon Artist

deviantART name: AlviaAlcedo

Location: St. Petersburg, Russia

Hometown: Kaliningrad, Russia

Date joined: April 30, 2009

Hobbies: fantasy sculpture

Favorite dragon: Amber dragon

Favorite quote: The only way of finding the limits of the possible is by going beyond them into the impossible. —Arthur C. Clarke

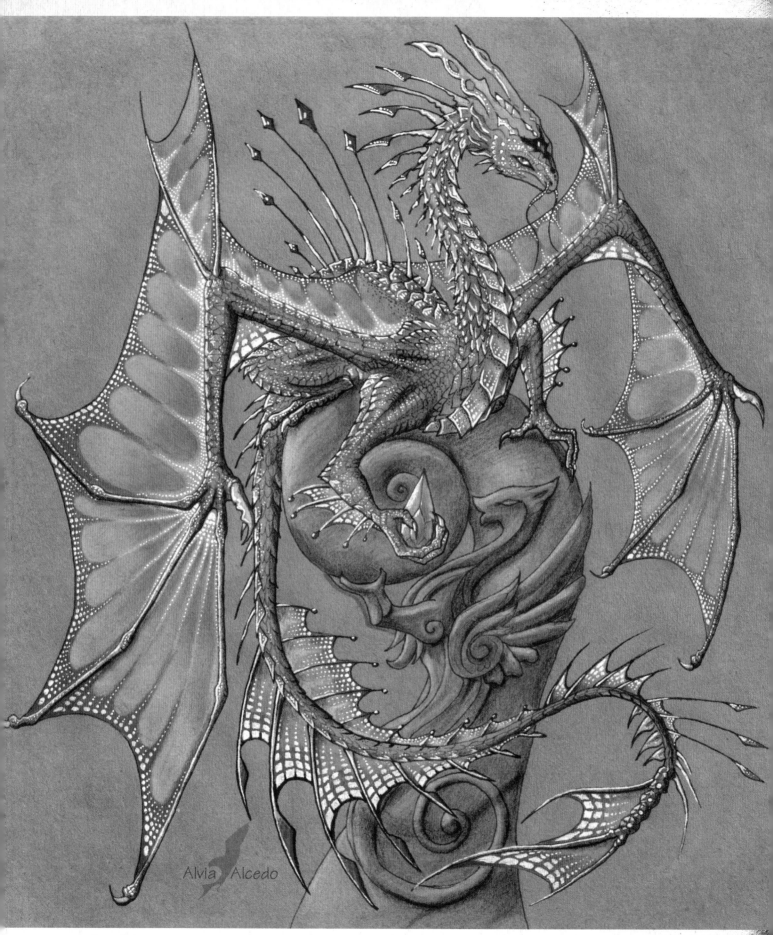

Tropical Crystal Dragon
Julia Chubarova | AlviaAlcedo

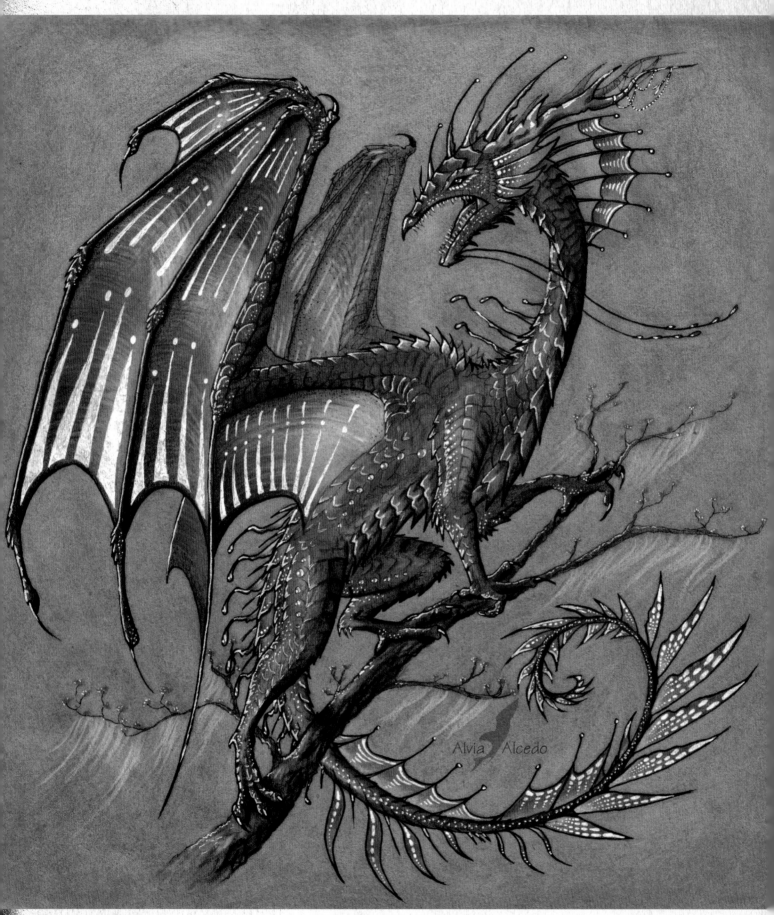

Sakura Dragon
Julia Chubarova | AlviaAlcedo

Visit http://dragonworld.impact-books.com for a free dragon demonstration

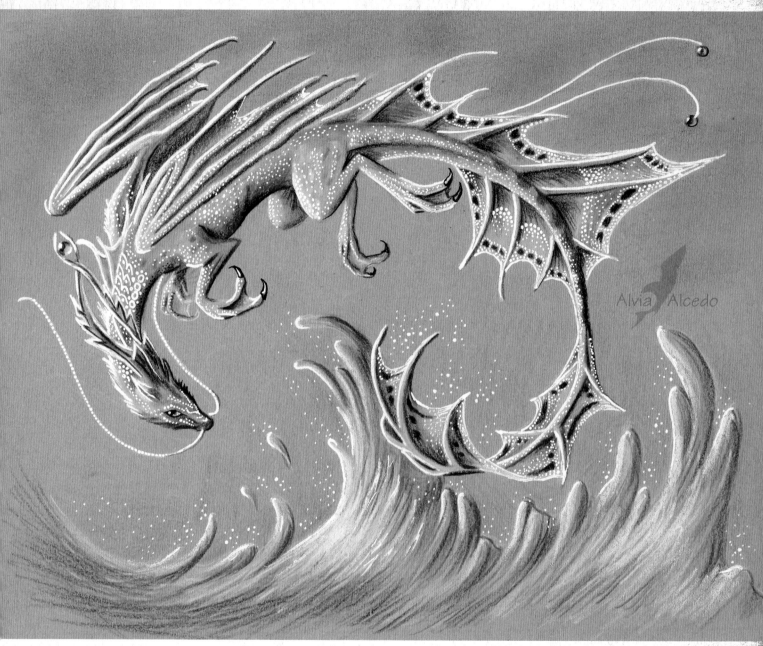

From Waves
Julia Chubarova | AlviaAlcedo

Nicolás Alejandro Peña | **Amisgaudi**

What qualities do dragons exemplify that inspire you?

Dragons are fascinating from every point of view, surrounded by incredible tales and legendary battles, a charming magic. It's unavoidable to feel inspired by such a beast. It's amazing how this creature has become a representative icon in so many cultures around the world throughout human history.

What creative license do dragons provide that other subjects don't?

I love to draw a lot of things, but I've always identified more with dragons. I can remember when I wanted to draw dragons but didn't feel skilled enough to draw them as they were in my mind. Once I started drawing them I couldn't stop.

Is there a story behind your pieces?

Most of my dragons are linked to the same tale—an eternal war between the powerful dragons and the dragon killers atop their giant owls. Together they share a fascinating world full of interesting and mysterious creatures.

Do your dragons incorporate qualities of other animals?

I always search in nature before painting a dragon. Several animals have an incredible likeness to dragons that inspire my art.

What personality traits do your dragons possess?

The personalities of my dragons depend on their type. The blue dragon is powerful and magnificent, full of vitality and strength. The green dragon is a daredevil—strong and honest, yet impatient and intolerant. Some have the ability to predict the future, while some are curious, perfectionist and charming. My dragons can also be imaginative, unpredictable, intelligent and proud.

What materials did you use to make these pieces of art?

I use a Wacom® tablet, Photoshop CS4® and Corel® Painter™ 11.

How does your art shape how you see the world?

It's my surrounding world that inspires me to do my art. My point of view of the world defines me as an artist.

What can dragons teach us about life and art?

They teach us to be persistent, perfectionist, patient and caring. They teach us to see things as more colorful and fantastic, to enjoy more the simple things in life like taking in beautiful sunsets.

profile of a
Dragon Artist

deviantART name: Amisgaudi

Location: Mexicali, Mexico

Hometown: Mar del Plata, Argentina

Date joined: July 24, 2009

Websites:
amisgaudi.blogspot.com
amisgaudi.daportfolio.com
amisgaudi.cghub.com

Hobbies: drawing, athletics

Favorite dragon: Earth dragon

Favorite quote: Empty pockets are the ideal arks to pick up new treasures.

Red Dragon
Nicolás Alejandro Peña | Amisgaudi

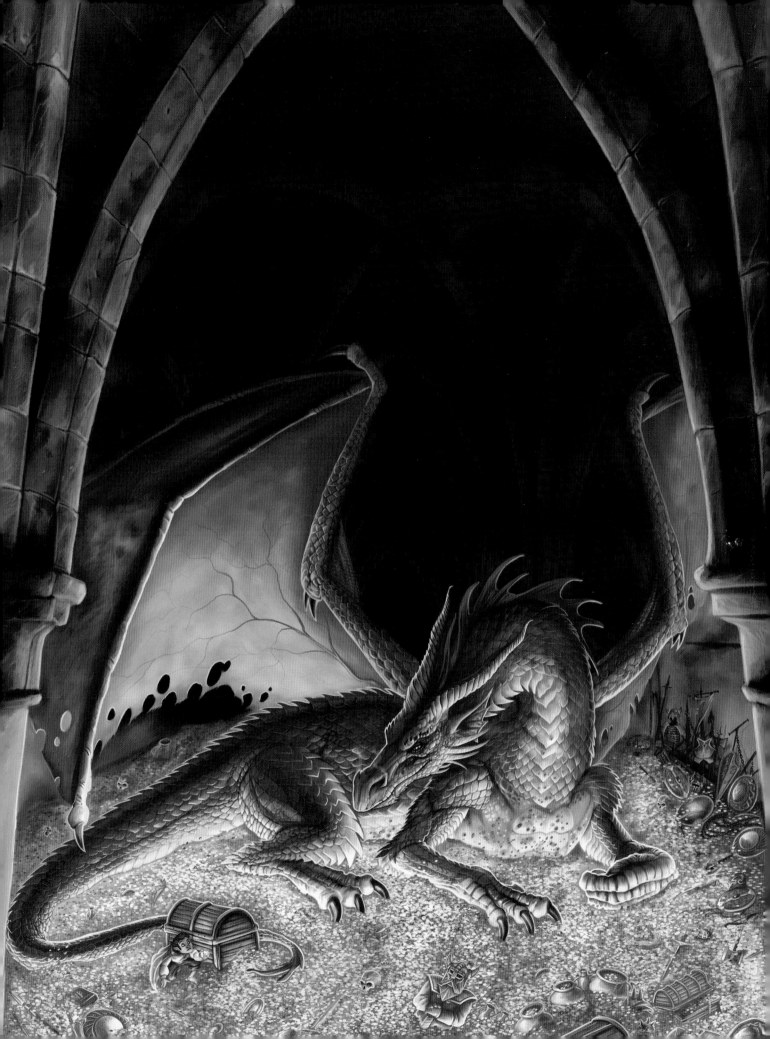

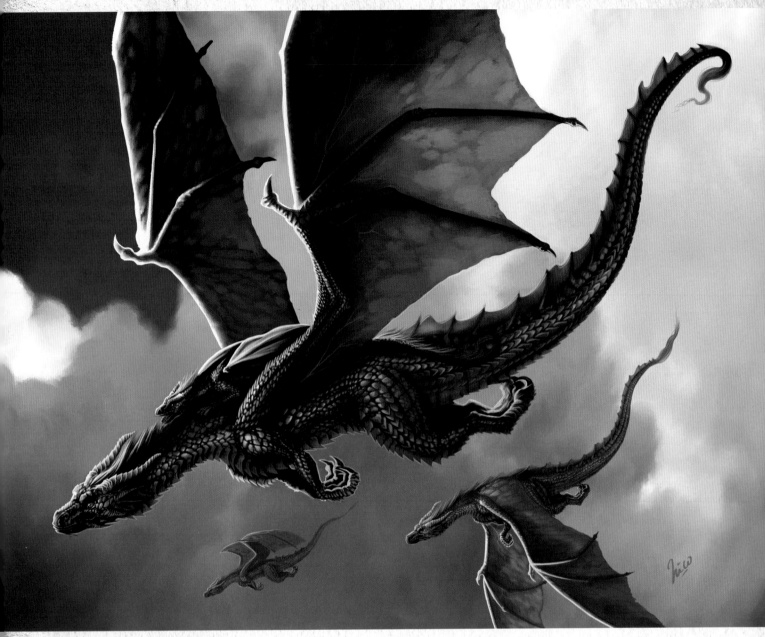

Blue Dragon
Nicolás Alejandro Peña | Amisgaudi

Visit http://dragonworld.impact-books.com for a free dragon demonstration

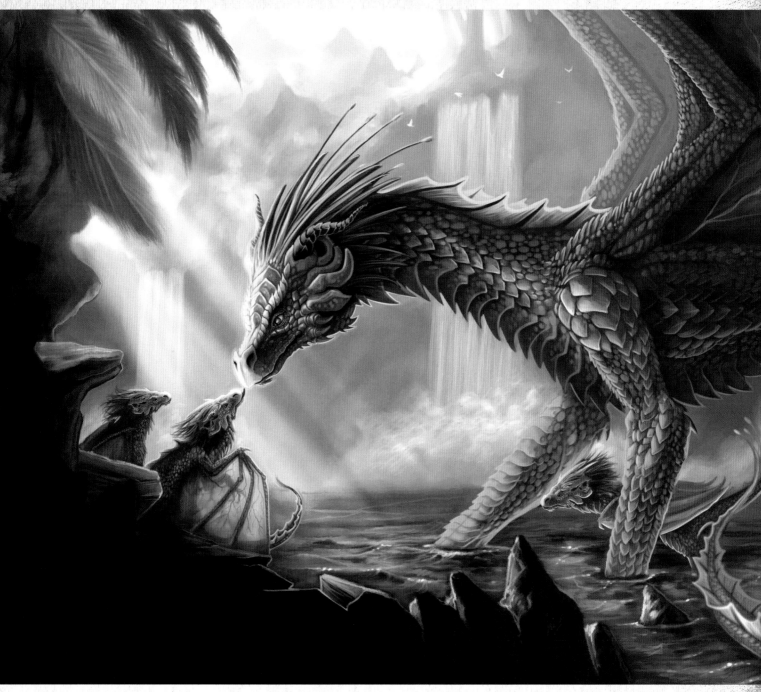

Golden Dragon
Nicolás Alejandro Peña | Amisgaudi

Emmy Cicierega | B1nd1

profile of a
Dragon Artist

deviantART name: B1nd1

Location: Massachusetts

Date joined: March 12, 2005

Website: emmyc.com

Hobbies: art, writing, crafts

Favorite dragon: Toothless

Favorite quote: I'd rather fail at something I love than succeed at something I hate.
—George Burns

What qualities do dragons exemplify that inspire you?
They are icons of adventure and mythology. I like that every culture has a different way of drawing dragons, and no matter how much time passes, society reinvents them over and over because we enjoy their mythology so much.

What creative license do dragons provide that other subjects don't?
Because their origins are in fiction, there's a lot of leeway for an artist to be creative with a dragon subject. It's terribly fun to stray from traditional designs and add an extra set of wings or two heads or vibrant colors. No one can tell you it's incorrect!

Is there a story behind your piece?
All my pieces have some small backstory to them. In this one, the dragon is desperately scenting out the person they were ordered to hunt. The person thought they were safe on an empty subway car, but apparently not as their aggressor has just smashed through the window.

Does your dragon incorporate qualities of one or more other animals?
I'd say there's definitely some poisonous frog in there somewhere! And raptor claws.

What personality traits does your dragon possess?
Diligent hunter. Does as he's told.

What materials did you use to make this piece of art?
Photoshop CS3 and a Wacom Intuos2 tablet.

How long did it take you to make this piece?
Quite some time! Longer than my average pieces because of my inexperience with backgrounds. Took me somewhere around 3 days of on-and-off work.

How does your art shape how you see the world?
I tend to look at the world in terms of scenes. What would make a good picture? How can mundane surroundings become exciting? What would I add or take away to make a story?

What can dragons teach us about life and art?
I think dragons teach us that myth and legend are a necessity. Everyone needs good stories!

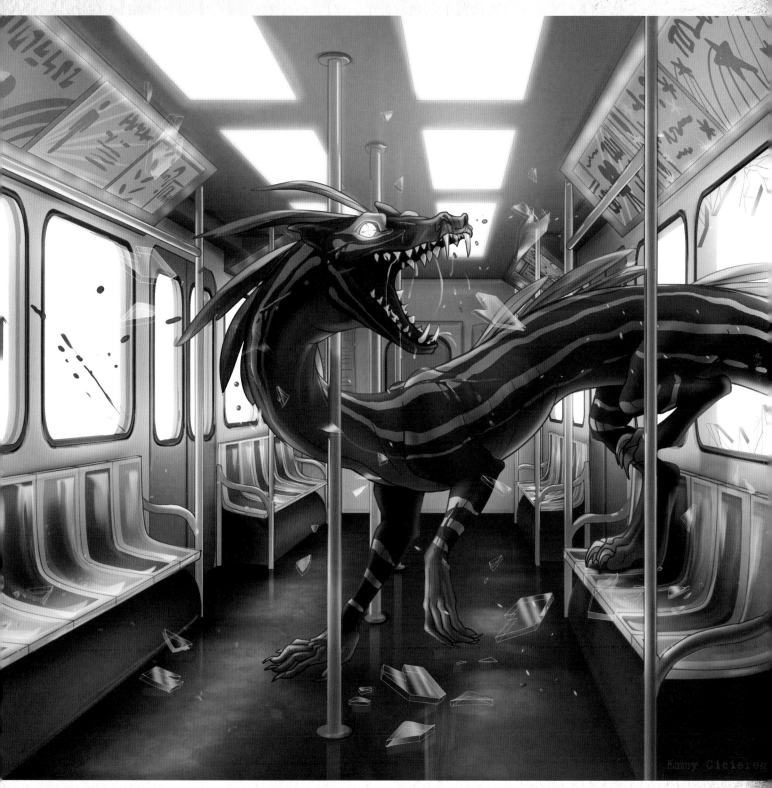

Subway Dragon
Emmy Cicierega | B1nd1

Ashley Hall | **Badhead-Gadroon**

What qualities do dragons exemplify that inspire you?
Dragons be like scaly mountains, immovable, wise and everlasting.

What creative license do dragons provide that other subjects don't?
Nae othyr kreature can wear a coat of mirrors, have wyngs that may broaden to hide the sun, nor inspyre such racing delight to the soul than dragonkind.

Is there a story behind your pieces?
The *Harlequin Dragon* variety of dragon likes to live near volcanoes and has a fondness for hot springs and geysers, too. *Marine Dragon*, an ocean-dwelling species, sometimes arcs above the surface of the watyr in a grand, gliding display. *Monarch Dragon* is a large species of firebreathing dragon; it thrives in arid and hot climates.

Do your dragons incorporate qualities of other animals?
Most of my dragons have specialised pheatures, Harlequin Dragon has a uniquely patterned hide much like pythons or othyr auld-whurld serpents. Marine Dragon has tiny scales and phishlike fins, and he sports whiskyrs like catphish do. Monarch Dragon bears arcing horns which are reminiscent of cattle horns.

What personality traits do your dragons possess?
Harlequin Dragon is quite proud, sociable and clever. Marine Dragon is wise, shy and enjoys the songs of whales. Monarch Dragon is boisterous, noisy and likes to challenge humans.

What materials did you use to make these pieces of art?
I used pencils, inks, ballpoint pens and my favorite soft eraser.

How long did it take you to make these pieces?
About 9 hours.

How does your art shape how you see the world?
Gosh ... I see dragons everywhere! Sometimes in clouds, or in the eyes of reptiles, and my imagination races when I see the dreadfully beautiful curves of snakes.

profile of a
Dragon Artist

deviantART name: Badhead-Gadroon

Location: Harlow, England

Date joined: January 1, 2008

Websites: aazari.com/Badhead_Gadroon/

Hobbies: making jewelry, drawing, console gaming, learning about dinosaurs

Favorite dragon: Thai Nagas! They're supyrnature!

Favorite quote: *BELLOW*

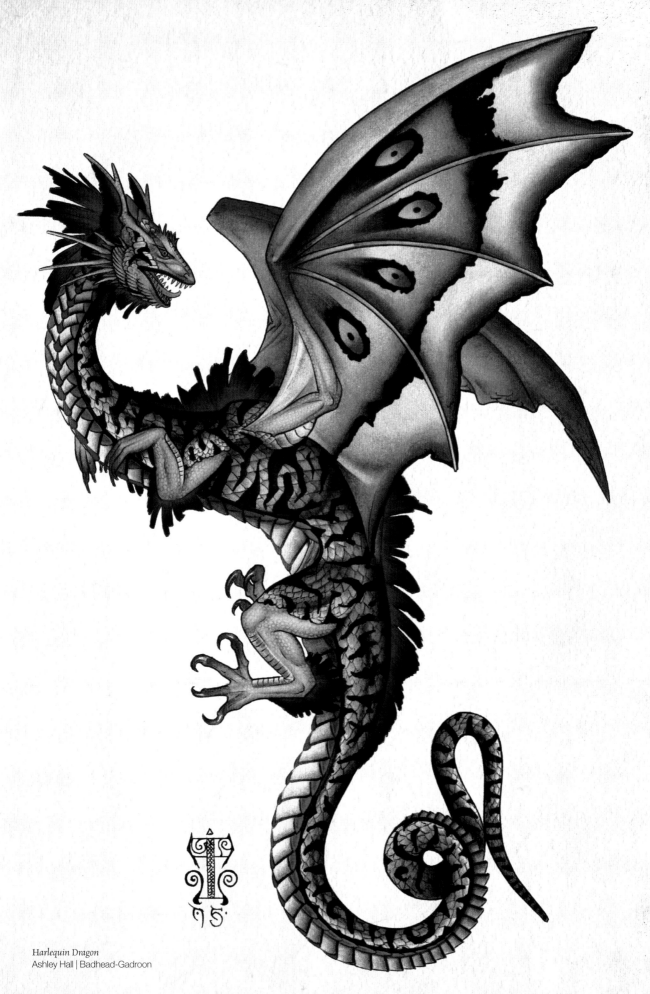

Harlequin Dragon
Ashley Hall | Badhead-Gadroon

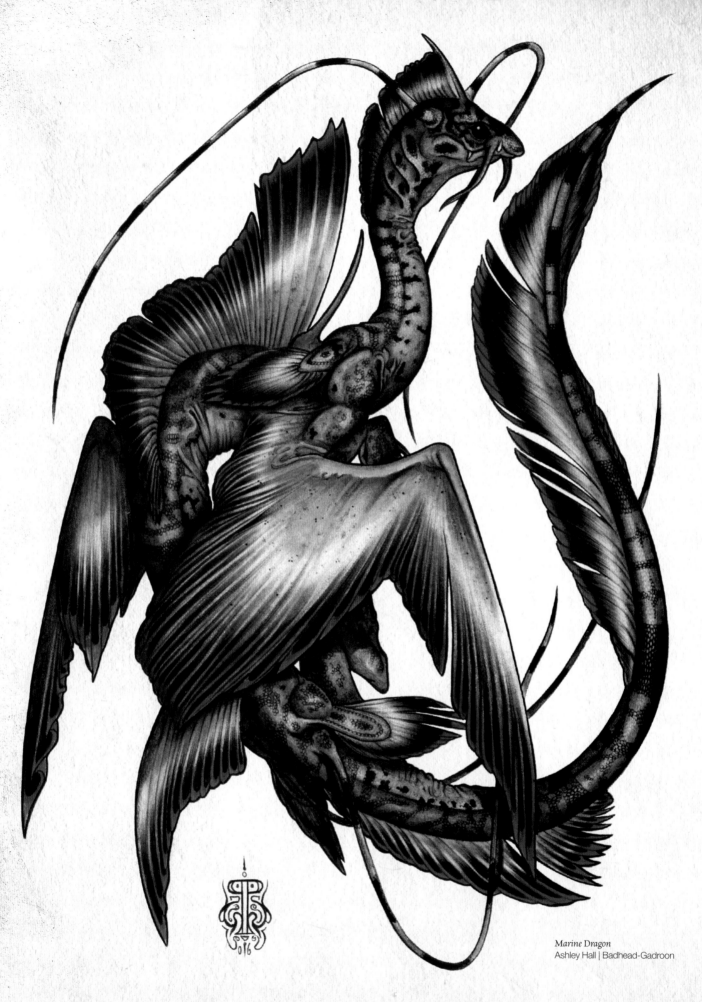

Marine Dragon
Ashley Hall | Badhead-Gadroon

Visit http://dragonworld.impact-books.com for a free dragon demonstration

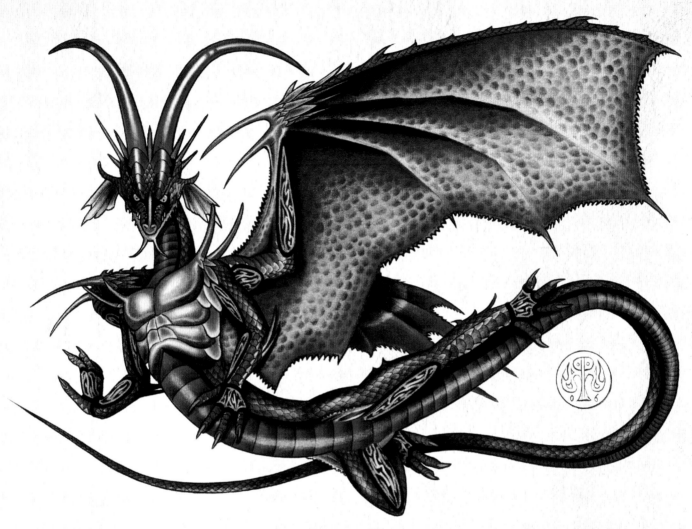

Monarch Dragon
Ashley Hall | Badhead-Gadroon

Chuck Wadey | **chuckwadey**

What qualities do dragons exemplify that inspire you?
Dragons can be terrifying or majestic. Either way it's the opportunity to depict on overwhelming, larger-than-life force that inspires me to paint and to try to capture that energy.

What creative license do dragons provide that other subjects don't?
Being creatures of fiction, dragons allow for the ultimate creative license, as in anything goes. It's just a question of how close you want to stick to the popular notion of what a dragon is. Even then you've got a pretty wide palette to work with, incorporating elements from most of the animal kingdom.

Does your dragon incorporate qualities of other animals?
When I was thinking about sketching this painting, there were some cardinals on the birdfeeder outside of my window. I realized that those pointy red heads with the black eye masks would make a great starting point for the dragon and the rest grew out of that.

profile of a
Dragon Artist

deviantART name: chuckwadey

Location: Austin, Texas

Date joined: June 15, 2007

Websites: chuckwadey.com

Hobbies: art, aviation

Favorite dragon: Vermithrax Pejorative from *Dragonslayer*

Favorite quote: You said you wanted to be around when I made a mistake; well, this could be it, sweetheart. —Han Solo

Is there a story behind your piece?
Since the cardinal bird was the inception for this dragon, it led me to the idea that its rider might also be a cardinal in the clerical sense. So I got excited about the notion of a dragon that worked in the service of the church, because I don't think it's something we've seen before. The idea gave me a lot of opportunity for ornamentation and the motivation to chain him to the monastery foundation. Usually in western culture dragons are aligned with evil. Here the dragon is only neutral, a force of nature to be tamed. His horns have been trimmed, his breast is shackled and he has beaten his wings up pretty bad in trying to escape.

What personality traits does your dragon possess?
This dragon is really a wild animal in captivity. I don't think he understands or cares about who these people are. The monks would be dead already if they weren't providing food. That's assuming that the dragon hasn't killed a few by accident. He's a dangerous mode of transportation, but the clergy endures it because of the powerful impression that it makes.

What materials did you use to make this piece of art?
Cardinal Dragon started as a digital sketch in Photoshop CS2. Once I felt that the drawing was in pretty solid shape, I layered in high-resolution scans of traditional watercolor washes that I had made on physical paper. From there I continued to build up the painting to a finish digitally in Photoshop.

How long did it take you to make this piece?
I only had a few days to finish this piece, so it was fast but focused work.

How does your art shape how you see the world?
I'm fortunate enough that my day job is creating or directing fantasy illustrations like this. For me dragons, orcs and elves are business as usual, and they fit in seamlessly with the rest of my world. Not much more unbelievable than earthquakes and oil spills, but a lot more fun.

What can dragons teach us about life and art?
I think they can teach adaptability, the way they are such an amalgamation of disparate parts. They say absorb all you can from the world around you and use it to your tactical advantage.

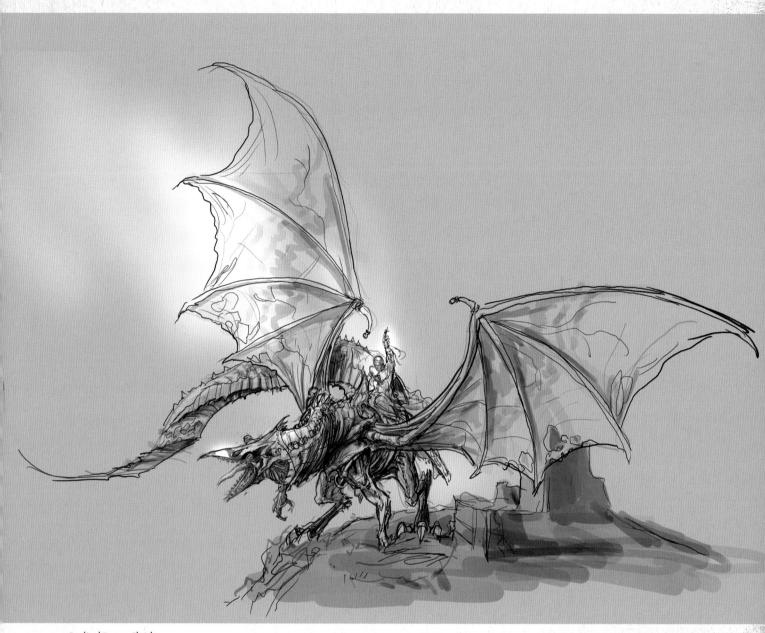

Cardinal Dragon Sketch
Chuck Wadey | chuckwadey

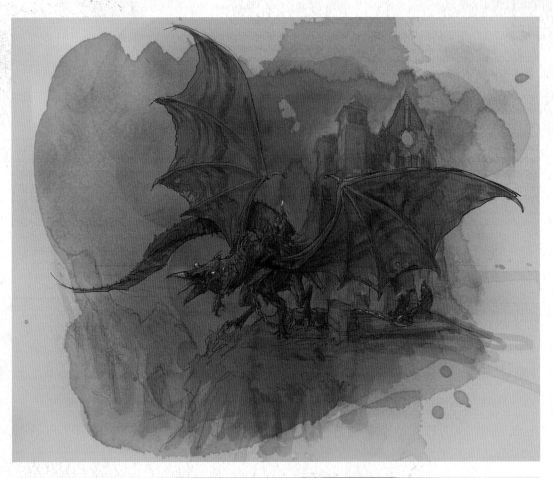

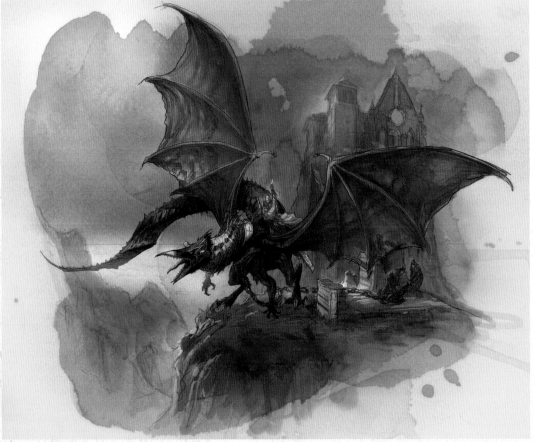

Cardinal Dragon
Chuck Wadey | chuckwadey

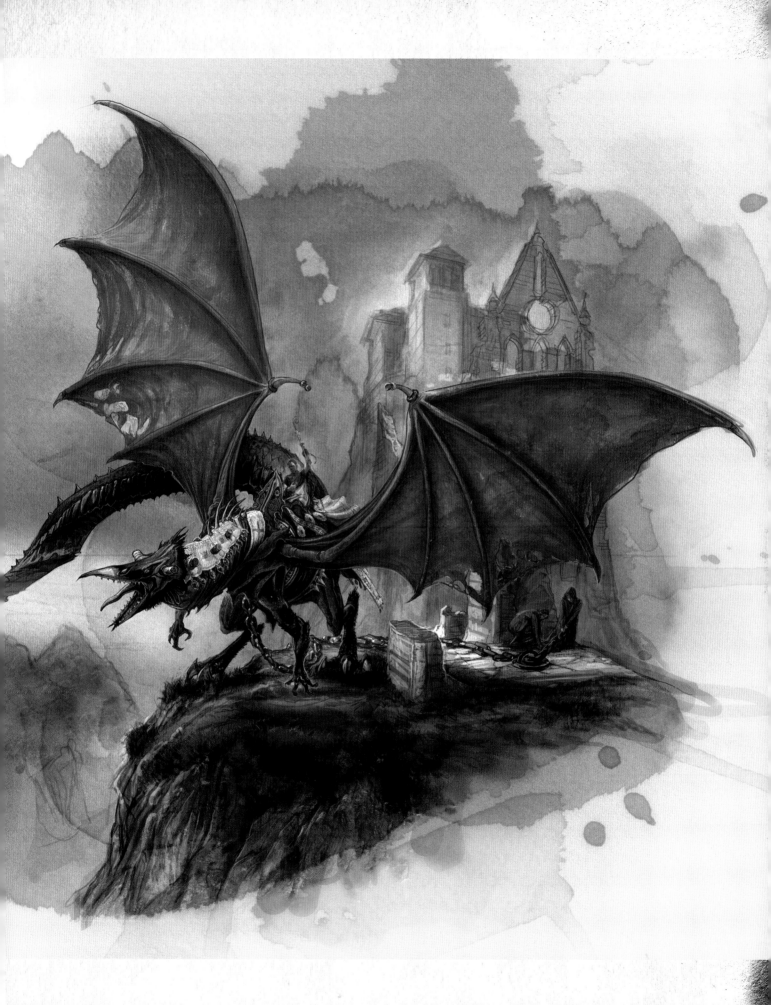

27

Ginger Cooley | **cooley**

What qualities do dragons exemplify that inspire you?
The qualities I am most drawn to are power and splendor. I think of dragons as regal beings that possess a combination of wisdom and strength. These qualities can be manipulated to create dragons ranging from good and wise to evil and brutally powerful.

What creative license do dragons provide that other subjects don't?
Dragons provide endless creative opportunities. They can be small like lizards or gigantic like dinosaurs. I love designing their heads and arranging their horns, crests, spines and teeth. Studying cultural influences in dragon designs is proof the ideas behind these beasts have been around a long time. Dragons possess a wide range of roles among different people groups. I recommend looking into dragon designs from across the world for inspiration.

Is there a story behind your pieces?
In 2007, a young woman commissioned me to create a monochrome tattoo of a dragon in the company of wolves. The result was *Dragon and Wolves*. I later added color and a background.
 Zarch Drake's background originally featured the ruins of a temple nestled in a jungle, a few songbirds and a lizard. I replaced the background with a sandy-colored one allowing the viewer to concentrate on the details of the dragon's design.

Do your dragons incorporate qualities of other animals?
The dragon in *Dragon and Wolves* has the body of a lizard but longer legs that allow it to run like its lupine companions. I drew inspiration for the dragon's head from Asian dragons, and some of the markings were inspired by Tlingit artwork.
 Zarch Drake is anthropomorphic. He is bipedal and wears armor like a human warrior. I was initially inspired by ancient and fantastical armor designs, but also drew ideas from birds, insects and lizards.

What personality traits do your dragons possess?
The dragon in *Dragon and Wolves* is inquisitive and intelligent, yet shy. It is a mysterious creature that is slow to trust others, but keeps its companions close. One may witness the beast running among wolves in the forest for a fleeting moment, and thereafter, never again. For the blessed, however, this curious dragon may return and even become a powerful ally in a time of need.
 Zarch Drake is an ancient dragon that has partaken in many battles over the course of his lifetime. He is a decorated warrior, heralded among dragons and people alike. Yet despite his accomplishments and popularity, he prefers solitude and takes solace in the chirping of songbirds.

What materials did you use to make these pieces of art?
I created both images with Photoshop CS2 and my Wacom Intuos3 9" × 12" (23cm × 30cm) tablet. For *Dragon and Wolves* I inked and colored it using Photoshop's Drop Shadow brush. I

profile of a
Dragon Artist

deviantART name: cooley
Location: Anchorage, Alaska
Hometown: Slidell, Louisiana
Date joined: April 8, 2004
Website: iamcooley.com
Hobbies: hunting, kayaking, swimming, cycling, skiing, snowboarding, snowshoeing, hiking, camping, video games, jewelry making, travel, wine tasting, photography, art

overlaid it with a paint splatter texture to create the background. For *Zarch Drake* I experimented with Photoshop's layer effects such as Glow and Gradient Overlay.

How long did it take you to make these pieces?
I spent between 10 to 12 hours on creating *Dragon and Wolves* and approximately 36 hours on *Zarch Drake*.

How does your art shape how you see the world?
As an artist, even something mundane can be inspiring. I get a lot of my creature design ideas from everyday animals, simple patterns, music and conversations with friends. One of my favorite things to do is go to natural history museums and gather ideas and photo references for future art projects.

What can dragons teach us about life and art?
I think dragons are a creative outlet for all ages. One can create a dragon to look like anything. There are no boundaries in dragon designs. Likewise, life shouldn't have boundaries either. We can accomplish a lot more than we may give ourselves credit for if we put our best efforts toward our goals and think creatively.

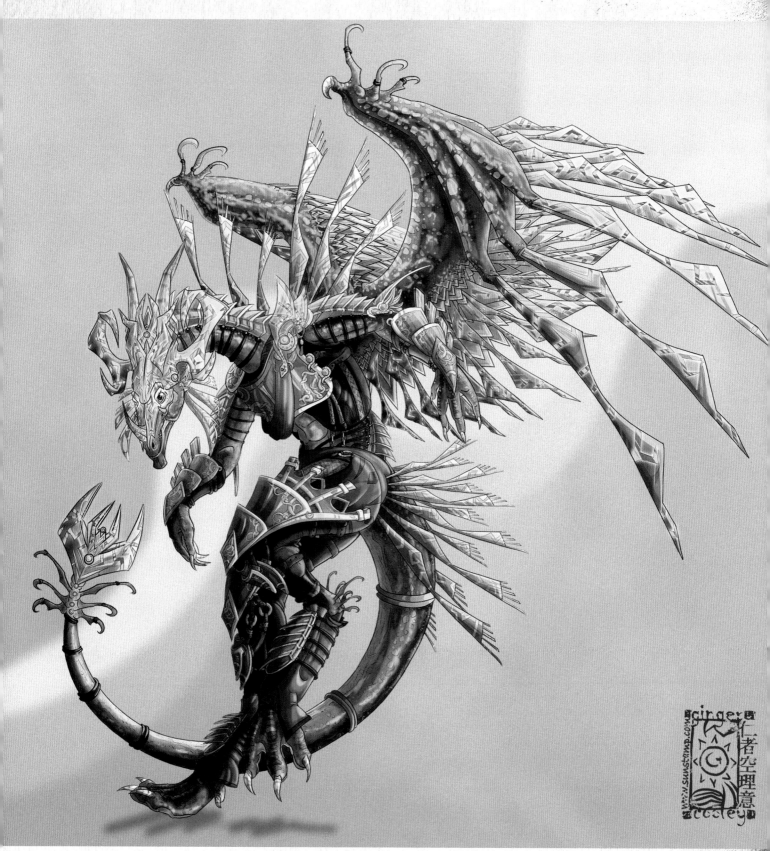

Zarch Drake
Ginger Cooley | cooley

Isabelle L. Davis | **drakhenliche**

What qualities do dragons exemplify that inspire you?

My imagination has always been captured by dragons; their fearsome aspect and their terrible majesty (be they goodly or malevolent) and the ancient intelligence that lurks behind their gaze. I try to portray some of that power and wisdom whilst not forgetting the monstrous, animal side that makes them the best of fantasy's beasts! Basically, dragons rock.

What creative license do dragons provide that other subjects don't?

There's a certain freedom in drawing dragons: no one's ever seen one for real, so no one can tell you how to draw one! The limit is your imagination, though having an understanding of real-life anatomy helps to ground your designs. My favorite dragons are from European mythology, but even within that category there is a whole world of possibilities. Long necks, short necks, heavyset or sinewy, scales, leathery skin, horns, spikes, small as a mouse or big as a mountain ….

Is there a story behind your pieces?

The backward glance of Green Dragon suggests he is in flight from somewhere significant. Quite possibly on his way back to his lair as dawn breaks, to reveal a trail of burned farmsteads and eaten livestock.

The Dragon of Despair is a terrible beast that revels in the misery he brings to the lives of men. Traveling with the great storms that ravage the land, his roars echo in chorus to the bellow and peals of thunder.

Another Dragon is a little less ferocious than my usual fare. I draw a lot of dragons and sometimes, I'm afraid to say, a snappy and exciting title eludes me.

Do your dragons incorporate qualities of other animals?

For *Green Dragon in Flight* I was inspired by bat wings for the way the wings join to the body. *Another Dragon* has a birdlike feel. I associate birds with being watchful and vigilant, and tried to incorporate that in this dragon. For *Dragon of Despair* I took some inspiration from photographs of sea snakes and their long, undulating coils.

What personality traits do your dragons possess?

Green Dragon in Flight: This is the sort of dragon that gives the rest a bad name! I can picture him flying out from his lair under cover of night, raiding the surrounding countryside for treasure and devouring livestock!

Another Dragon: Watchful and perhaps a little pensive, I can imagine this dragon alert, eyeing up a possible intruder into his territory.

Dragon of Despair: This is a dragon that revels in chaos and mayhem, something I used the contorted pose to convey.

profile of a
Dragon Artist

deviantART name: drakhenliche

Location: London, England

Date joined: June 23, 2002

Websites:
necrodragonart.com
daemonslayers.net

Hobbies: drawing, working on my graphic novel, reading, keeping fit at the gym and socializing with my friends!

Favorite dragon: Smaug from J.R.R. Tolkien's *The Hobbit*

Favorite quote: If you can keep your head while all around you are losing theirs … then you're probably missing the bigger picture!

What materials did you use to make these pieces of art?

Green Dragon in Flight: I drew the initial sketch in pencil on watercolor paper, then inked it with dip ink pens and waterproof India ink. I then shaded and colored the drawing with watercolor.

Another Dragon: I drew the initial sketch in pencil on Bristol board, then inked it with dip ink pens and waterproof India ink. I used an airbrush with acrylic paint to add color, blocking some areas with masking fluid.

Dragon of Despair started as a pencil sketch. The line art was created with pen and ink on Bristol board. I shaded him with watercolor paint and finished the color digitally in Photoshop.

How long did it take you to make these pieces?

Green Dragon in Flight: about 2 hours; *Another Dragon*: 5 to 6 hours; and *Dragon of Despair*: about 12 hours.

How does your art shape how you see the world?

I'm not sure if how I see the world is shaped by my art, or if my art is shaped by how I see the world! I'm fascinated by castles, ruins, mountains and wild places … places where a dragon could belong. Often I'll let my mind wander by imagining my dragons populating a world not too dissimilar to our own.

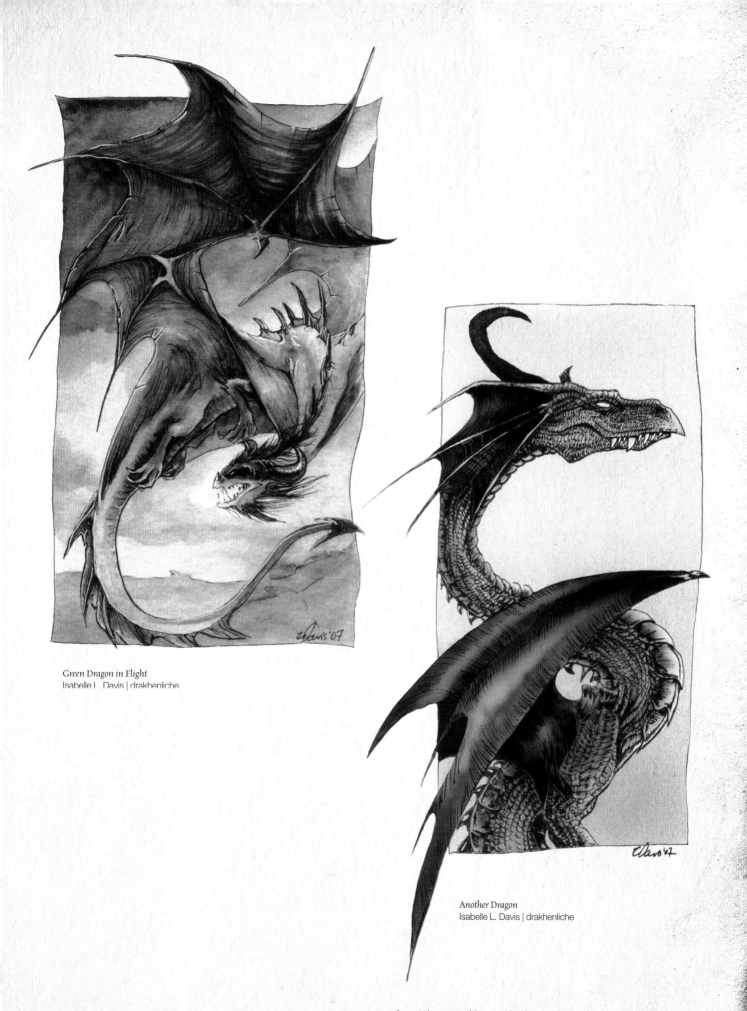

Green Dragon in Flight
Isabelle L. Davis | drakhenliche

Another Dragon
Isabelle L. Davis | drakhenliche

Visit http://dragonworld.impact-books.com for a free dragon demonstration

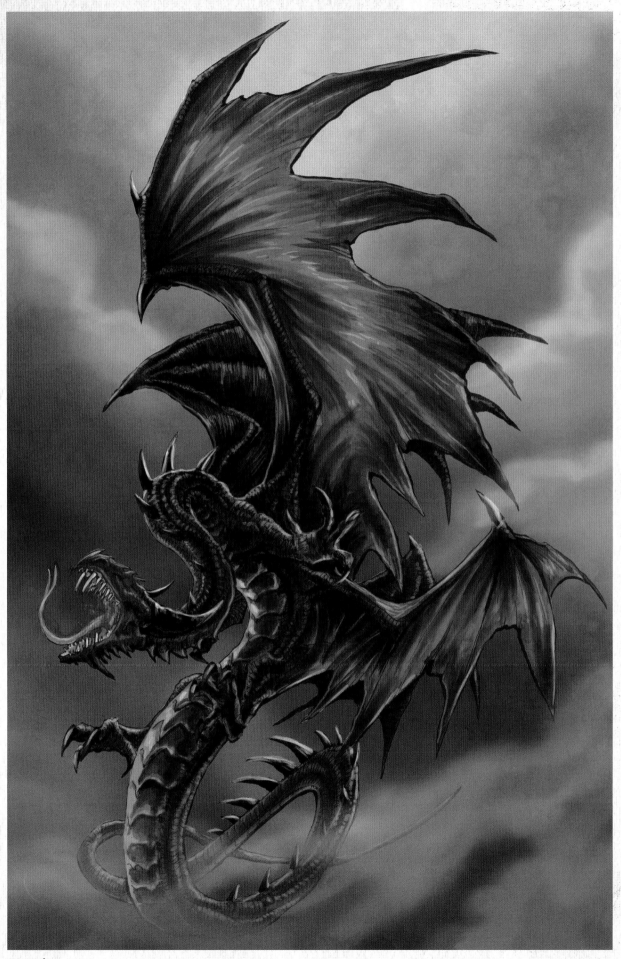

Dragon of Despair
Isabelle L. Davis | drakhenliche

John Staub | **dustsplat**

Is there a story behind your piece?
The designs were created for a short story wherein the elemental dragons had a role in the creation of the world.

Do your dragons incorporate qualities of other animals?
I tried to incorporate real-life animal qualities into the design of the dragons so that the viewer would have more of a connection with the piece. For example, for *Water Dragon*, I designed the head like a shark to give it an aquatic quality.

What materials did you use to make these pieces of art?
Pencil to draw the lines then painted over with digital colors.

How long did it take you to make these pieces?
A couple days for each design.

How does your art shape how you see the world?
Doing art helps me view the world in a more creative way. Instead of seeing the world for what it is, art gives me the chance to view the world for what it could be.

profile of a
Dragon Artist

deviantART name: dustsplat

Location: San Francisco, California

Hometown: Manila, Philippines

Date joined: February 14, 2006

Websites:
dustsplat.carbonmade.com
dustsplat.blogspot.com

Hobbies: drawing, scuba diving, watching clouds, entertaining my cats

Earth Dragon
John Staub | dustsplat

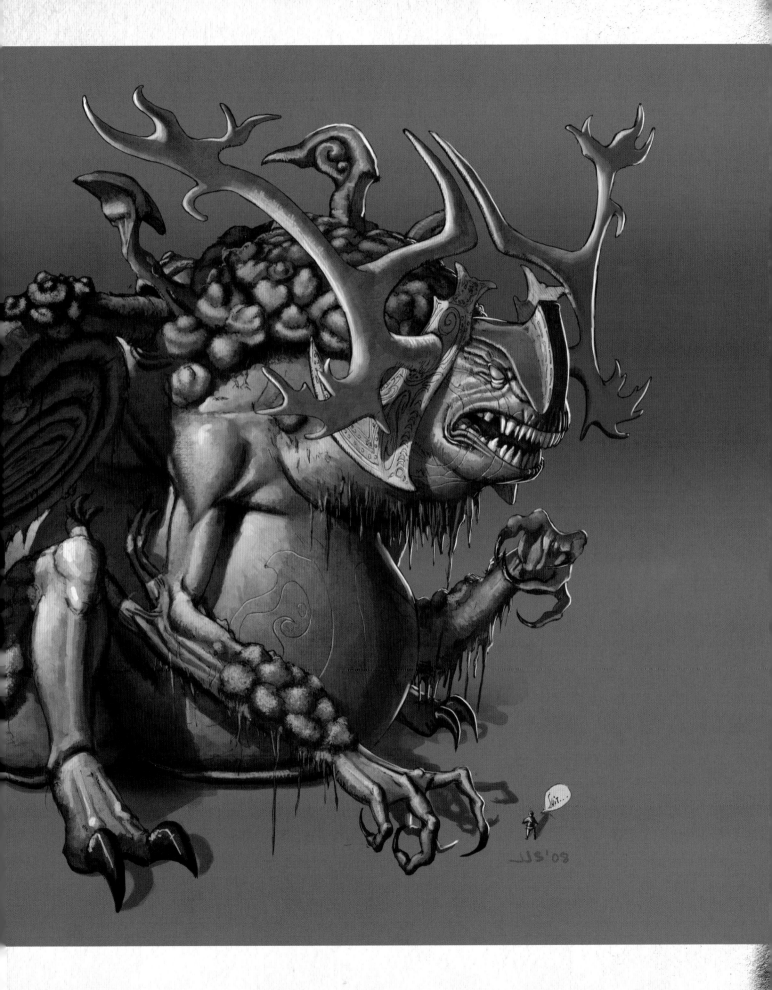

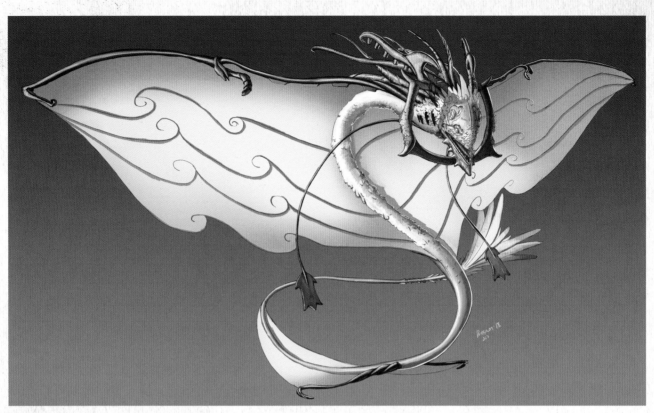

Wind Dragon
John Staub | dustsplat

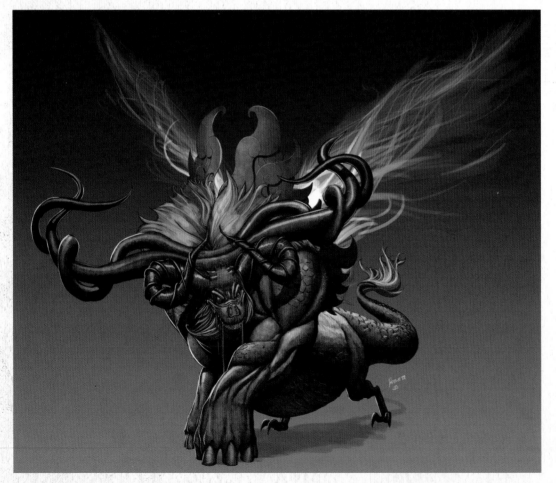

Fire Dragon
John Staub | dustsplat

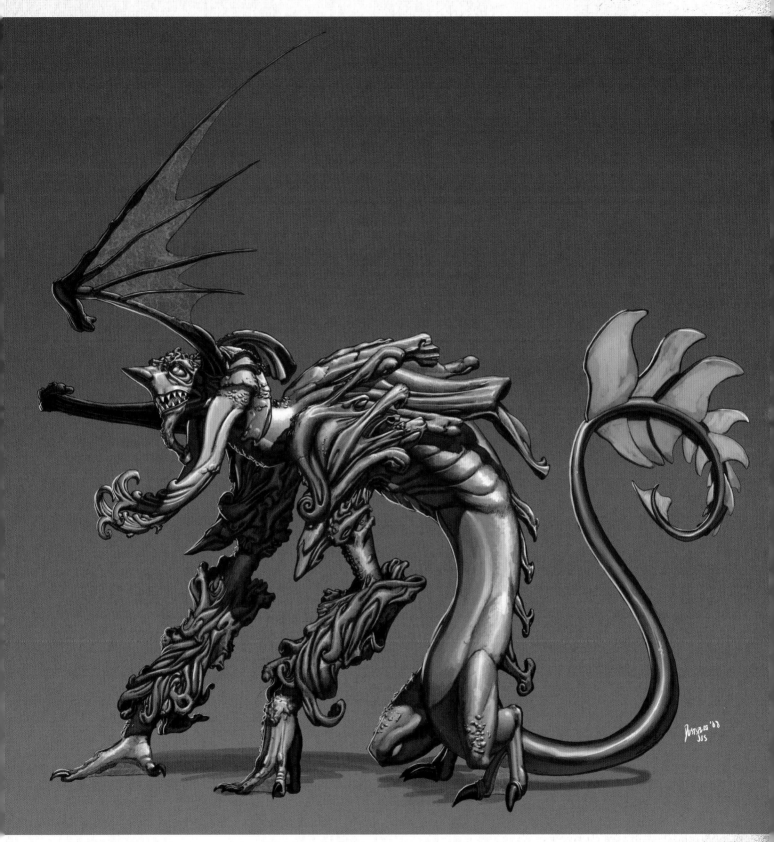

Water Dragon
John Staub | dustsplat

Eduard Mirica | **eduardmirica**

What qualities do dragons exemplify that inspire you?
Their power and unstoppable, explosive energy.

What creative license do dragons provide that other subjects don't?
Anything that exists outside of reality stimulates our imagination more than anything else.

Is there a story behind your piece?
I had a high school notebook with an interesting dragon cover. While looking at the cover one day, I said to myself that I had never done dragons … now seems a good time to start. So I grabbed paper and a pencil and started to draw.

Does your dragon incorporate qualities of other animals?
Though it has animal elements like ears, nose and claws, to me dragons—and this one in particular—seem more human than any other animal.

What personality traits does your dragon possess?
Demonic brute force.

What materials did you use to make this piece of art?
Printer paper (grabbed in a hurry) and an old green mechanical 2B pencil.

How long did it take you to make this piece?
Around 2 hours.

How does your art shape how you see the world?
It creates a potential explosion of imagination for me and all others who see it.

What can dragons teach us about life and art?
They teach us about the energy inside each of us. Dragons release this energy through fire; we do it through other ways.

profile of a
Dragon Artist

deviantART name: eduardmirica
Location: Piteşti, Romania
Date joined: July 9, 2006
Hobbies: computer programming
Favorite quote: Your only limit is your imagination.

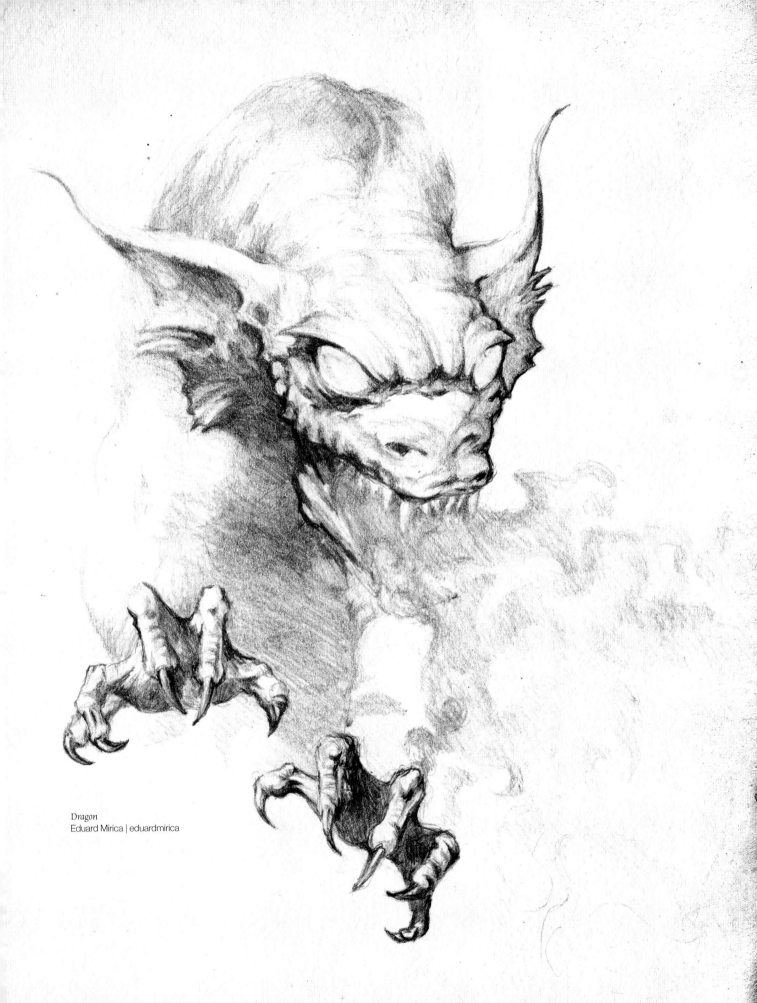

Dragon
Eduard Mirica | eduardmirica

E.J. Su | EJ-Su

What qualities do dragons exemplify that inspire you?

Dragons have been the subject of many fabled stories through-out the ages, and there was no lack of such stories in Asia where I grew up. The "untouchable" sense that surrounded these creatures inspired my fantasies when I was a kid.

What creative license do dragons provide that other subjects don't?

There is so much room for creativity in drawing dragons. No human has ever laid eyes on a dragon before, so they can be anything our imaginations allow them to be.

Is there a story behind your image?

My dragon is an experimental nanotechnology embryo that has the ability to grow itself by absorbing mechanical parts and programs according to the environment its been exposed to. By accident, it gained knowledge of giant, flying lizardlike creatures, so it built itself into a mythical dragon.

Does your dragon incorporate qualities of one or more other animals?

I have always been a huge dinosaur nut, and here I took partial inspiration from the anatomical structure of dinosaurs. I also borrowed traits from a few existing animals to ground my dragon in reality.

What personality traits does your dragon possess?

Curious and cautious like a newborn baby.

What materials did you use to make this piece of art?

Like a lot of my artwork these days, this piece is completely digital. I love how natural Autodesk® SketchBook® Pro feels, and for coloring, I went with Photoshop.

How long did it take you to make this piece?

Sketching took me a couple of hours and coloring about 3 to 4 hours.

How does your art shape how you see the world?

Since I am an industrial designer by trade, I've always thought that I am shaping the world with art, design and imagination.

profile of a
Dragon Artist

deviantART name: EJ-Su

Location: Los Angeles, California

Hometown: Kaohsiung, Taiwan

Date joined: July 23, 2004

Websites: protodepot.com
ejsouffle.blogspot.com

Hobbies: basketball, baseball, video games, drawing, watching, cartoons and daydreaming

Favorite dragon: Draco from *DragonHeart*

Favorite quote: Talent is worthless without hard work.

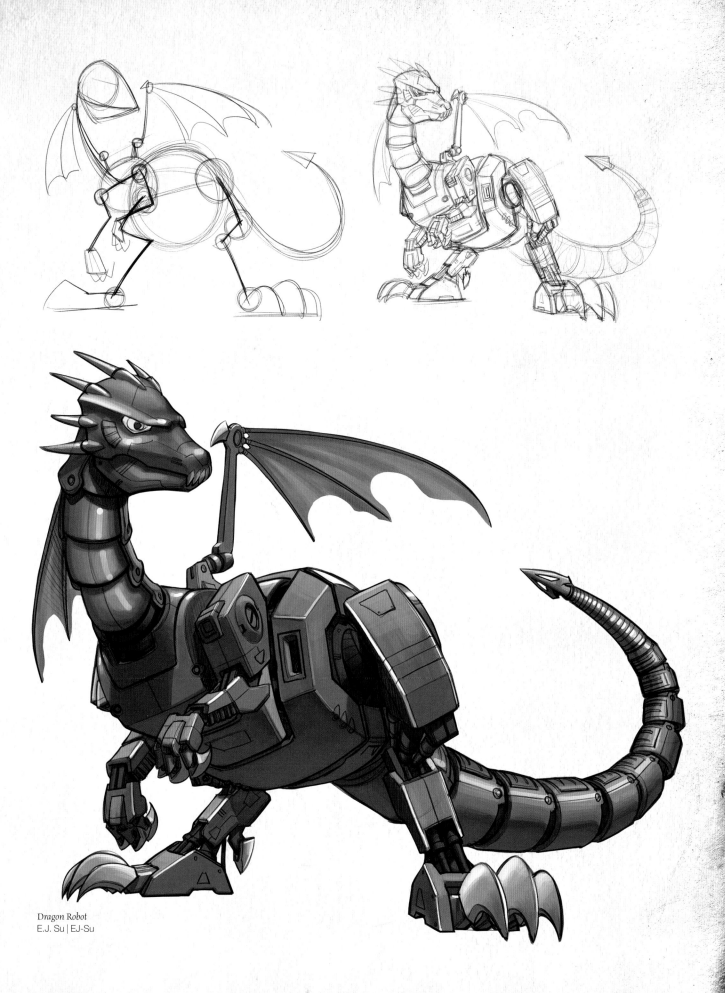

Dragon Robot
E.J. Su | EJ-Su

Mauricio Herrera | **el-grimlock**

What qualities do dragons exemplify that inspire you?
Power, poise and elegance. Dragons are not simple beasts, but magic beings with a special kind of authority over the other creatures.

What creative license do dragons provide that other subjects don't?
I feel a special kind of liberty creating images of dragons. The possibilities range from aerodynamic details to a great action pose, or creating natural manifestations of power and rage such as flames or rays. Drawing dragons allows great opportunity to use the environment, clouds and light in a dramatic scene.

Is there a story behind your pieces?
Black Dragon Attack is a demo of an idea for a personal story, probably a comic book. Several riders of small wyverns are hunting a not-too-ancient Wyrm and really failing in that mission. The difference of power is clear in the attack—the ancient Wyrm is the real hero in this battle.

Esmeralda is a female dragon, with a mountainlike habitat. It's a quiet scene. The figure's pose and silhouette were inspired by a swan.

Do your dragons incorporate qualities of other animals?
Esmeralda was inspired by a swan. *Black Dragon Attack* is not so specific but has a little of a Tyrannosaurus rex and the muscle of a heavy feline.

What personality traits do your dragons possess?
Strong. With authority.

What materials did you use to make these pieces of art?
Photoshop and a Wacom tablet.

How long did it take you to make these pieces?
Around 8 hours for *Esmeralda* and 3 days for *Black Dragon Attack*.

What can dragons teach us about life and art?
I see dragons as an artistic creation, an icon of the purest qualities beyond human possibility.

profile of a
Dragon Artist

deviantART name: el-grimlock

Location: Federal District, Mexico

Date joined: August 24, 2004

Hobbies: books, movies, video games, comics, soundtrack music

Favorite dragon: A wyrm with fire element and mountain habitat

Esmeralda
Mauricio Herrera | el-grimlock

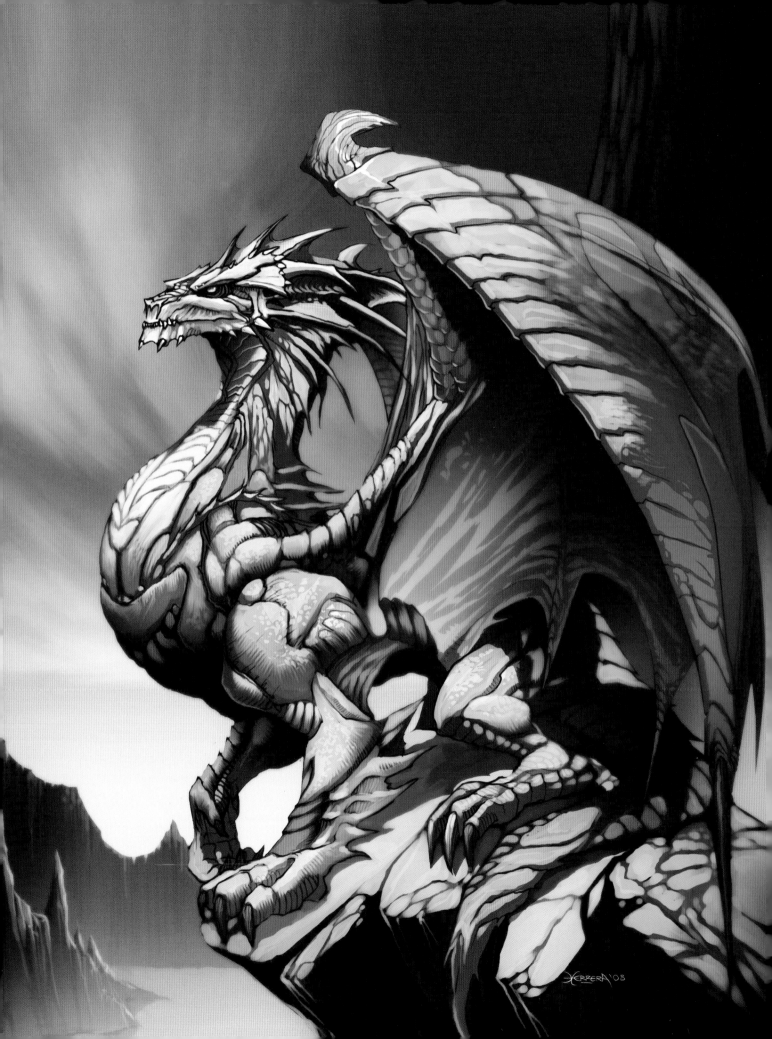

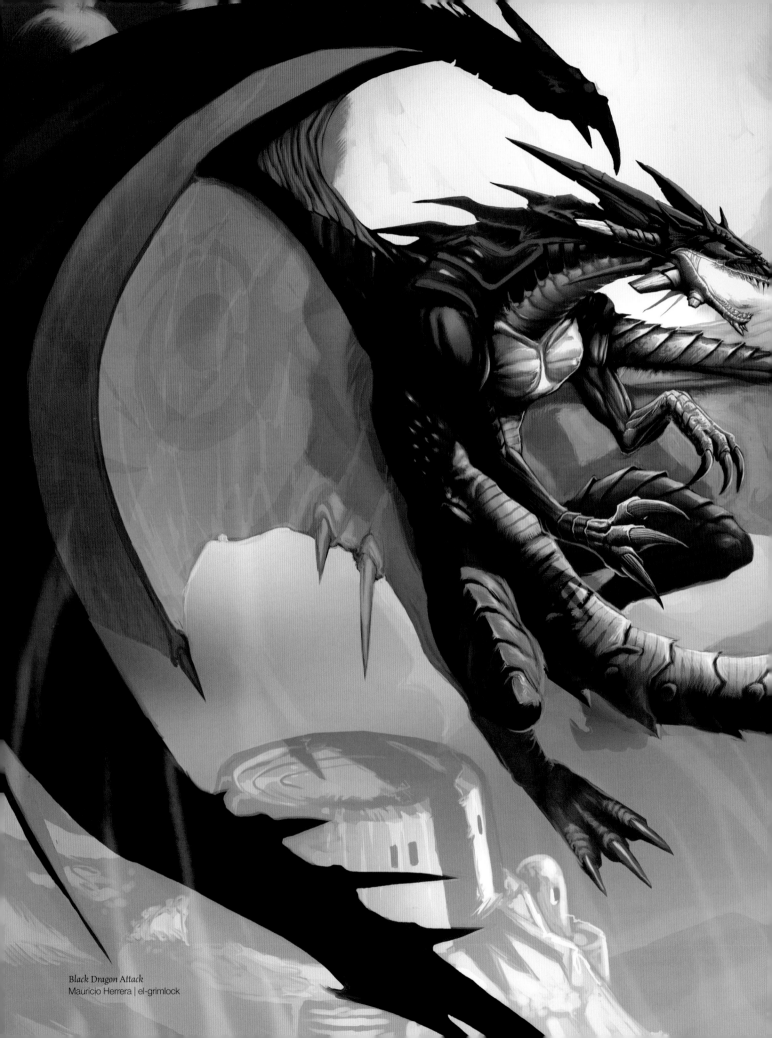

Black Dragon Attack
Mauricio Herrera | el-grimlock

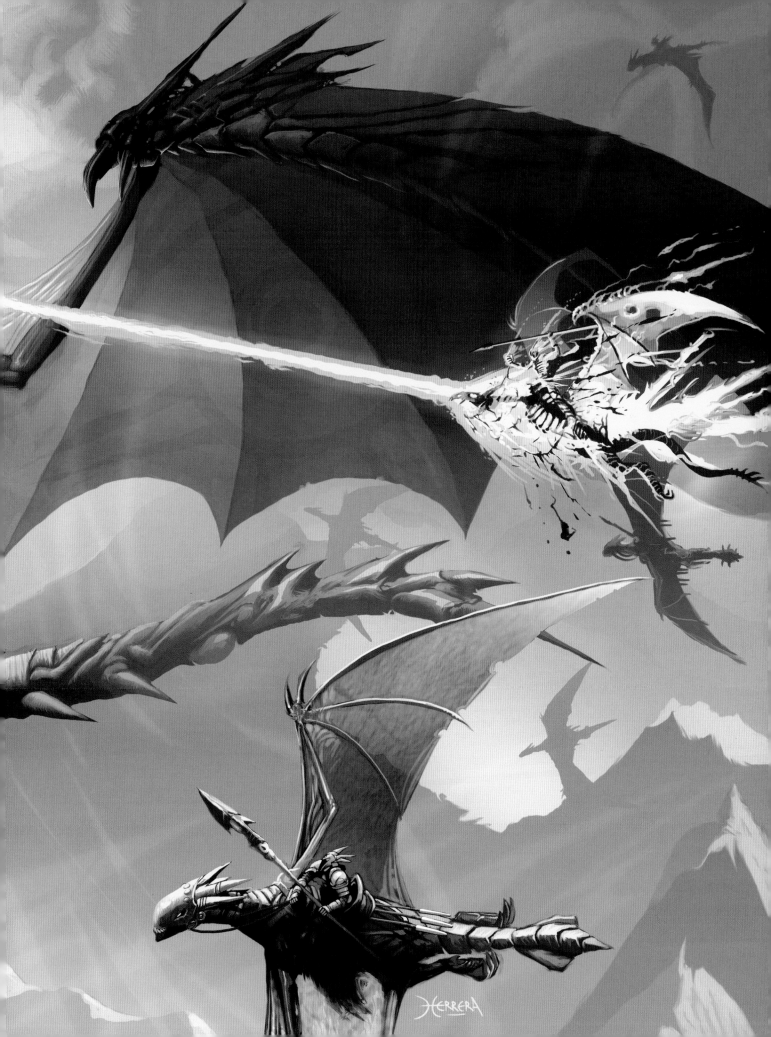

Victoria Maderna | **entdroid**

What qualities do dragons exemplify that inspire you?
I like their versatility, really. I also like the mythic and mysterious aspects of these imaginary creatures. I love fantasy as a genre, and dragons are an important part of it.

What creative license do dragons provide that other subjects don't?
Since dragons are not real animals there are no set rules on how you should depict them. You always have the freedom to draw them in any way you like.

Is there a story behind your pieces?
For *D is for Dragon* I wanted to move away from the idea of a dragon being powerful, wise, majestic and graceful and draw a clumsy, awkward dragon clearly unfit for flying. For *My Dragon Pet* I wanted to make a more child-friendly fantasy illustration, so I drew an elf kid and his pet dragon.

Do your dragons incorporate qualities of other animals?
D is for Dragon has a pretty straightforward classic dragon, but its general morphology was pretty heavily inspired by birds that are bad at flying or unable to fly, such as chickens, kiwis and penguins. For *My Dragon Pet* I tried to give this dragon a bit more of a lizard/serpent-like appearance: slim and sinuous shapes.

What personality traits do your dragons possess?
D is for Dragon is clumsy, silly, funny and a bit weird. *My Dragon Pet* is friendly and kind.

What materials did you use to make these pieces of art?
D is for Dragon was sketched in pencil and inked and colored in Photoshop; *My Dragon Pet* was sketched in pencil and the final was made using a combination of Illustrator® and Photoshop.

How long did it take you to make this piece?
For both pieces, probably about 6 hours or so.

What can dragons teach us about life and art?
I have no idea. My dragons refuse to teach me anything.

profile of a
Dragon Artist

deviantART name: entdroid
Location: Edinburgh, Scotland
Hometown: Rosario, Argentina
Date joined: September 24, 2007
Websites: victoriamaderna.com
Hobbies: reading, sewing

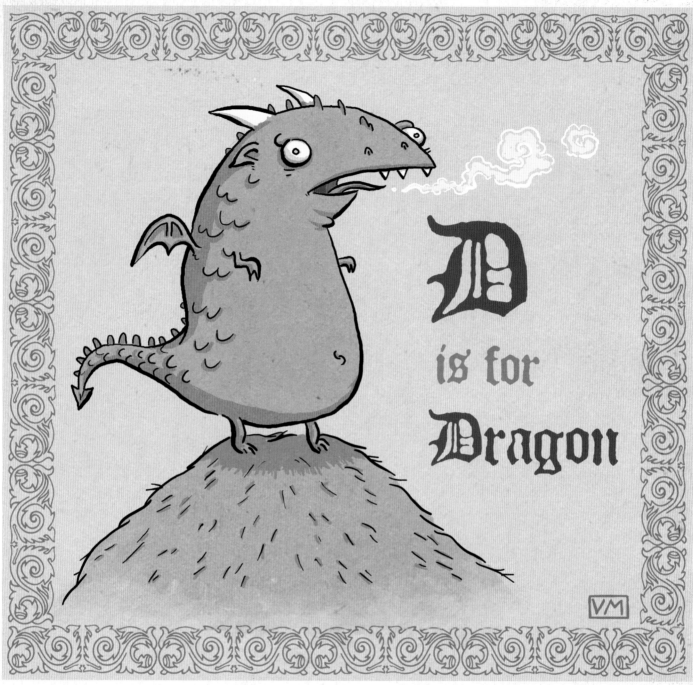

D is for Dragon
Victoria Maderna | entdroid

My Dragon Pet
Victoria Maderna | entdroid

Kaitlin Reid | **Flying-Fox**

profile of a
Dragon Artist

deviantART name: Flying-Fox

Location: Catonsville, Maryland

Date joined: May 19, 2004

Websites: sunsetdragon.com
sunsetdragon.blogspot.com

Hobbies: cosplay, sewing, photography

Favorite dragon: Gorbash from *The Flight of Dragons*

Favorite quote: Meddle not into the affairs of dragons, for you are crunchy and taste good with ketchup.

What qualities do dragons exemplify that inspire you?
Dragons are regal and majestic—and of course magical. I've always been enamoured with dragons and all that they exemplify. The thoughts and dreams of fantasy are always enticing.

What creative license do dragons provide that other subjects don't?
You can have free rein! You can make whatever you want with dragons and really have fun with it. Whether it's getting into the intricate design and details or making up a cute little dragon fellow—it's all up to you!

Is there a story behind these pieces?
These are both series in my book *Monsters!* that I completed for my senior thesis while I was in school. They both have a legend behind them. The Ryujin is a Japanese water god and the Dragon of Marduk is a hybrid dragon that guards the entrance to a Babylonian tomb.

Do your dragons incorporate qualities of other animals?
The Dragon of Marduk, most certainly! He has a chameleon or lizardlike head and cheeks, and lion front paws with bird back legs. A scorpion tail completes his crazy look.

What personality traits do your dragons possess?
Ryujin is a god, so he is certainly mystical and powerful in his underwater depths—I mean, look at that goatee! Ancient! The Dragon of Marduk strikes me as a more quirky, quizzical dragon.

What materials did you use to make these pieces of art?
Both are linework ink drawings which are then scanned into Photoshop and digitally painted.

How long did it take you to make these pieces?
Each probably was in the ballpark of 10 to 12 hours, from thumbnail to finished piece.

How does your art shape how you see the world?
I love color and pattern—I try to put these into each piece. I think the vibrant color comes through the most.

What can dragons teach us about life and art?
Dragons, in my opinion, give us an open mind. I still believe dragons are out there in our world, but hidden. What do you think?

Ryujin
Kaitlin Reid | Flying-Fox

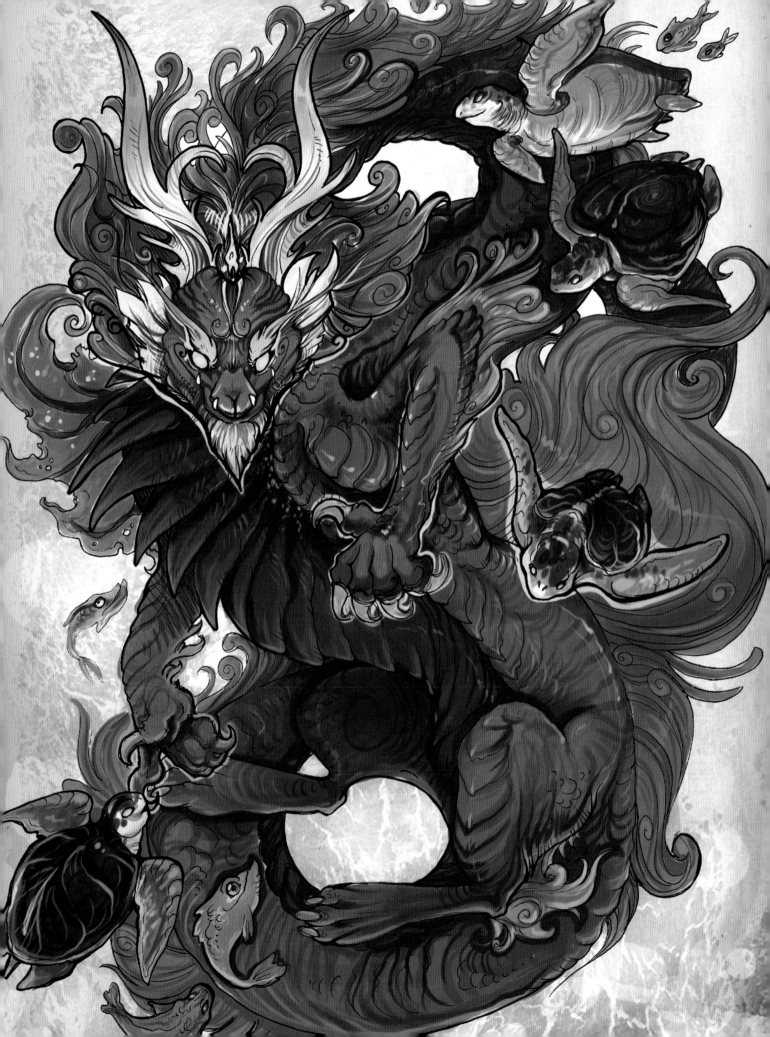

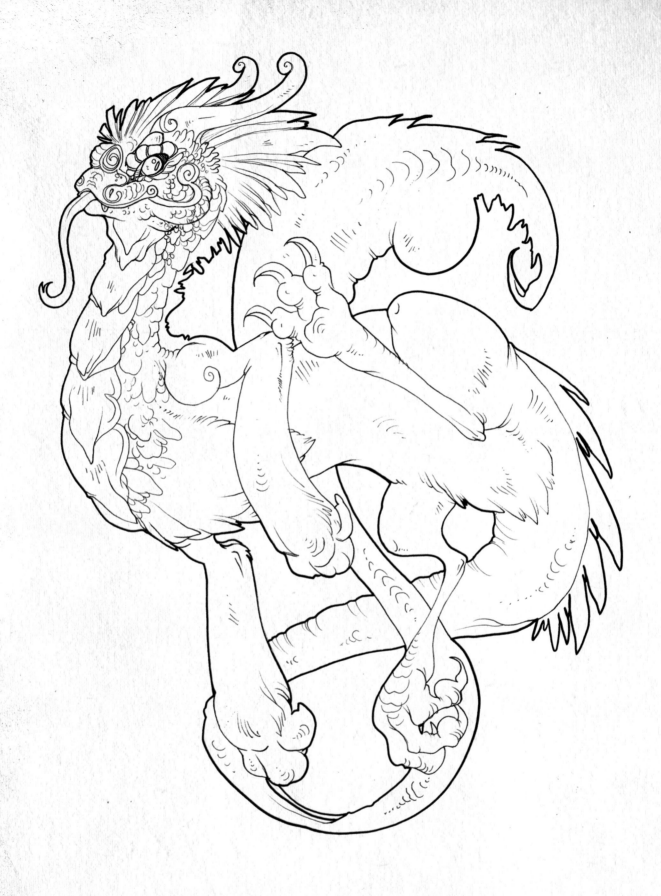

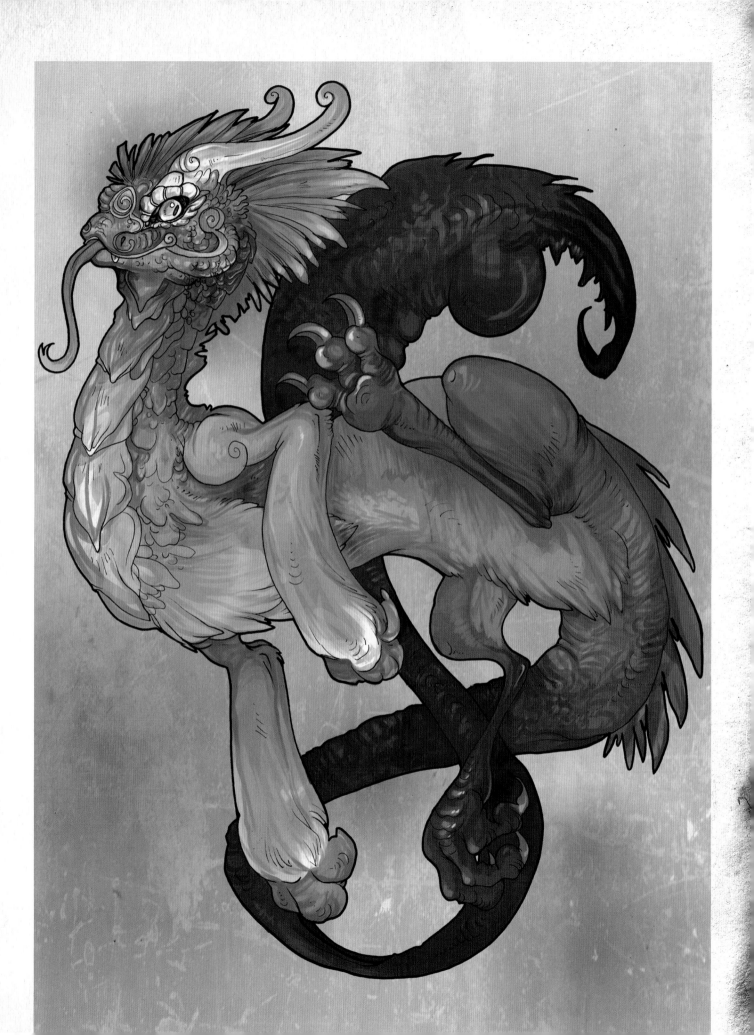

Jim Pavelec | **Genethoq**

What qualities do dragons exemplify that inspire you?
Dragons embody the delicate balance of fluid motion and raw brute force that I strive to portray in the images I create.

What creative license do dragons provide that other subjects don't?
Dragons allow us to draw on a wide variety of animal anatomy and provide a unique opportunity to explore different skin textures.

Is there a story behind these pieces?
In *Green's Wrath*, the people of the spired city of Afeleon have diverted the Dal-Tribess river so it pours into their domain, helping to power their mining equipment. Little did they know that the river was the water source for a pack of fearsome green dragons. Here the elder green takes its revenge.

The giant lava dragon in *On Fiery Currents* streaks through the sky like a great meteor, leaving a trail of soot and ash in its fiery wake. Food is scarce in the lava carved wasteland it calls home, so it flies out to the neighboring realms of cultivated earth to scoop up cattle, horses and the occasional human.

Does your dragon incorporate qualities of other animals?
The green dragon combines anatomical aspects from bats, horses, lizards and lions. For *On Fiery Currents* I used photos of rhinos, Komodo dragons and hawks.

What personality traits do your dragons possess?
The green dragon is ferocious and cunning, and the red dragon in *On Fiery Current*s is adaptable.

What materials did you use to make these pieces?
For *Green's Wrath*, I mounted a copy of the drawing onto a piece of Masonite. I began the painting in acrylic and moved on to oils. Then I scanned the painting and finished it digitally in Corel Painter and Adobe Photoshop. I started *On Fiery Currents* in watercolor and finished in oil.

How long did it take you to make these pieces?
Each piece took a week to make.

How does your art shape how you see the world?
My art is an escape from the real world, for myself and hopefully for those who see it.

What can dragons teach us about life and art?
They teach us to keep our eyes wide open because you never know what might swoop down and snatch you up.

profile of a
Dragon Artist

deviantART name: Genethoq

Location: Chicago, Illinois

Date joined: May 18, 2008

Websites: jimpavelec.com
inkbloomadventure.com

Hobbies: reading, watching anime

Favorite dragon: lava dragon

Favorite quote: When asked what is best in life, Conan replied, "To crush your enemies, see them driven before you, and to hear the lamentations of the women."

Green's Wrath
Jim Pavelec | Genethoq

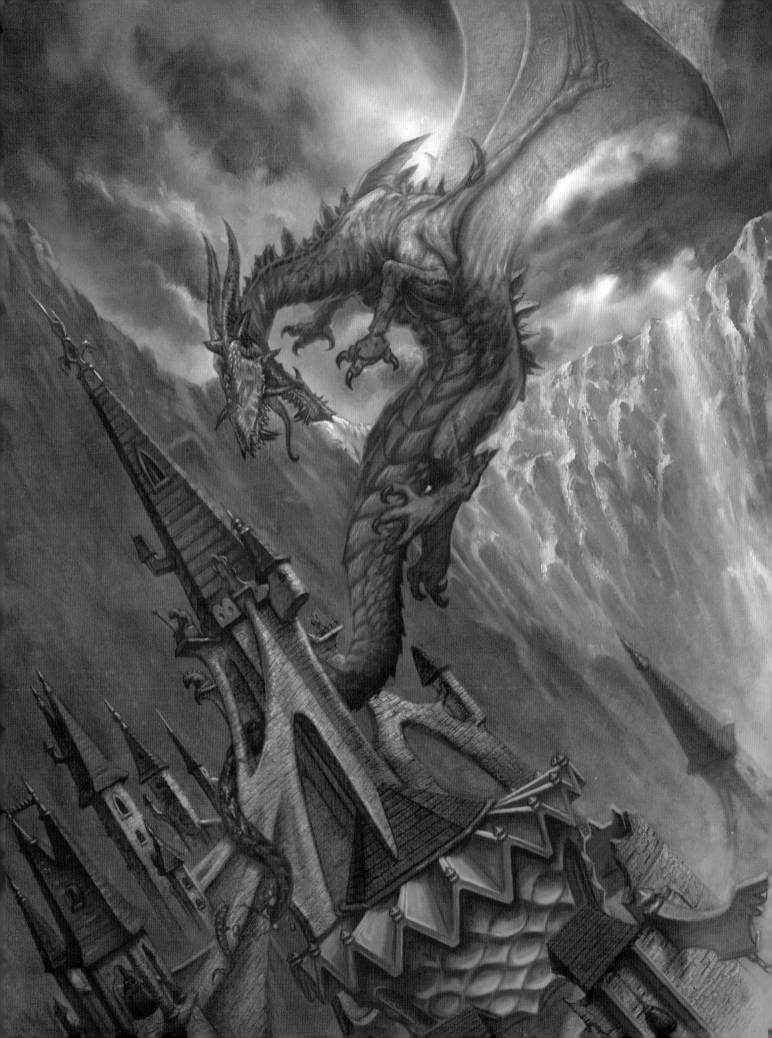

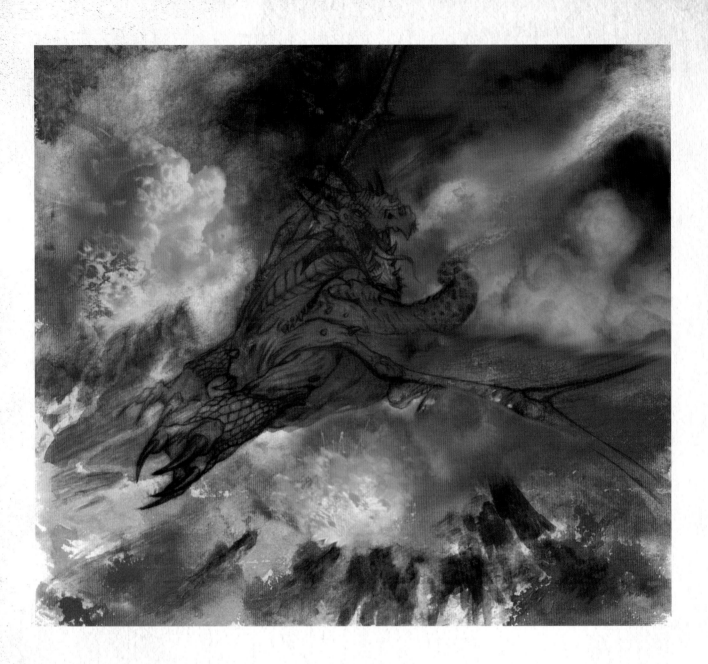

Visit http://dragonworld.impact-books.com for a free dragon demonstration

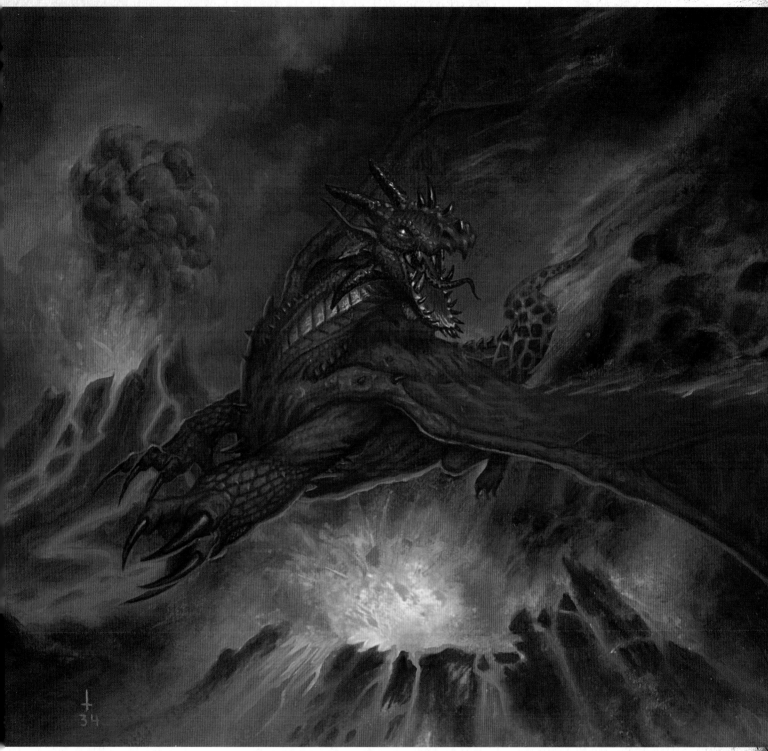

On Fiery Currents
Jim Pavelec | Genethoq

Tiago da Silva | **Grafik**

What qualities do dragons exemplify that inspire you?
Strength, fearlessness and wisdom.

What creative license do dragons provide that other subjects don't?
Dragons are not bound by earth and human rules. They are mythological creatures, so there's creative freedom on so many levels.

Is there a story behind your pieces?
The Dragon King Ao-Kuang is my representation of the king of dragons. I tried to portray how this magnificent creature would move in the skies he rules.

Dragon Tribes: The Calling was a personal work. I imagined how a tribe would live among dragons. They would be mountain people, for sure.

Do your dragons incorporate qualities of other animals?
The skin is like a reptile's. The Chinese dragon has a body that resembles a serpent.

What personality traits does your dragon possess?
The Dragon King Ao-Kuang is strong, fearless and wise.

What materials did you use to make these pieces of art?
For both illustrations, I used Photoshop CS2 and Wacom Intuos3.

How long did it take you to make these pieces?
The Dragon King Ao-Kuang was about 2 days' work and *Dragon Tribes: The Calling* took around 3 days.

How does your art shape how you see the world?
I "see" imaginary things all the time. In my art I try to represent what this world isn't.

What can dragons teach us about life and art?
Dragons can be very motivating and teach us about character. As an art form, dragons are one of a kind and can be very inspiring.

profile of a
Dragon Artist

deviantART name: Grafik

Location: Algarve, Portugal

Date joined: September 8, 2003

Hobbies: surf, football (soccer), photography, movies, reading art-related books, reading comics, going out with friends

Favorite dragon: The Dragon King Ao-Kuang

Favorite quote: An idea can turn to dust or magic depending upon the talent that rubs against it. —Bill Bernbach

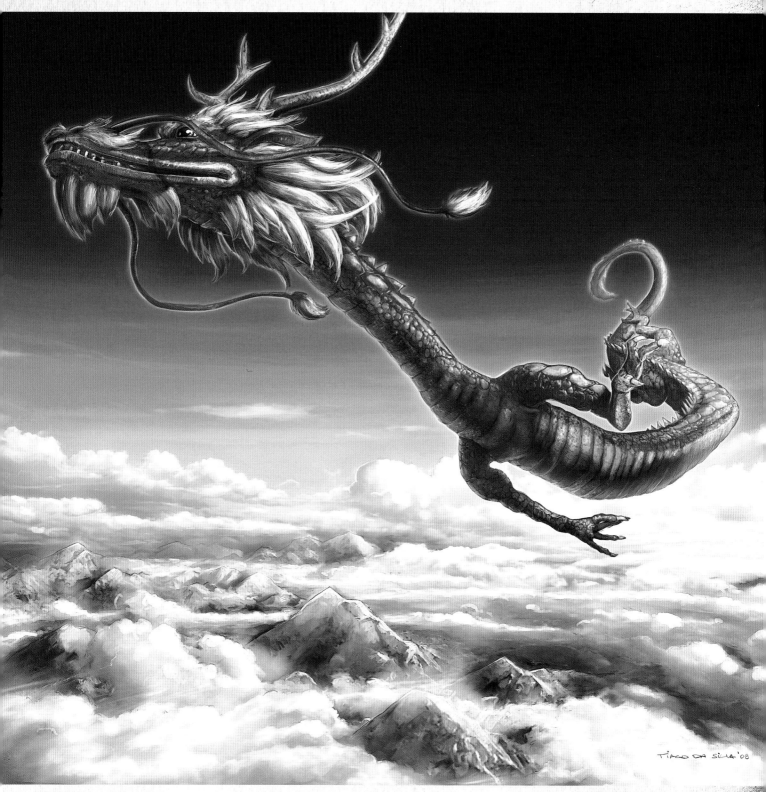

The Dragon King Ao-Kuang
Tiago da Silva | Grafik

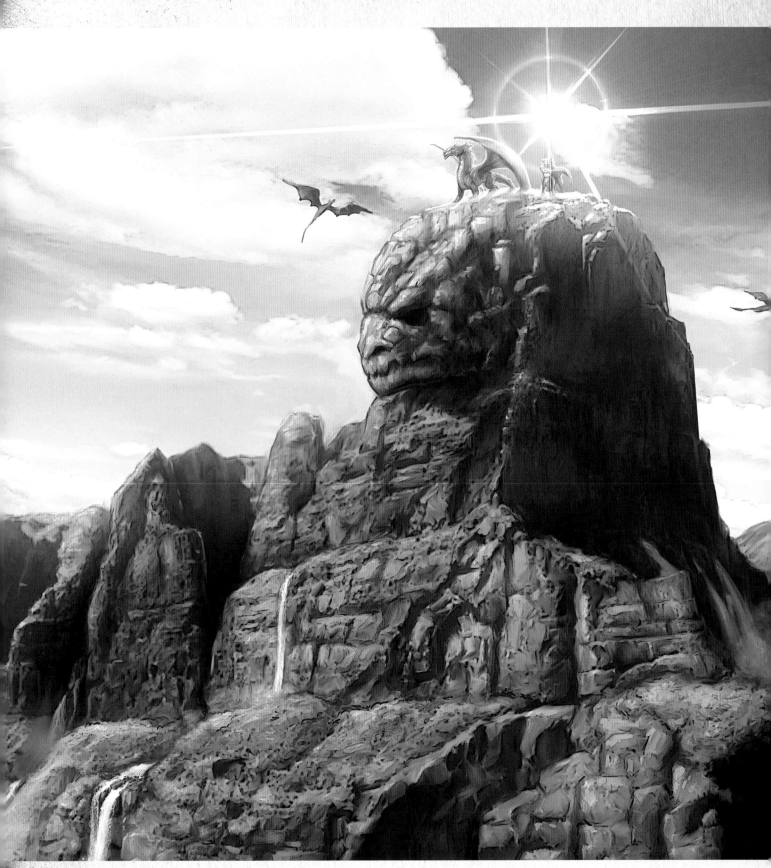

Dragon Tribes: The Calling
Tiago da Silva | Grafik

Visit http://dragonworld.impact-books.com for a free dragon demonstration

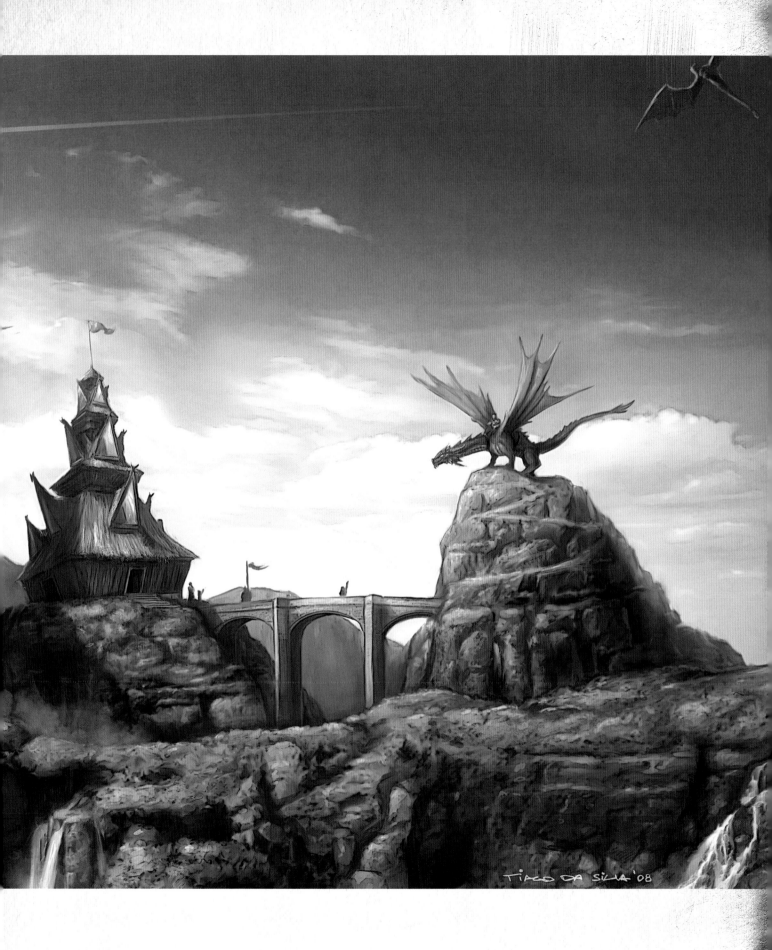

Katarzyna Marcinkowska | **grzanka**

What qualities do dragons exemplify that inspire you?
Dragons are really great inspiration because of their wide variety of appearance. I am inspired by European dragons. They look like almighty beasts, holding their powers in their monstrous bodies.

Is there a story behind your piece Only a Dragon**?**
It lives in the desert where it is the biggest creature.

Do your dragons incorporate qualities of other animals?
My wingless dragon looks like a four-legged carnivorous dinosaur with horns of a typical dragon.

What materials did you use to make this piece of art?
Only a Dragon is a traditional painting. I used black ink, watercolor and acrylic on watercolor textured paper. I like when artwork sometimes looks unfinished—it's more interesting.

How long did it take you to make this piece?
Only a Dragon took about 3 to 4 hours.

How does your art shape how you see the world?
Through drawing or painting dragons we can discover how to become better artists.

What can dragons teach us about life and art?
I think it's great fun to create dragons, when you don't have to care about anything else.

profile of a
Dragon Artist

deviantART name: grzanka

Location: Aleksandrów Kujawski, Poland

Date joined: December 15, 2007

Hobbies: art, art history, motorcycles, aquaristics

Favorite dragon: Ruth from *The Dragonriders of Pern*

Favorite quote: Carpe diem. —Horace

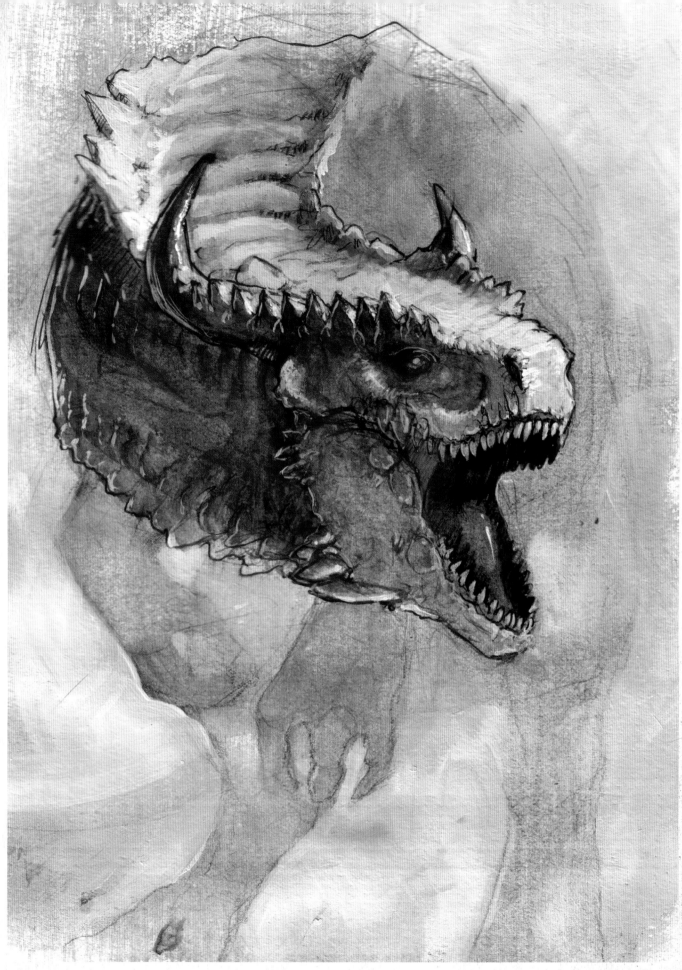

Only a Dragon
Katarzyna Marcinkowska | grzanka

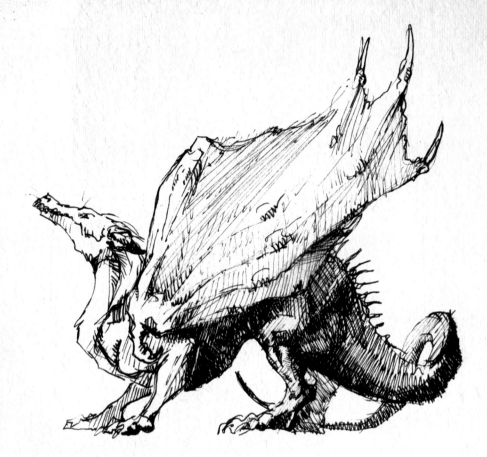

Dragon Sketch
Katarzyna Marcinkowska | grzanka

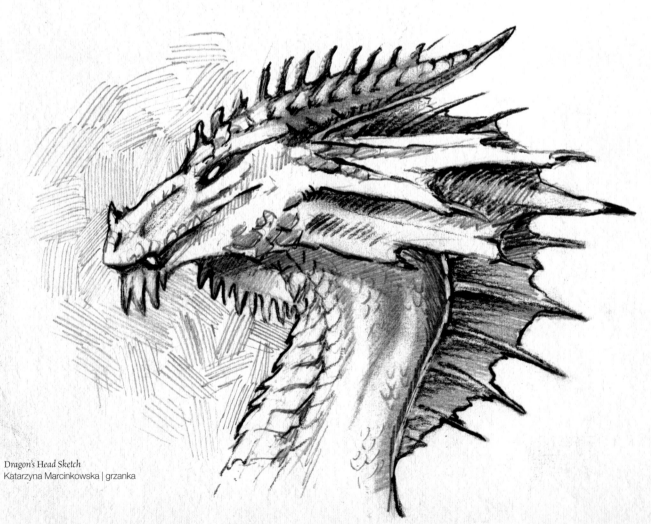

Dragon's Head Sketch
Katarzyna Marcinkowska | grzanka

Vulture Dragon
Katarzyna Marcinkowska | grzanka

Bobby Chiu | **imaginism**

profile of a
Dragon Artist

deviantART name: imaginism

Location: Toronto, Ontario

Date joined: October 20, 2006

Website: imaginismstudios.com

Favorite dragon: Night Fury from *How to Train Your Dragon*

Favorite quote: All children are artists. The problem is how to remain an artist once he grows up. —Pablo Picasso

What qualities do dragons exemplify that inspire you?
I'm inspired by the mystical quality of dragons. Their mystery causes my imagination to run wild!

What creative license do dragons provide that other subjects don't?
Everything! From anatomy to personality, dragons don't exist, so license is limitless.

Is there a story behind your piece?
In *Carrot Run* there's a tribe of small and fuzzy—but ferocious—creatures living in the jungle. And because they are so small and the animals they hunt are so big, they have to work together in order to obtain food. Their favorite prey is a pig dragon that loves carrots, so every year, when a member of their tribe reaches the age of maturity, he has to undergo a test of bravery to prove his worth to the tribe. He must wear the sacred carrot suit and become the bait in the annual Carrot Run. His job is to lure the big pig dragon into the tribe's hunting trap. If he succeeds, he will be accepted as a brave warrior of the tribe and the tribe will have food for the winter. If he fails ... well, I think we can all guess what happens then.

Does your dragon incorporate qualities of other animals?
I didn't intend to infuse my dragon with the qualities of any particular animal. (Honestly, I think most prey animals in real life would be much smarter than my pig dragon!)

What personality traits does your dragon possess?
The pig dragon in *Carrot Run* is kind of dopey, oafish and single-minded in his pursuit of food.

What materials did you use to make this piece of art?
Carrot Run was created completely digitally in Photoshop.

How long did it take you to make this piece?
About 2 weeks, from start to finish.

How does your art shape how you see the world?
My art is a product of how I see the world. Despite being creatures, my characters often have human traits.

What can dragons teach us about life and art?
Dragons, in all their forms and variations, demonstrate that there are always many ways to interpret a single idea.

Kei Acedera | **imaginism**

What qualities do dragons exemplify that inspire you?
Dragons are a kind of universal legend—all cultures have some idea of dragons. The mythology of dragons as mighty creatures with mystical powers would inspire wonder in anyone!

What creative license do dragons provide that other subjects don't?
The universality of dragons allows them to be interpreted broadly, but at the same time, a dragon design can be easily pinned to a certain culture or background. For example, broad wings on a dragon can identify it as a European-style dragon, while horns and a long, snakelike body can identify a dragon as Asian. Not many other subjects have this kind of innate styling while still offering broad creative license.

Is there a story behind your pieces?
Dragon Song is more like an answer to a question I thought of one day—what would happen if a princess who loves to dance met a dragon who loves to play music? I like this piece because it turns the traditional princess-held-captive-by-a-fierce-dragon idea upside-down. To me, it's a metaphor for how, despite our differences in culture, race or religion, we will always have some common ground to help us get along if we could turn our traditional prejudices upside down.

Do your dragons incorporate qualities of other animals?
My dragons are definitely more humanlike. I picture the dragon in *Dragon Song* as a kind of bard except he's, you know, a dragon.

What personality traits does your dragon possess?
My dragon is definitely romantic, whimsical and carefree.

What materials did you use to make this piece of art?
Dragon Song was completed in gouache and inks.

How long did it take you to make this piece?
About 6 hours. I was amazed by how quickly this painting came to me. It was a sure sign of how special this image would be!

What can dragons teach us about life and art?
The dragon myths from around the world remind us that nothing lasts forever except stories and wonder.

profile of a
Dragon Artist

deviantART name: imaginism
Location: Toronto, Ontario
Date joined: October 20, 2006
Website: imaginismstudios.com
Hobbies: traveling, music, movies, trying new foods
Favorite dragon: Mushu from *Mulan*
Favorite quote: Imagination is more important than knowledge. —Albert Einstein

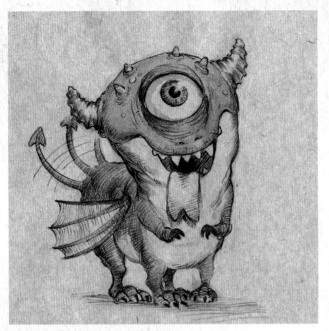

Cyclops Dragon
Bobby Chiu | imaginism

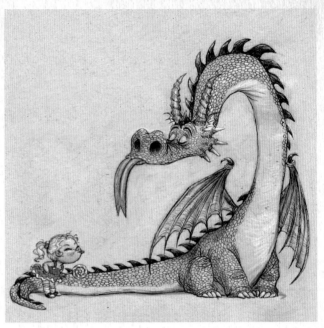

Blue Tongue Battle
Kei Acedera | imaginism

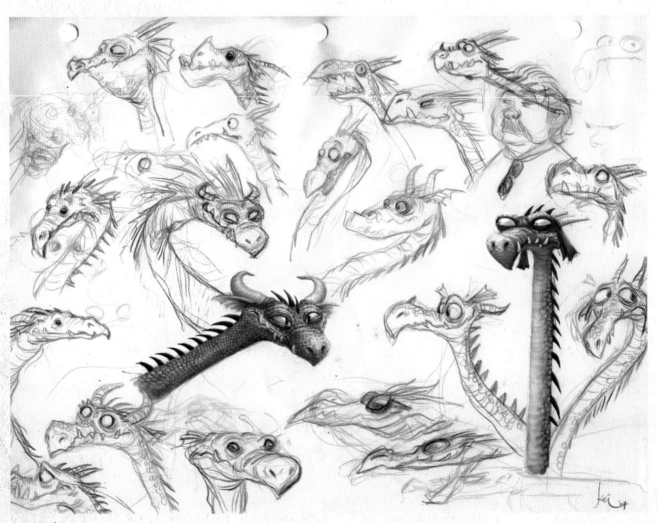

Dragon Studies
Kei Acedera | imaginism

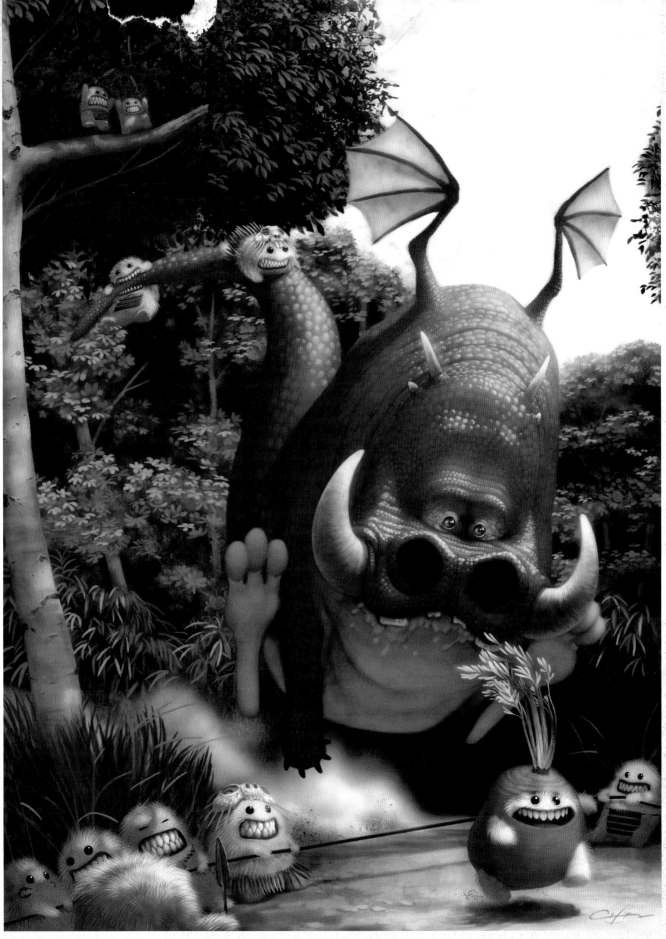

Carrot Run
Bobby Chiu | imaginism

Twins
Bobby Chiu

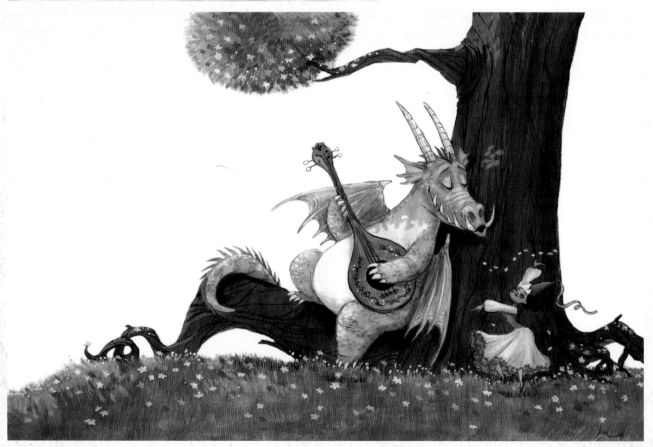

Dragon Song
Kei Acedera | imaginism

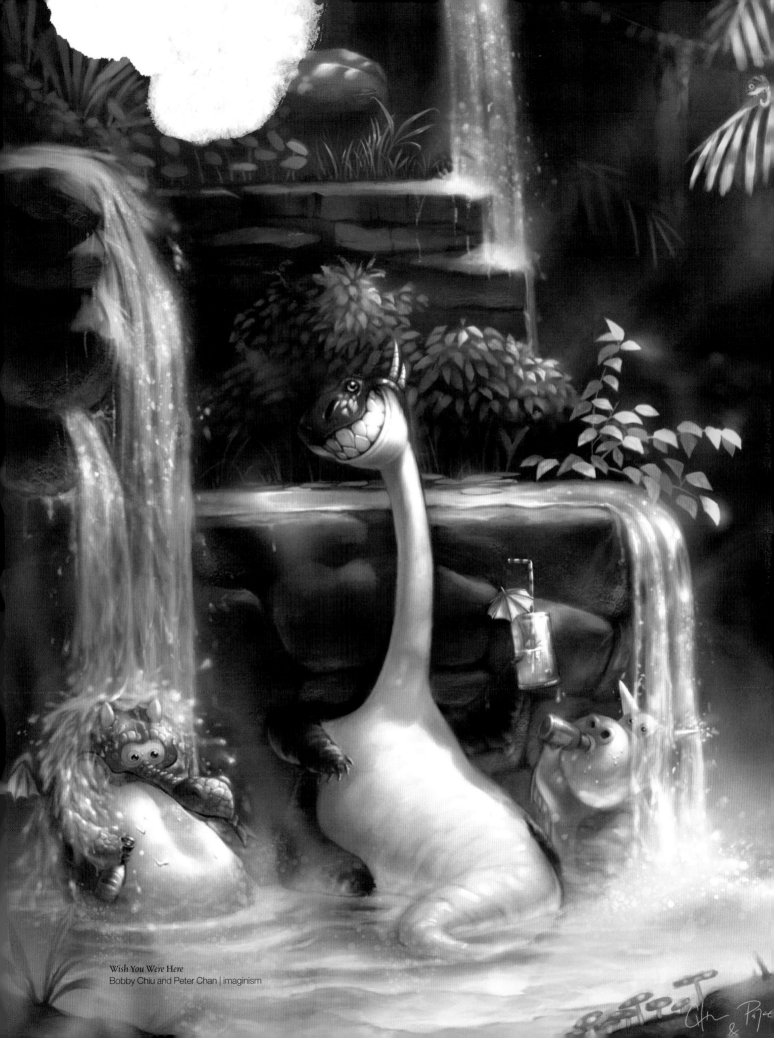

Wish You Were Here
Bobby Chiu and Peter Chan | imaginism

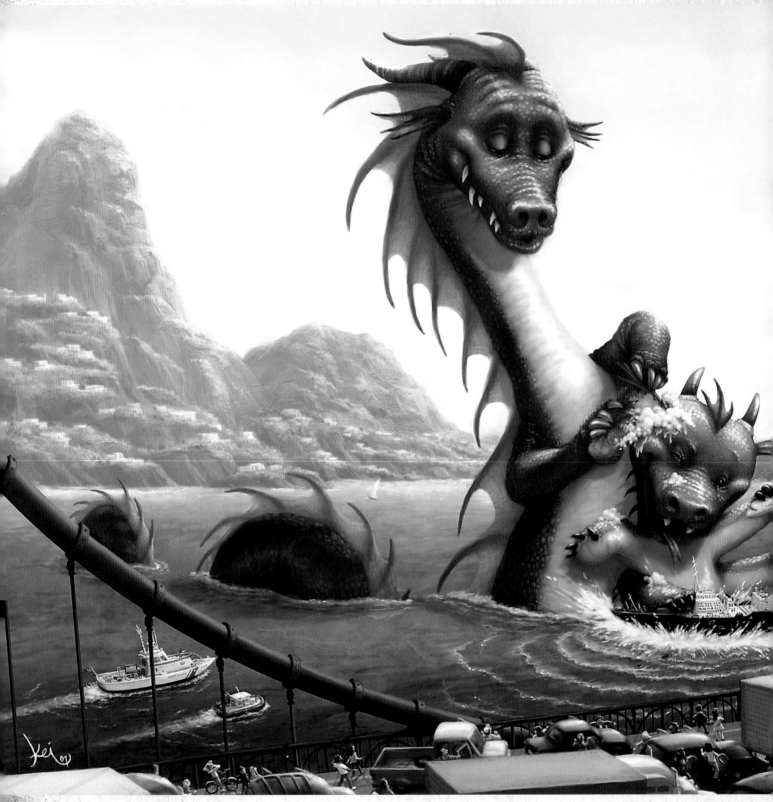

Bath Time
Bobby Chiu | imaginism

Visit http://dragonworld.impact-books.com for a free dragon demonstration

73

Thanaphan Dechboon | **jengslizer**

What qualities do dragons exemplify that inspire you?
I'm inspired by a dragon's power and magnificence while soaring through the sky and breathing fire as it roars.

What creative license do dragons provide that other subjects don't?
The power of creating natural phenomena—calling thunder, creating a giant wave or even breathing fire. The threatening feature that terrifies any creatures by spreading its wings.

Is there a story behind your piece?
Lilith and Dragon implies that even powerful dragons have weak spots. The dragon in this piece falls for the beauty of the woman.

What personality traits does your dragon possess?
Calm and ready to strike if it feels unpleasant. He acts on instinct.

What materials did you use to make this piece of art?
The sketch was done with pencil on paper. All color was done digitally in Photoshop 6.0.

How long did it take you to make this piece?
About 3 days.

How does your art shape how you see the world?
While working, I like to see the enjoyable aspects of the world. I enjoy creating my art by adding in a story or an ordinary thing I see every day. To me, the world is like a big amusement park.

What can dragons teach us about life and art?
To live free and to believe in the power of creation.

profile of a
Dragon Artist

deviantART name: jengslizer

Location: Bangkok, Thailand

Date joined: January 15, 2005

Website: happydrawing.com

Hobbies: plastic models

Favorite dragon: Bahamut from the *Final Fantasy* series

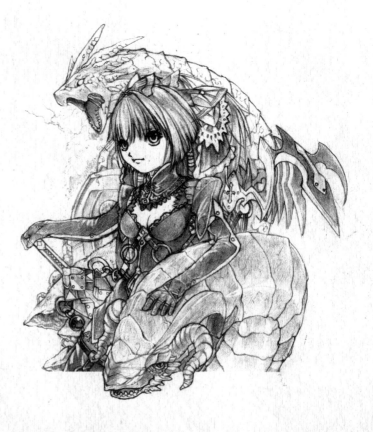

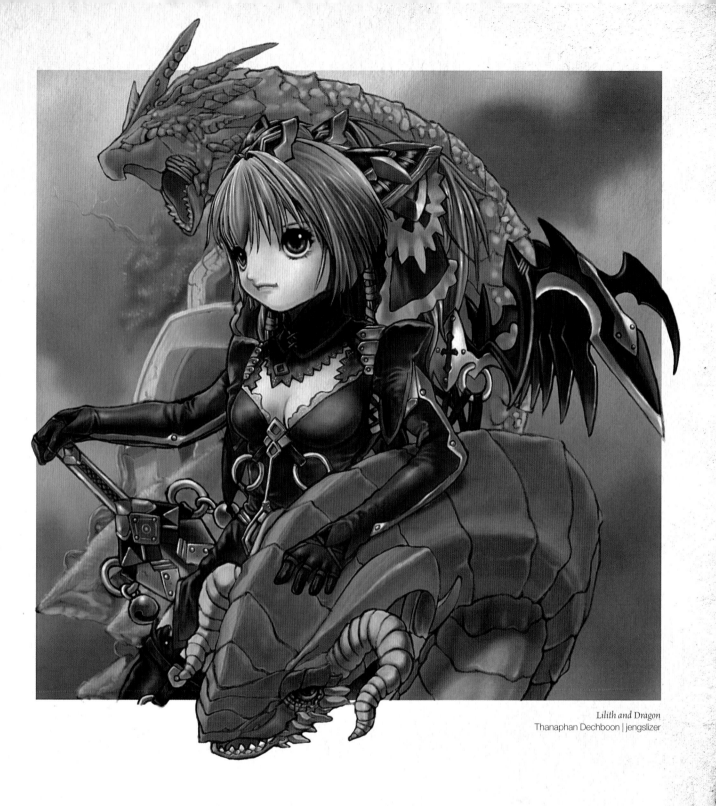

Lilith and Dragon
Thanaphan Dechboon | jengslizer

Carlos Eulefí | **Kaek**

What qualities do dragons exemplify that inspire you?
They're giant badass flying lizards. They're awesome—like a mix of T-rex with an F-16 or something. Cool stuff to draw.

What creative license do dragons provide that other subjects don't?
Sometimes I draw dragons just for fun and try to put personality in them.

Is there a story behind these pieces?
Embittered Dragon is a no-heart dragon from a friend's tale. I would like to illustrate the amazing tale someday. *Oriental Dragon* was just for fun!

Do your dragons incorporate qualities of other animals?
I used image references of cows for the nose, dinosaur skeletons for the neck anatomy, and Komodo dragons and bats for the rest.

What personality traits do your dragons possess?
In these examples, my dragons are a bit angry and embittered about life, the universe and everything.

What materials did you use to make these pieces of art?
Pencils, paper and colored in Photoshop.

How long did it take you to make these pieces?
Oriental Dragon took about 30 minutes and *Embittered Dragon* about 4 hours.

What can dragons teach us about life and art?
Dragons are a great exercise to learn animal anatomy—lizards, birds, dinosaur features, claws, wings. When combined with other animal stuff you get infinite variations. Dragons are in almost all human ancient cultures, from America to Europe and China. How they imagined similar creatures without contact is awesome!

profile of a
Dragon Artist

deviantART name: Kaek

Location: Santiago, Chile

Date joined: February 15, 2005

Website: kaeks.blogspot.com

Hobbies: drawing, sci-fi and fantasy novels, movies, PS3 and more drawing

Favorite dragon: the dragon from the animated TV series *Alfred J. Kwak* in episodes 41–42

Favorite quote: To a new world of gods and monsters.
—Dr. Pretorius, *Bride of Frankenstein*

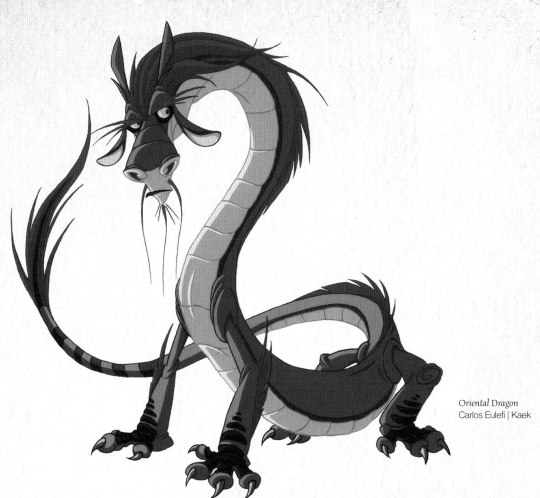

Oriental Dragon
Carlos Eulefi | Kaek

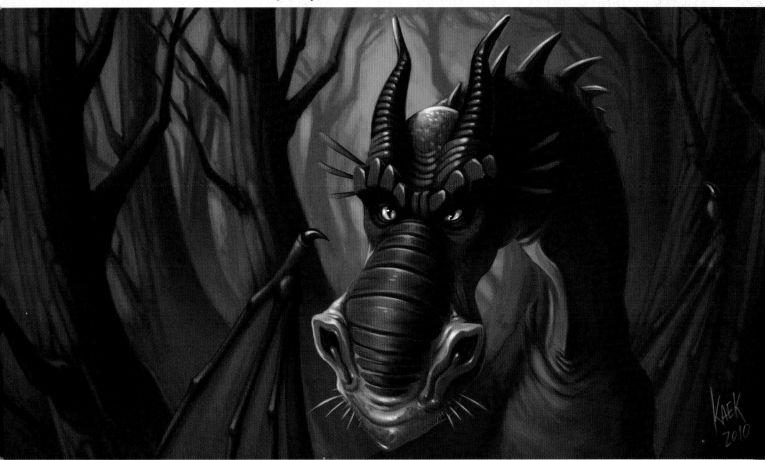

Embittered Dragon
Carlos Eulefi | Kaek

Alyssa T. Davis | **KaiserFlames**

What qualities do dragons exemplify that inspire you?
Dragons are creatures that embody strength of the body and strength of the mind. They can be powerful yet graceful, and also proud and humble. Dragons are the protectors and upholders of loyal and honorable ideals. Dragons are the knights in shining armor of the mythical creature realm and in my mind are never evil or cruel.

What creative license do dragons provide that other subjects don't?
Because dragons come from so many cultures, they also come in so many shapes and sizes. In the East dragons are snake-like and long, with the faces of lions and the antlers of deer. In Europe dragons are powerful, scaled creatures who breathe fire and soar on great wings. In South America, dragons come in the form of great feathered snakes. As cultures mesh in this modern age, all of these forms are mixing. Through the imaginations of artists, dragons are taking on so many more shapes. I believe that dragons provide a great opportunity for creative interpretations because they have such a varied history all across the world.

Do your dragons incorporate qualities of one or more other animals?
Lagai of the Forest is based on a green iguana, which mostly shows in his coloration, his whip-like tail, and his rounded and stocky head. I imagine he likes to sun himself, too, much like an iguana.

profile of a
Dragon Artist

deviantART name: KaiserFlames

Location: Reading, Pennsylvania

Date joined: November 27, 2004

Hobbies: drawing, illustrating, painting, reading, keeping loads of pets, writing, gaming

Favorite dragon: Draco from *DragonHeart*

Favorite quote: Synchronized panicking is not a proper battle plan.

Docerian Dragon is based on many creatures. He is a bit bow-legged and walks much like a crocodile, while his head and neck are similar to a turtle's. He has small wings, though he can't fly, and the coloration on his head is similar to a vulture.

Is there a story behind your pieces?
In *Lagai of the Forest*, Lagai belongs to a world where a great evil is trying to overtake everything. He is older and has spent his whole life fighting it. Though he's small and not as skilled at fighting as the other dragons, he has the ability to control plants. He can heal them, make them grow faster or slower, and can even change their colors.
Docerian Dragon is a dragon that belongs to a world called Docerae. It is a predatory creature that lives in the mountains and is a distant, more animalistic cousin to a race of gryphon-like people known as the Aquenn. He is feared by people not because he is evil but because he is so strong and large.

What personality traits do your dragons possess?
Lagai is a very old dragon who has seen a lot of hardship in his life, and because of this he can be a bit of a grump. When he's in a good mood though, he's more than willing to tell stories of when he was younger or teach a few neat tricks he's picked up in his life.

What materials did you use to make these pieces of art?
Lagai of the Forest was created digitally using Photoshop CS5 and a Wacom tablet. *Docerian Dragon* started as a pencil sketch and was colored in Photoshop using a Wacom tablet.

How long did it take you to make these pieces?
Lagai of the Forest took a few days to plan and color, probably about 8 hours total. *Docerian Dragon* took about 6 or 7 hours from sketch to finish.

How does your art shape how you see the world?
Whenever I move around in the world, I find myself mentally cataloguing things that I enjoy or find interesting to use later in my art. If I see a pretty color or an interesting animal or even a really cool cloud, I make sure to remember or sketch it in my sketchbook. Sketchbooks are an artist's best friend.

What can dragons teach us about life and art?
Dragons teach us that things are not always as they seem. For example, a dragon who may look very large and intimidating can be very friendly and gentle. The fact that dragons can appear in so many variations goes to show us that art itself can appear in so many ways and that it does not always have to be just a painting or a drawing.

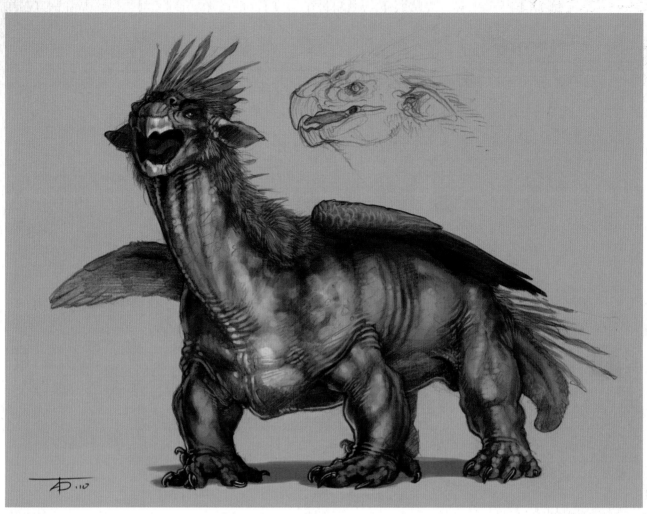

Docerian Dragon
Alyssa T. Davis | KaiserFlames

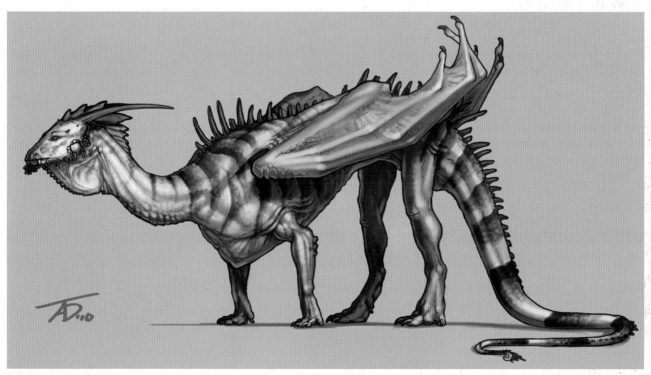

Lagai of the Forest
Alyssa T. Davis | KaiserFlames

Kerem Beyit | **kerembeyit**

What qualities do dragons exemplify that inspire you?
They're big and nasty. They have sharp teeth and horns. They come in lots of variation, and on top of that they fly! How cool is that?

What creative license do dragons provide that other subjects don't?
Fictional creatures provide much more extensive creative license than nonfictional creatures, though that doesn't mean they come without a set of rules. If you want to produce a design that is believable and makes sense, you have to draw some components—the skin, horns, teeth, eyes—as realistic and physics-appropriate as possible.

Do your dragons incorporate qualities of one or more other animals?
If you want your dragons to look impressive, it is very important to use reference at the rendering stage even though the general design is fictional. For instance, African bison have great horns that are a perfect feature to borrow for a dragon. I always examine dinosaur skulls for jaw and teeth structure, and reptiles for realistic skin. These are not mandatory, but they sure do make the end result more realistic.

What personality traits do your dragons possess?
For commissions, the traits of the creature are requested by the client. But for my own designs, I usually focus on the pose before the personality since I prefer determining the mood first. The facial features and all the rest are of secondary importance to me since it is easier to play with them as you wish. For instance, to achieve a cunning expression all you have to do is to narrow the eyes a bit and give an upward curl to one end of the mouth. I usually define the final facial characteristics with the Liquify effect in Photoshop. I go for intelligence in the eyes with some hints of malice or pure fierceness. I definitely do not like huge eyes, so in short, my dragons are not on the sweet side.

What materials did you use to make these pieces of art?
I have been all digital since 2008. Before that I would sketch on paper and color digitally, but as I got more comfortable in the digital medium and realized how much time I could save, I started drawing my sketches in Photoshop as well. I use SmudgeGuard™ gloves, a Cintiq™ 12WX tablet, Apple® Cinema Display™ monitor and mainly Photoshop for the software.

How long did it take you to make this piece?
Steampunk took about 8 to 10 hours. I am a fairly quick painter.

How does your art shape how you see the world?
My occupation is always a determining factor for my actions. My shopping bag and even my hobbies move in that trajectory. Sometimes the observation behavior steps in without me even realizing it, and I find myself examining how the volumetric light seeping through a window lights the carpet partially, or simply the shadow of a dog or a person's hand.

What can dragons teach us about life and art?
Dragons cannot teach a rational human about life because of their sheer fictional existence, though a literary work about dragons can. Since a good picture is also a good teacher, a fine dragon painting can be very educating. For example, light partially passes through dragon wings because they are semi-transparent. Usually the color of a transparent organic surface is a pinkish red. I learned that from dragon pictures, and now apply the same principle to the backlit ears of a human. The realism it brings to the picture is unquestionable.

profile of a Dragon Artist

deviantART name: kerembeyit
Location: Ankara, Turkey
Date joined: March 13, 2004
Website: theartofkerembeyit.com
Hobbies: collecting comics and action figures
Favorite dragon: *Dungeons & Dragons'* Red Dragon
Favorite quote: The harder you work, the luckier you get. —Gary Player

Steampunk
Kerem Beyit | kerembeyit

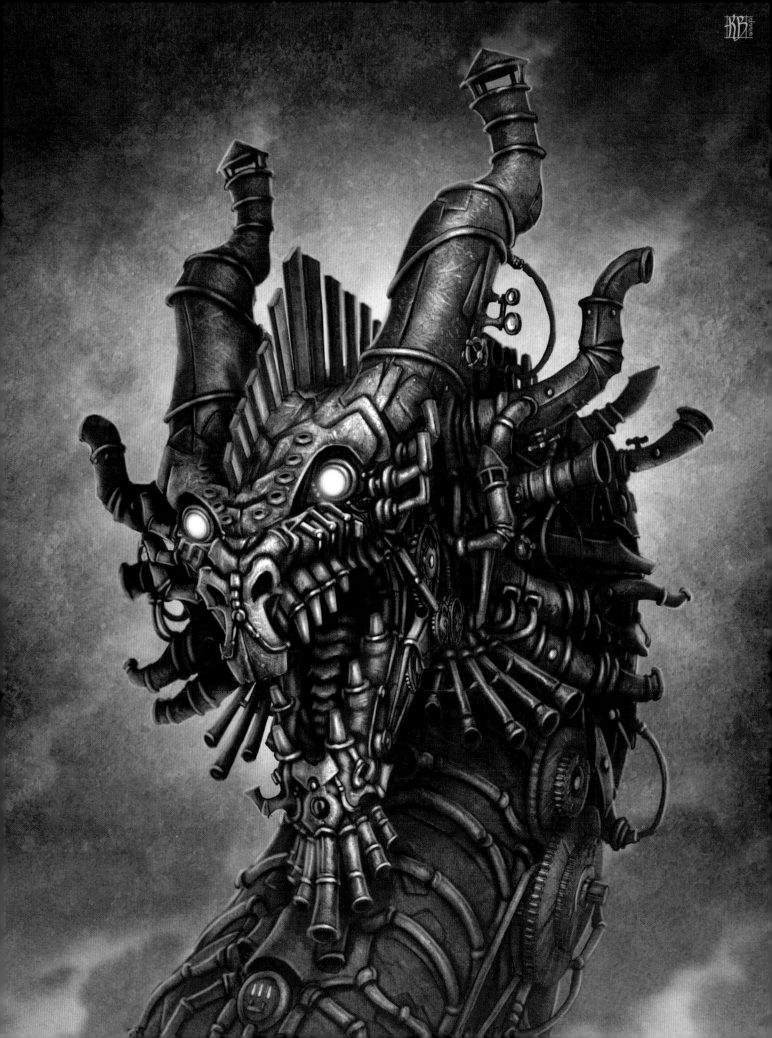

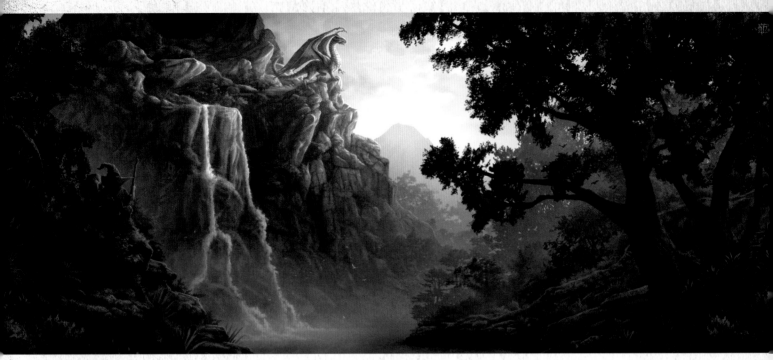

Egg Thief
Kerem Beyit | kerembeyit

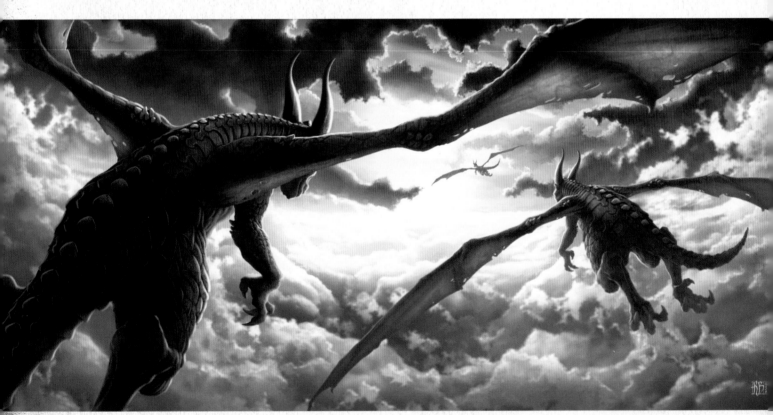

Over the Clouds
Kerem Beyit | kerembeyit

First Lesson
Kerem Beyit | kerembeyit

Visit http://dragonworld.impact-books.com for a free dragon demonstration

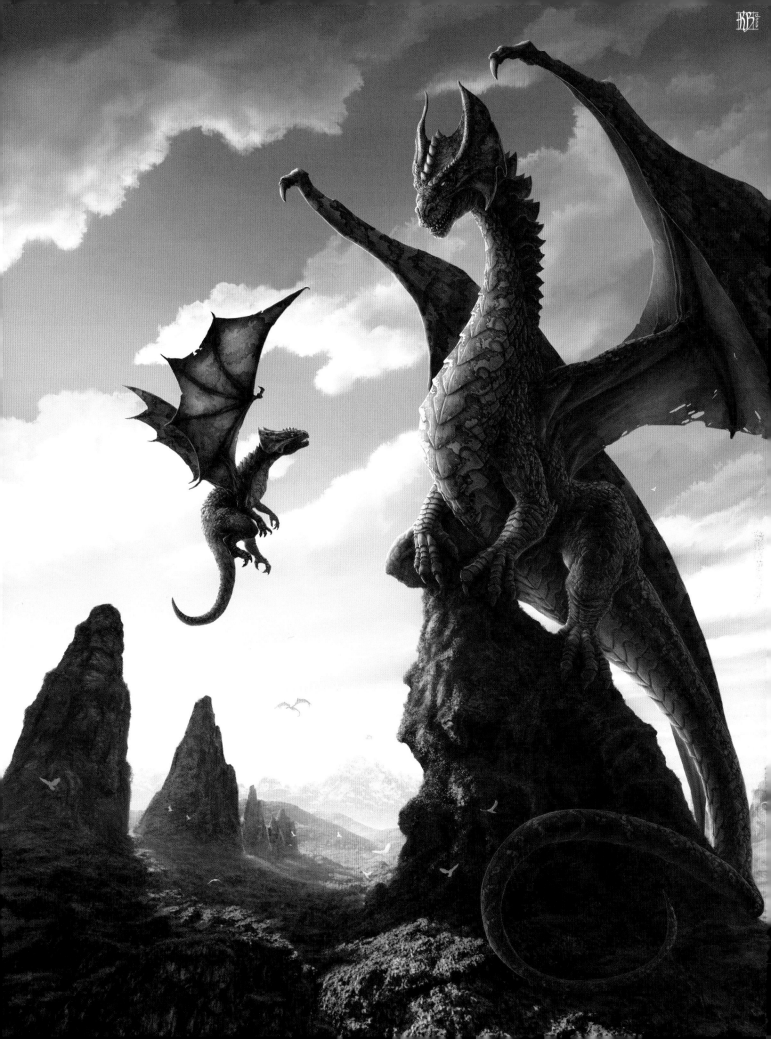

K. "Kez" Laczin | **Kezrek**

What qualities do dragons exemplify that inspire you?
Versatility: they can fly, run, walk and look like almost anything to fit in any environment.

What creative license do dragons provide that other subjects don't?
Being mythological helps. They aren't bound by rules—they break them!

Does your dragon incorporate qualities of one or more other animals?
Bats and various animal skeletons.

What personality traits does your dragon possess?
He likes long walks on a red tide-infested beach.

What materials did you use to make this piece of art?
Mechanical pencil sketch and Photoshop CS3 for color.

How long did it take you to make this piece?
The sketch took about 1 hour, coloring took 30 minutes.

How does your art shape how you see the world?
If it's well done, even a creature such as a Lich dragon can feel like it exists.

What can dragons teach us about life and art?
Like dragons, life and art can live forever in legacy.

profile of a
Dragon Artist

deviantART name: Kezrek

Location: Zionsville, Indiana

Date joined: July 1, 2004

Website: kezrek.com

Hobbies: thinking, dreaming, analyzing the universe

Favorite dragon: Red Death from *How to Train Your Dragon*

Favorite quote: If you want to live a happy life, tie it to a goal, not to people or things. —Albert Einstein

Lich Dragon
K. "Kez" Laczin | Kezrek

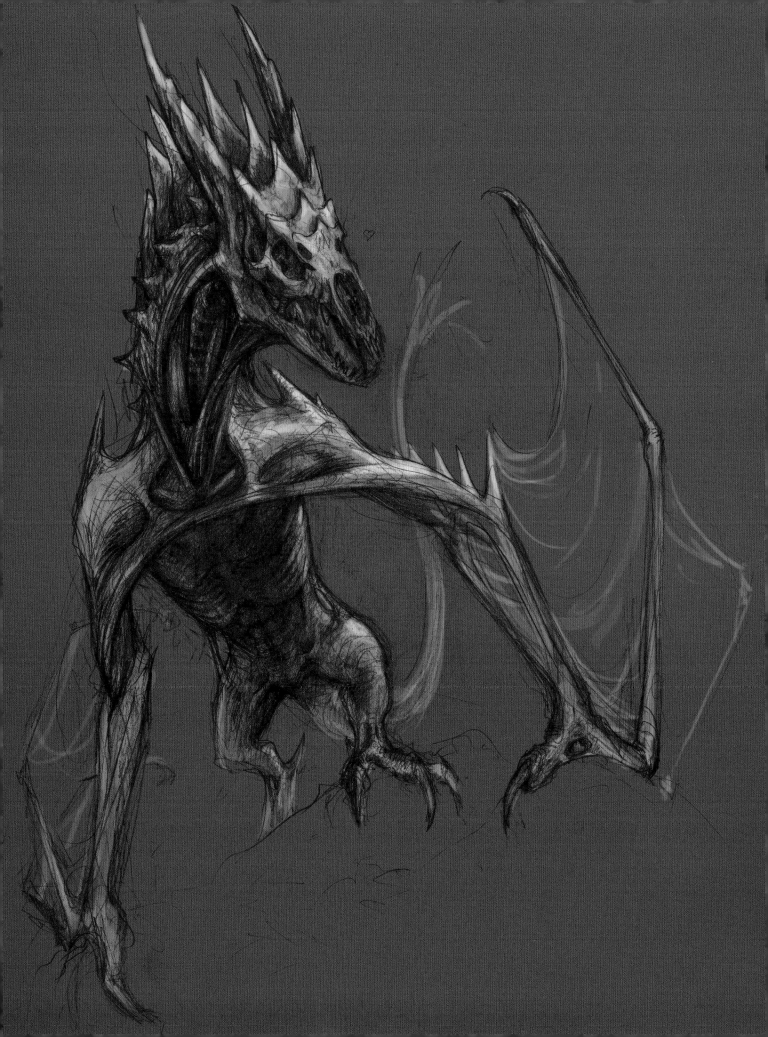

Sarah Jaffe | **klar**

What qualities do dragons exemplify that inspire you?
I enjoy their cunning manipulative ways, and their weakness for treasure.

What creative license do dragons provide that other subjects don't?
Probably the fact that there are no live or dead specimens to reference, which makes it an interesting exercise in design that isn't necessarily easy to get right.

Is there a story behind your piece?
The piece is just a working sketch, but a rich villain of mine needed some air transport and a place to hoard his stolen wealth. He makes a bad deal with a young red dragon he meets when shipwrecked on a volcanic island.

Does your dragon incorporate qualities of one or more other animals?
It's a bit of a bowerbird in some ways, choosing to live by the sea and in some cases preferring blue glass and aquamarine to objects of real value.

What personality traits does your dragon possess?
Adventurous, dominating and content to suffer the presence of mortals if they are profitable and amusing.

What materials did you use to make this piece of art?
Mechanical pencil in red and graphite.

How long did it take you to make this piece?
About 1 to 2 hours.

How does your art shape how you see the world?
I really can't look at anything without thinking about how I would draw it. And when I'm dreaming about something fantastic, I often end up searching for a sketchbook or a camera.

What can dragons teach us about life and art?
Dragons are a combination of incredible physical and mental power, with many human traits both dark and enlightened. Contemplating their nature can bring you courage, wisdom and creativity.

profile of a
Dragon Artist

deviantART name: klar

Location: Vancouver, British Columbia

Hometown: Ottawa, Ontario

Date joined: January 27, 2002

Hobbies: beachcombing, thrift diving, video-game fan art

Favorite dragon: Ruth from the *Dragonriders of Pern*

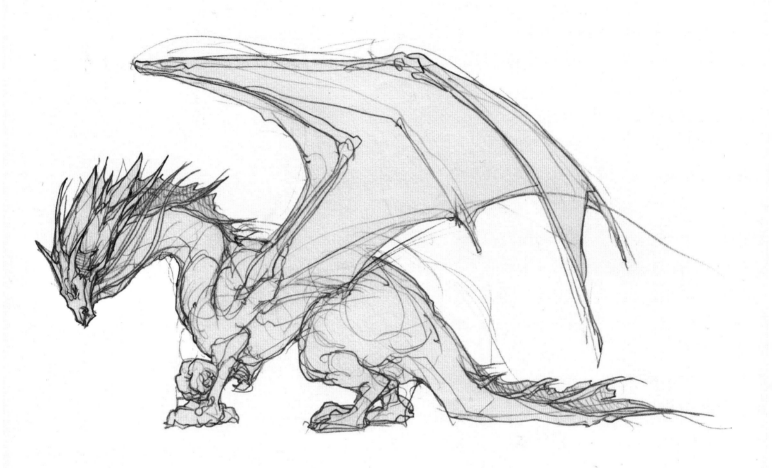

Sindhs Dragon
Sarah Jaffe | klar

Kendrick Lim | **kunkka**

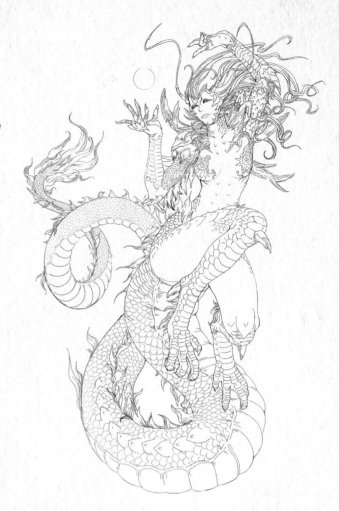

What qualities do dragons exemplify that inspire you?
Wisdom, inner strength and mystery are qualities of dragons that inspire me.

What creative license do dragons provide that other subjects don't?
Because dragons are creatures of fantasy, there is no restriction to ground them in reality and one can basically get wildly creative when depicting them.

Is there a story behind your piece?
Dragon Lady is a pinup of an original character of mine. Basically she is my version of a hybrid between a human and an Oriental dragon.

Does your dragon incorporate qualities of one or more other animals?
Dragon Lady is half dragon and half human. Though she is now in a hybrid form, she can take on the forms of either a full dragon or a full human.

What personality traits does your dragon possess?
Borne of a young female dragon and a skilled human hunter, she inherits her mother's energetic and fiery passion more than her father's calm and patience.

What materials did you use to make this piece of art?
This is a digital illustration, done using Photoshop CS3.

How long did it take you to make this piece?
This took around 15 hours from concept to finish.

What can dragons teach us about life and art?
Life is short, unless you are a dragon! So do what you enjoy and live life to the fullest.

profile of a
Dragon Artist

deviantART name: kunkka

Location: Singapore

Date joined: April 2, 2003

Website: imaginaryfs.com

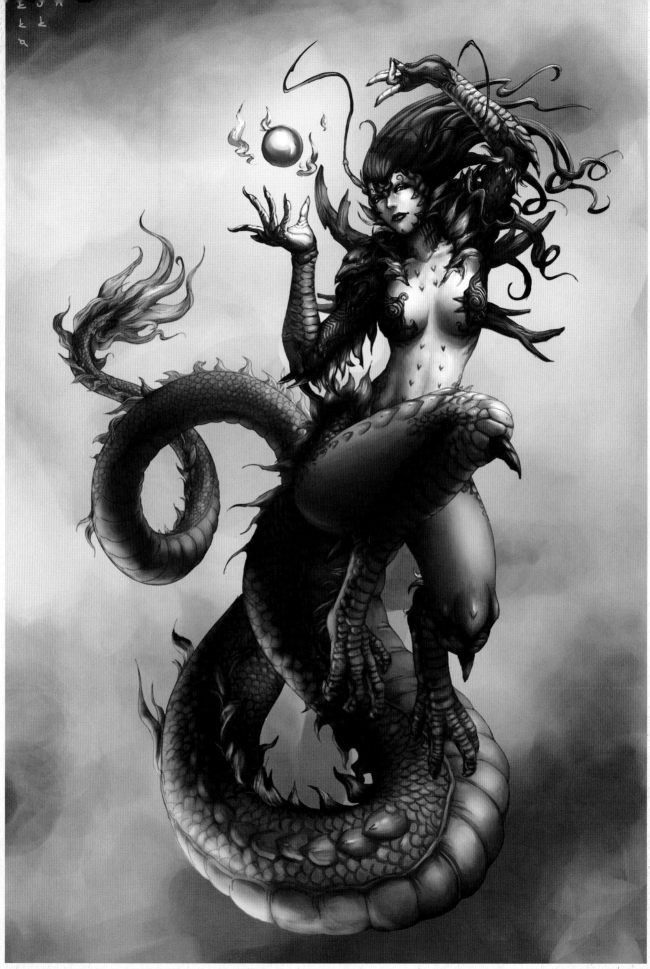

Dragon Lady
Kendrick Lim | kunkka

Alice Duke | **melora**

What qualities do dragons exemplify that inspire you?
As creatures from myth and folklore they can take on any quality, which is what can be so inspiring! I particularly like how dragons came to symbolize a general fear of the unknown.

What creative license do dragons provide that other subjects don't?
The description of a dragon can be so flexible, yet they are one of the most recognized fantasy creatures. You can add aspects of almost any other creature to a dragon without distorting the perception of what they are.

Is there a story behind your piece?
I had this idea for a really visceral image showing a violent act. If I'd used a creature that exists to illustrate that, the impact would have been completely different—probably quite repellent. As a purely fantasy image though, I can get away with something quite grotesque, whilst still being thought-provoking. I've had responses that have discussed hunting and animal cruelty, as well as responses that just describe the image as cool. I'm happy with both.

Does your dragon incorporate qualities of one or more other animals?
No animals in particular, but it does have a kind of snake/fish/whale thing going on.

What personality traits does your dragon possess?
Good question! Decide for yourself—is it a dumb beast or can you see a spark of intelligence in its eye?

What materials did you use to make this piece of art?
A pencil drawing and colored in Photoshop.

How long did it take you to make this piece?
About a day, probably.

How does your art shape how you see the world?
Difficult to answer, but it does mean that I am always on the lookout for interesting visuals to appropriate for my artwork.

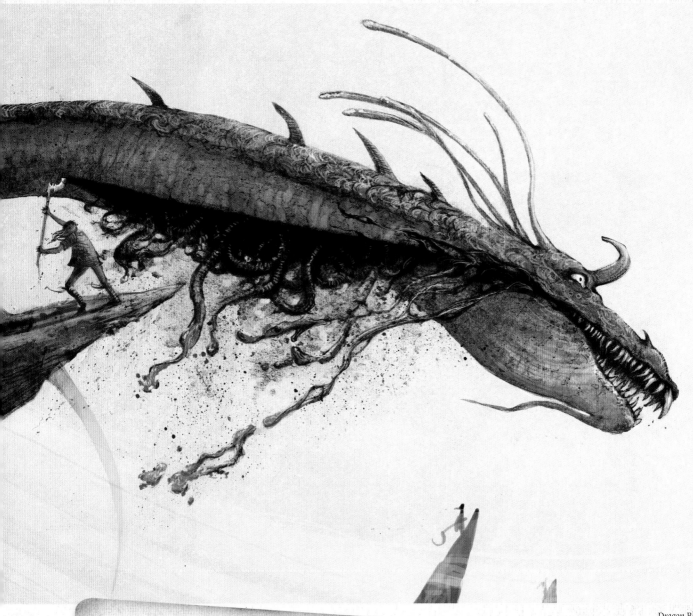

Dragon Blood
Alice Duke | melora

profile of a
Dragon Artist

deviantART name: melora

Location: Liverpool, England

Date joined: February 28, 2003

Website: aliceduke.com

Hobbies: making food and playing video games

Favorite dragon: *Electric Dragon's Morrison*

Melita Curphy | **missmonster**

What qualities do dragons exemplify that inspire you?

I love that dragons are portrayed as both fierce beasts and intelligent beings across different cultures and mythos. Plus, yay big fangs and scales!

What creative license do dragons provide that other subjects don't?

I think a lot of people can identify with the misunderstood beast aspect, while others really dig the big scary monster thing. People love charismatic megafauna, and dragons have been a popular creature for thousands of years. They have a lot of history behind them that people appreciate.

Is there a story behind your piece?

Not really! I just felt like drawing a dragon!

Does your dragon incorporate qualities of one or more other animals?

Sure! It's like a mush between a Komodo dragon and a wildebeest.

What personality traits does your dragon possess?

He's MEAN! But smart ….

What materials did you use to make this piece of art?

I did an inked piece with real media, then scanned it in and colored it with Photoshop.

How long did it take you to make this piece?

About 2 hours.

How does your art shape how you see the world?

An artist never stops being an artist. Everything we see is inspiration. We study color, light and line constantly.

What can dragons teach us about life and art?

Hmm, I don't know. I think it depends on who is looking at the dragon. Some people might see dragons as evil, some see them as examples of wisdom or power … some just think they look cool and mean nothing.

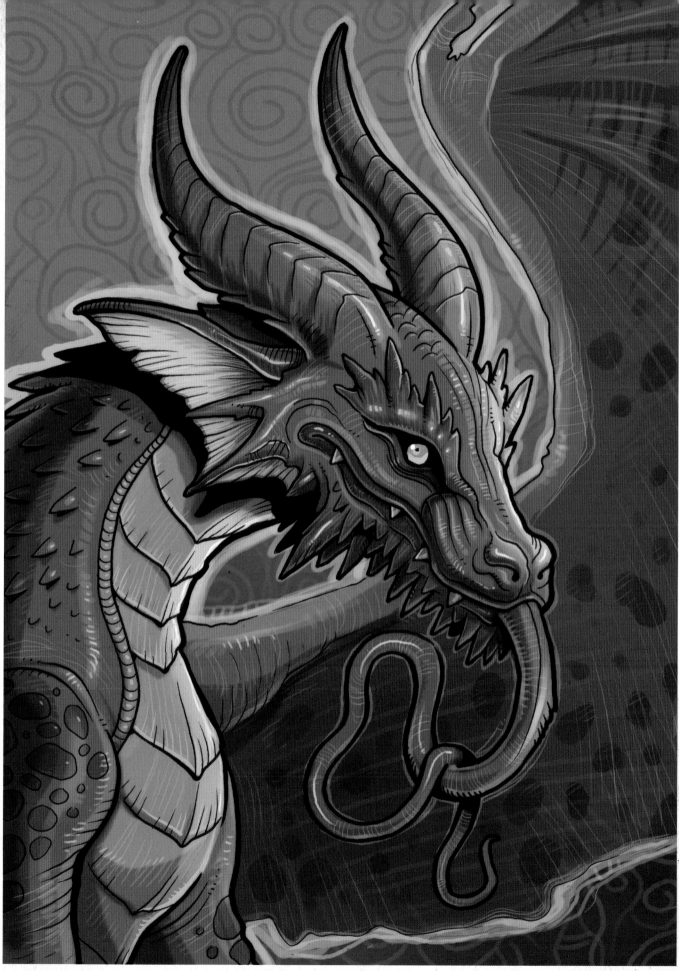

Dragon Card 2
Melita Curphy | missmonster

Michelle Parker | **Mparker**

What qualities do dragons exemplify that inspire you?
Dragons have flexibility of character that is extremely inspiring.
They can have a fierce nobility or a coy playfulness, but there's
always a sense of freedom.

Does your dragon incorporate qualities of one or more other animals?
Regal Dragon possesses scales, hair, feathers and horns, and
so is not an entirely reptilian sort of dragon, but something with a
softer side.

What materials did you use to make this piece of art?
Regal Dragon was created in a variety of soft and hard pastels on
a sueded paper, giving it tooth enough to hold the most delicate
application of color.

profile of a
Dragon Artist

deviantART name: Mparker
Location: Houston, Texas
Date joined: May 23, 2004
Website: knotwyrks.com

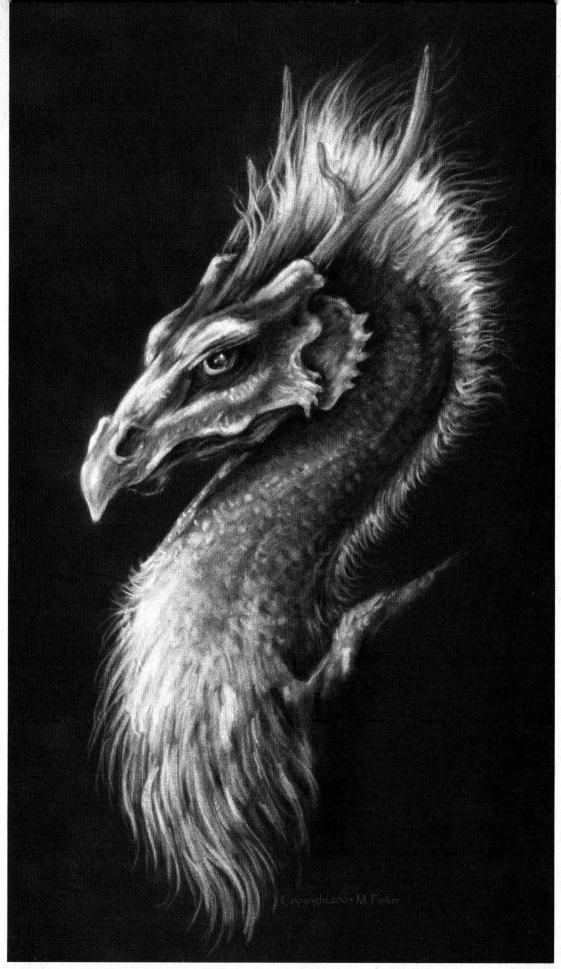

Regal Dragon
Michelle Parker | Mparker

Jessica Peffer | **neondragon**

What creative license do dragons provide that other subjects don't?
Dragons, and conceptual creatures in general, provide the opportunity to not only draw a certain subject, but to design an entire creature. Choosing how the anatomy fits together, what colors and patterns to use, and how the proportions work is very gratifying. Concept creatures are a treat to draw and an exercise in creativity!

Is there a story behind these pieces?
Last Guardian was a piece I intended to be ready for Earth Day. Once this dragon protected an entire forest with his kin, but over time, the forest has been reduced to a landfill. He is the last, and though he only has a small handful of life to guard, he continues on.

Tokeneki was a commissioned work done for a person of the same alias. I was given the opportunity to draw Tokeneki's Eastern dragon character in a setting of my choosing. Token seemed very gentle, so I placed him in a tranquil Asian-inspired setting.

Does your dragon incorporate qualities of one or more other animals?
My dragons will often incorporate the qualities and anatomy of many different animals. I tend to model my Eastern dragons' bodies after ferrets and otters, while my Western dragon bodies typically resemble large felines and canines. Pulling inspiration from existing animals can be a great way to get convincing and unique combinations of horns, wings, scales, talons and all the pieces and parts that add up to a unique dragon!

What personality traits do these dragons possess?
My dragons are typically feral, fierce monster-dragons. *Last Guardian* expresses wisdom and sorrow, while *Tokeneki* is gentle with a little streak of mischief buried beneath his placid exterior.

What materials did you use to create your art?
These two works are entirely digital. I sketch, ink, color and render in Photoshop using a Wacom tablet.

How long did it take you to make these pieces?
Around 7 to 10 hours each.

How does your art shape how you see the world?
I think art has made me a better observer of the world around me. I may notice a neat interplay of light and shadow in between the leaves of a tree or a subtle hue shift in objects I might have previously overlooked.

profile of a
Dragon Artist

deviantART name: neondragon
Hometown: Cleveland, Ohio
Location: Columbus, Ohio
Date joined: February 8, 2002
Websites:
neondragonart.com
neondragon.livejournal.com
twitter.com/neondragonart
Hobbies: candle making, *World of Warcraft*, biking, hermit-crab aficionado
Favorite dragon: Draco from *DragonHeart*. It's Sean Connery and a dragon rolled into one. How could anyone not love that!?
Favorite quote: Everything's perfectly all right now. We're fine. We're all fine here now, thank you. How are you?
—Han Solo

Last Guardian
Jessica Peffer | neondragon

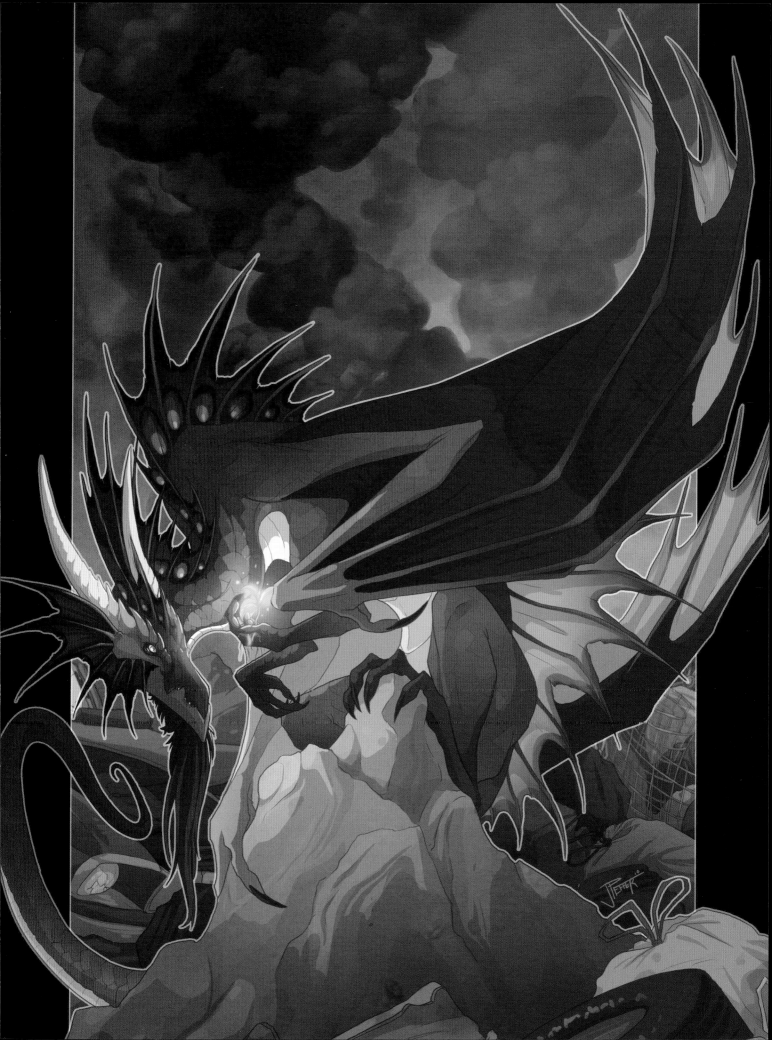

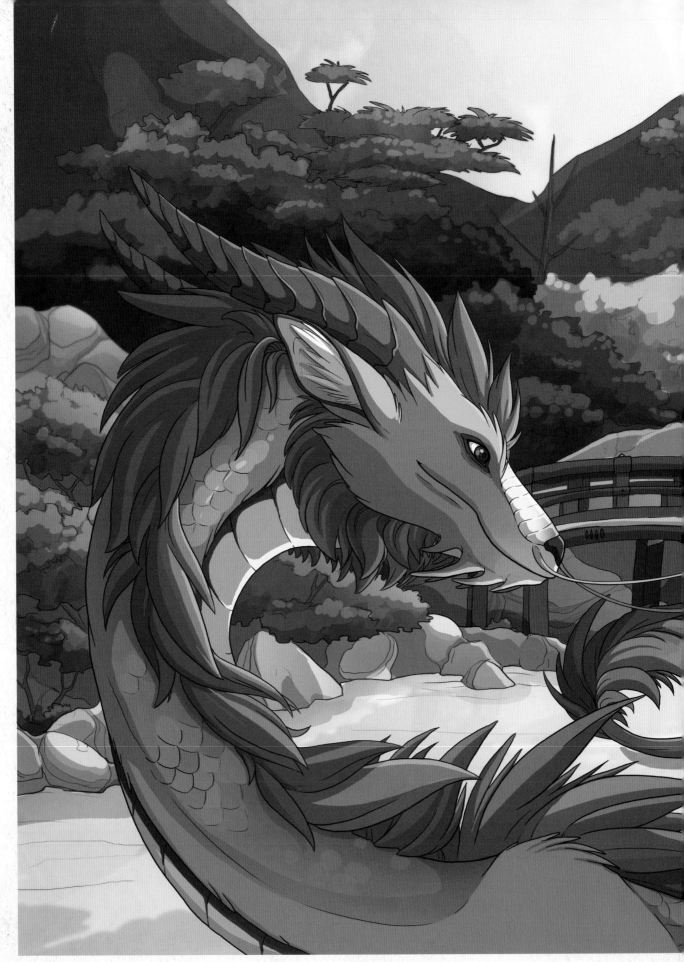

Tokeneki
Jessica Peffer | neondragon

Visit http://dragonworld.impact-books.com for a free dragon demonstration

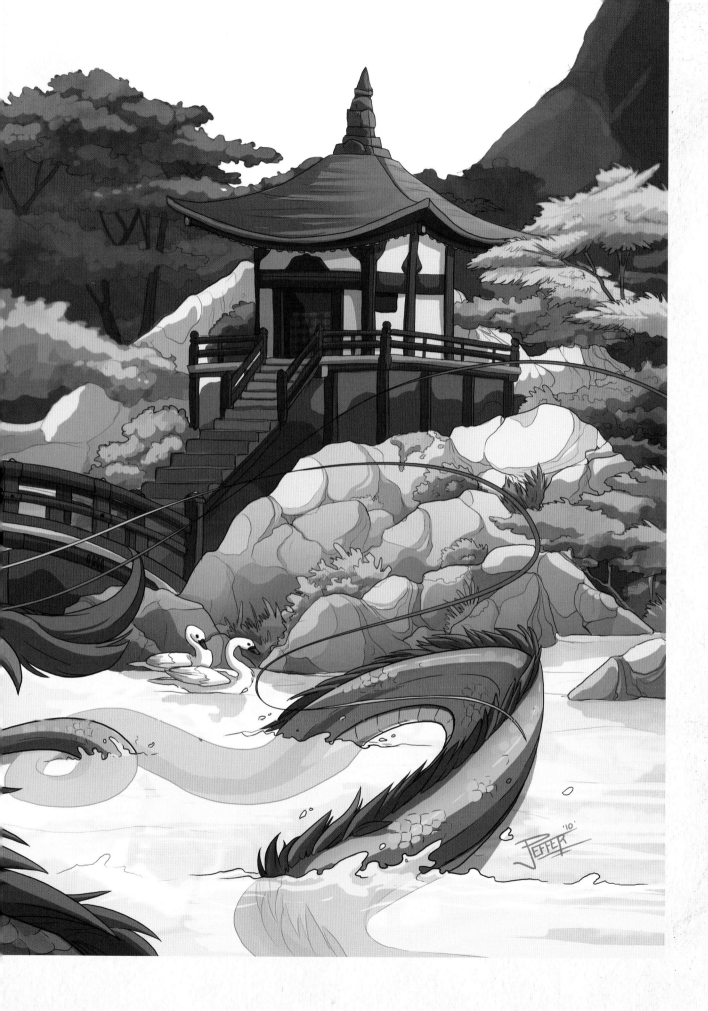

Juan Calle | **onikaizer**

What qualities do dragons exemplify that inspire you?
How dragons have adapted to different environments, as seen by cultures around the world, makes me regard dragons as a force of nature, a keeper of the boundaries. Dragons not only teach with a kind spirit, but they punish transgressors with the swiftness of a hungry predator. It's the respect for nature that the dragon represents that really drives my work.

What creative license do dragons provide that other subjects don't?
The diverse views of the dragon in culture allow us to adapt the designs not only to legend, but to the local environment—from icy mountains to the depths of the sea.

profile of a
Dragon Artist

deviantART name: onikaizer

Location: Bogotá, Colombia

Hometown: Medellín, Colombia

Date joined: January 21, 2007

Websites: juancalle.com
liberumdonum.com

Hobbies: video games

Is there a story behind your pieces?
Chinese Coiled Dragon: The Panlong is a mythical creature derived probably from an actual extinct crocodile. I tried to fuse both versions of the story and give the dragon a more realistic approach.

Dragon Exhibit Case: Here I tried to depict famous dragons from around the world in relative scale to show the differences between the winged dragons and the water dragons, derived from two different evolutionary lines.

Do your dragons incorporate qualities of one or more other animals?
They derive from actual creatures, mostly related to a basic line between dinosaurs and crocodilians.

What materials did you use to make your artwork?
All done digitally. Photoshop for software and a small Wacom tablet for drawing.

How long did it take you to make these pieces?
About 12 hours each.

How does your art shape how you see the world?
I try always to incorporate part of the unknown world of creatures and plants for all to see, as a way to educate and show interest and respect for things that appear small but still make up our natural world. It makes me realize how much potential each creature has to adapt and live even in the harshest environments, and at the same time realize how brittle we can be.

What can dragons teach us about life and art?
Invention and creation must be adaptive, just as the dragon has adapted to every creed and culture.

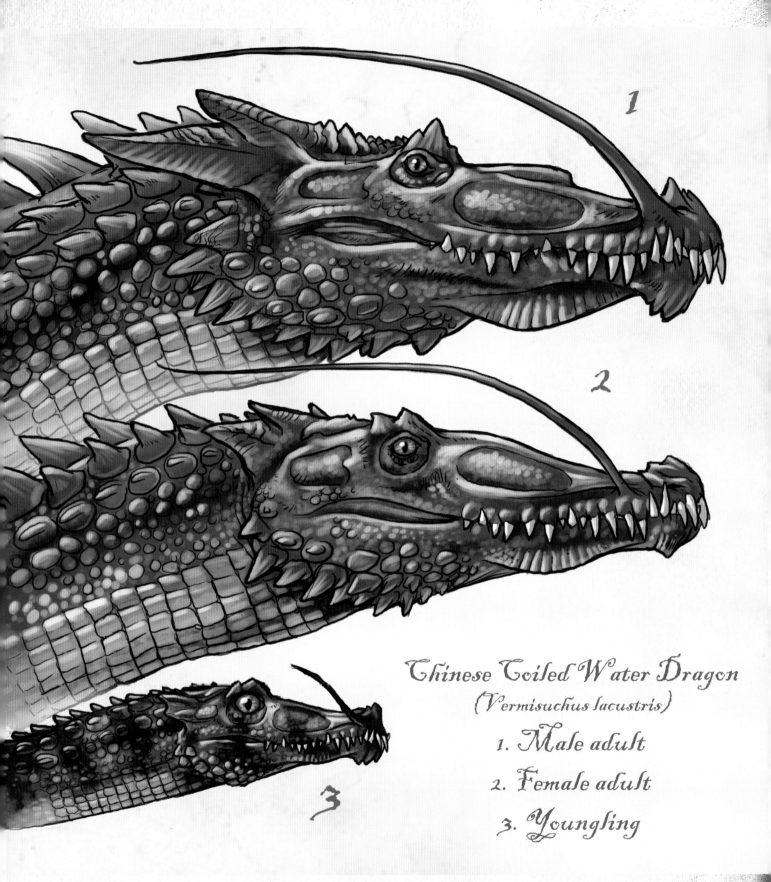

Chinese Coiled Water Dragon
(Vermisuchus lacustris)

1. *Male adult*

2. *Female adult*

3. *Youngling*

Chinese Coiled Dragon
Juan Calle | onikaizer

Stefanie Morin | **psycho-kitty**

What creative license do dragons provide that other subjects don't?
They come in so many shapes and sizes and so many different personalities, very much like humans. All the while they allow the creator a huge amount of design freedom.

Does your dragon incorporate qualities of one or more other animals?
There is some obvious bat in the wings and lizard in its slithe physique, but it still retains a pure dragon form in muscle and shape.

What personality traits does your dragon possess?
It is very adamant and very proud of its power.

What materials did you use to make this piece of art?
This was a mixed-media piece, incorporating a hand-inked drawing and watercolor background with photographs of rocky textures mixed in with Photoshop.

How long did it take you to make this piece?
Somewhere around 8 to 10 hours.

How does your art shape how you see the world?
I have such a vivid imagination with everything I see. I create stories out of little events like riding the bus—creating characters to these stories, drawing them into my art and creating worlds for them.

What can dragons teach us about life and art?
To be strong and fierce in everything we do!

profile of a
Dragon Artist

deviantART name: psycho-kitty

Location: Montreal, Quebec

Date joined: July 22, 2003

Websites: stefm.net
stefm.blogspot.com

Hobbies: video games, comic books, photography, baking, drawing, crafting and sculpting

Favorite dragon: Rayquaza

Eragon Dragon
Stefanie Morin | psycho-kitty

Stephanie Pui-Mun Law | **puimun**

What qualities do dragons exemplify that inspire you?
Dragons are creatures who can be symbols of humankind's most base desires and traits, as well as the highest aspirations of goodness. They are fantastical creatures who can embody in the form of a monster both greed and terror, rampage and destruction. The other end of the spectrum is as embodiments of beauty in majesty and grace and incarnations of nature itself.

What creative license do dragons provide that other subjects don't?
As it's a mythical creature, an artist can choose their own way to depict it. Even in cultures that have very specific descriptions of a dragon, there are still innumerable ways that they are drawn and painted as seen through the mind's vision of each artist who approaches the subject.

Is there a story behind your work?
In *Four of Pentacles* the dragon coils tightly around his hard-earned hoard. He has spent many human lifetimes to gather up such a vast treasure. No one shall touch it! No one shall steal it from him!

 Year of the Dragon is one of an intended series for the Chinese zodiac.

profile of a
Dragon Artist

deviantART name: puimun
Location: Oakland, California
Date joined: October 7, 2003
Hobbies: reading, playing piano, dancing flamenco, cooking
Websites:
shadowscapes.com
shadowscapes-stephanielaw.blogspot.com

When Dragons Dream is based on one of my favorite concepts. In Chinese feng shui, it is believed that all the land is atop sleeping dragons. When the earth shifts or calamity befalls, it is because these giants are shifting in their dreams. The flow of energy and the earth's life force is the blood that pulses in the sleeping dragons' veins.

Do your dragons incorporate qualities of one or more other animals?
Yes, they incorporate a wide spectrum of animal qualities. My dragons are never the same from one painting to the next. Sometimes they are serpentine and writhing wingless through the skies, with majestic lion and horse manes. Other times they have wings, sometimes feathered, sometimes webbed, deer antlers, scales.

What personality traits do your dragons possess?
Four of Pentacles—greed, possessiveness
Year of the Dragon—grace and elegance
When Dragons Dream—dreamlike, ancient

What materials did you use to make these pieces?
Watercolors on illustration board.

How long did it take you to make these pieces?
Four of Pentacles—20 hours
Year of the Dragon—20 hours
When Dragons Dream—30 hours

How does your art shape how you see the world?
Try to glimpse the strange beauty that can be hidden in all aspects of the world and in the smallest details. Hidden shapes and shadows and the way light strikes an object. It is usually easy to find beauty in nature, but even in human motion, in man-made lines, and in decay, there is an elegance that I try to use as inspiration to shape my art.

Four of Pentacles
Stephanie Pui-Mun Law | puimun

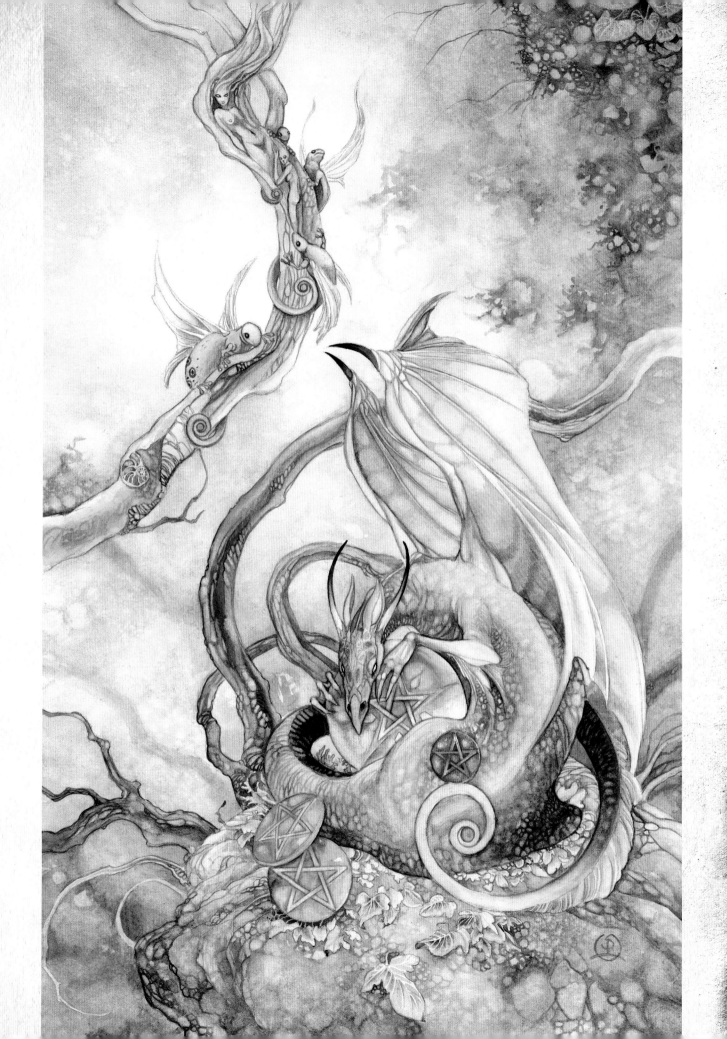

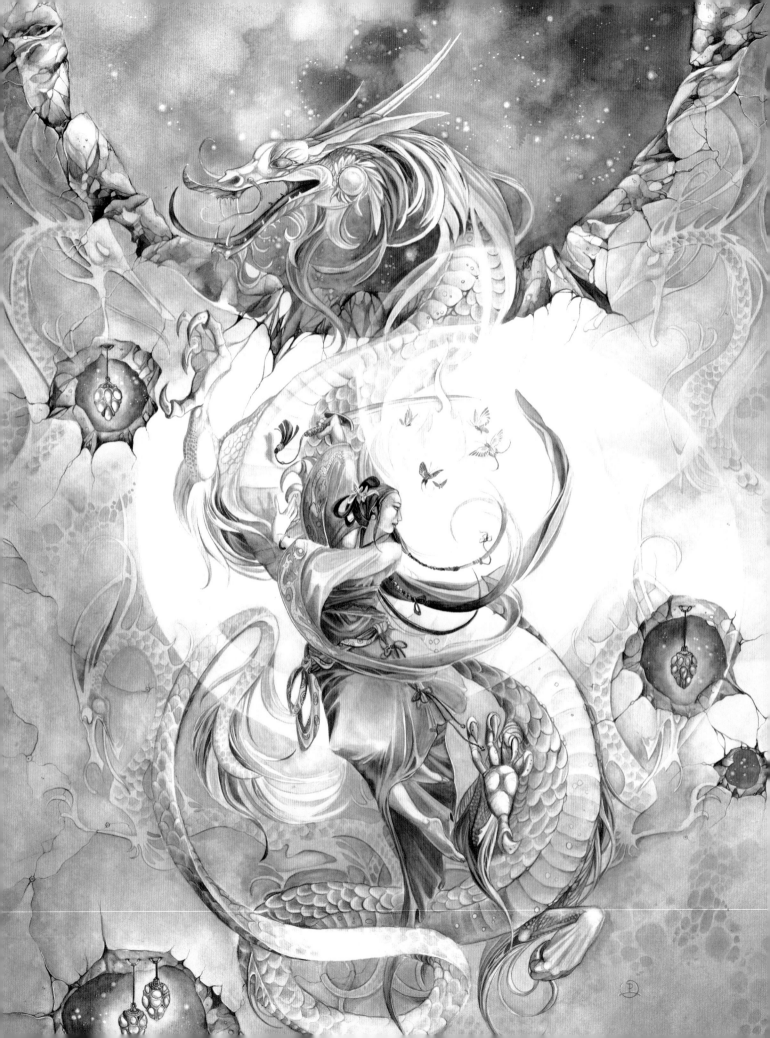

When Dragons Dream (Ink Concept)
Stephanie Pui-Mun Law | puimun

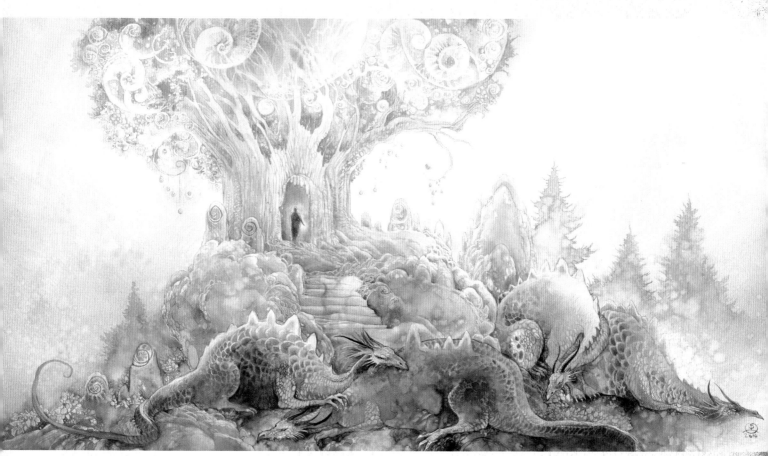

When Dragons Dream
Stephanie Pui-Mun Law | puimun

Year of the Dragon
Stephanie Pui-Mun Law | puimun

Collette J. Ellis | **purpleglovez**

What qualities do dragons exemplify that inspire you?

I have loved drawing dragons since I was a little girl. I collected books on the subject, and as I grew older I became more interested in mythology.

What creative license do dragons provide that other subjects don't?

When I am composing a dragon I can let my imagination run wild. Endless possibilities and mythologies surround these great beasts from a rich variety of cultures all over the globe.

Is there a story behind your pieces?

The Four Dragons was inspired by the Chinese legend and popular children's story *The Jade Emperor and the Four Dragons*. The dragons represent the four rivers in China and the animals that live along their shores. From left to right, the Zhu Jiang (Pearl) River, the Huang (Yellow) River, the Chang Jiang (Long) River and the Heilongjiang (Black Dragon) River.

I developed *Spirit* from a sketch. He is a forest guardian—a friendly spirit who guides lost travelers out of his forest.

Do your dragons incorporate qualities of one or more other animals?

Nature and wildlife play a large part in the design process of my dragons. I am fascinated by anatomy and strive to produce anatomically feasible designs. The animals I tend to draw inspiration from are usually big cats, wolves, birds of prey and a variety of sea life.

What personality traits do your dragons possess?

I like to think of my dragons as having individual personalities with minds of their own. I portray them as both intelligent and mysterious, but with a dangerous, unpredictable side.

What materials did you use to make these pieces?

I use watercolors and ballpoint pens for almost everything I draw. I have never been particularly good with a graphics tablet, though I use Photoshop to layer textures in the final stages of my illustrations.

How long did it take you to make these pieces?

For *The Four Dragons* I brought together four separate A3-sized drawings in Photoshop. Each piece took approximately 3 to 4 days to complete. *Spirit* took approximately 3 days.

How does your art shape how you see the world?

I am always drawing inspiration from the world around me, be it nature or architecture. My brain is always busy thinking up the next interesting concept or idea. Some people think it a little weird when I am excited by the design of a clock or the shape of a tree, but I guess that just comes with being an artist.

profile of a
Dragon Artist

deviantART name: purpleglovez

Location: Gwynedd, North Wales

Hometown: Bangor, North Wales

Date joined: April 20, 2006

Websites:
collettejellis.blogspot.com
community.imaginefx.com/
fxpose/purpleglovezs_portfolio/
default.aspx

Favorite dragon: Eastern

Favorite quote: The important thing is not to stop questioning. Curiosity has its own reason for existing. —Albert Einstein

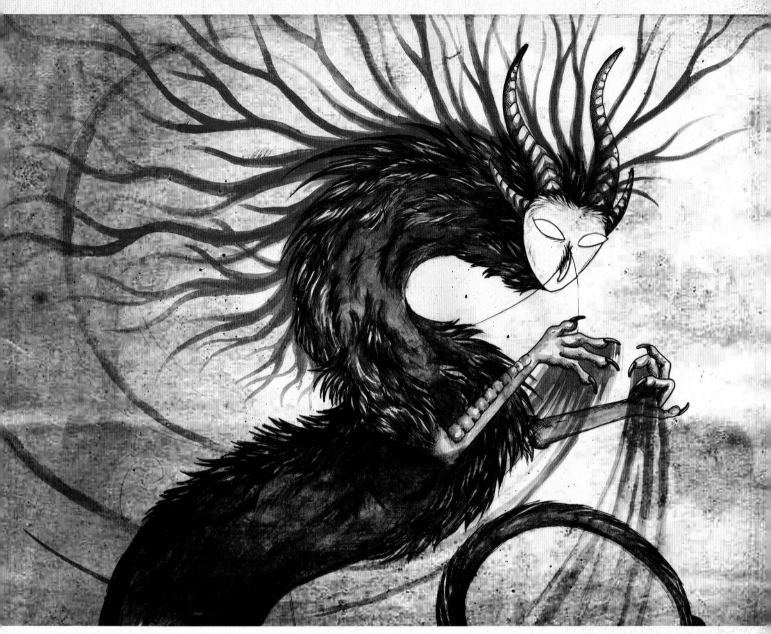

Spirit
Collette J. Ellis | purpleglovez

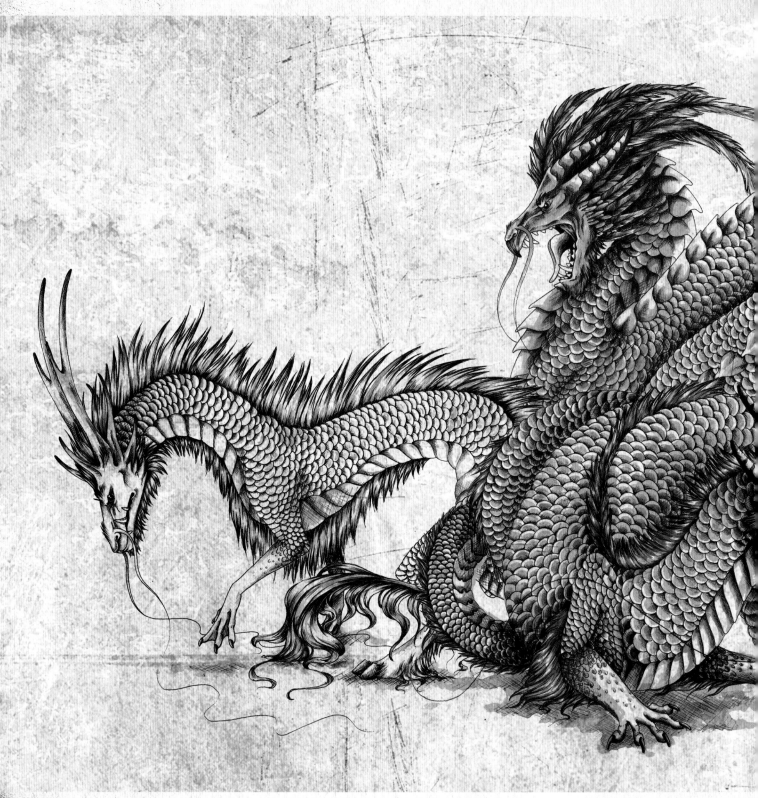

The Four Dragons
Collette J. Ellis | purpleglovez

Visit http://dragonworld.impact-books.com for a free dragon demonstration

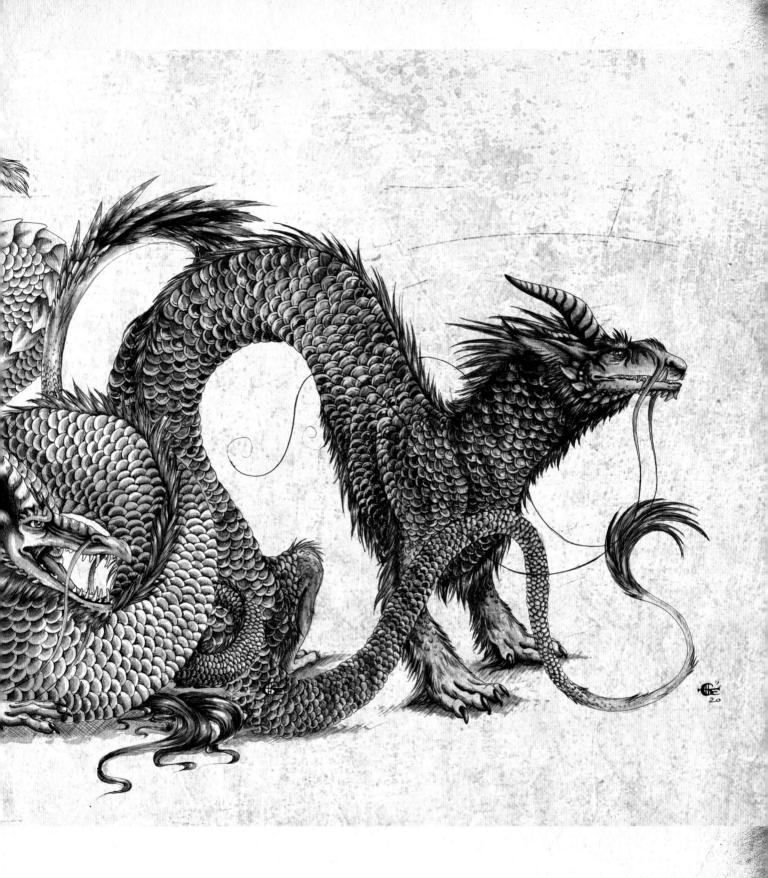

Corinne Aiello | **Rin-Rin-Rin**

profile of a
Dragon Artist

deviantART name: Rin-Rin-Rin

Location: Orlando, Florida

Date joined: April 8, 2004

Websites: rinaiello.com
navi-rin.blogspot.com

Hobbies: video games, cooking and eating!

Favorite dragon: Haku from *Spirited Away*

Favorite quote: The fundamental cause of the trouble is that in the modern world the stupid are cocksure while the intelligent are full of doubt.
—Bertrand Russell

What qualities do dragons exemplify that inspire you?
I always imagined my ideal type of dragon as a majestic, serene being—very peaceful. These are the traits that inspire me most.

What creative license do dragons provide that other subjects don't?
Dragons can be anything, really. It's fun to experiment with different creature combinations.

Is there a story behind your pieces?
My drawings usually don't have stories behind them, but rather a feeling or design element I was inspired by.

Do your dragons incorporate qualities of one or more other animals?
I love incorporating deer antlers into my designs. *Look North*'s dragon is heavily inspired by a buffalo.

What personality traits do your dragons possess?
I want my dragons to have a regal air about them.

What materials did you use to make these pieces of art?
My sketches start with a mechanical pencil and plain paper. Any color is added in Photoshop.

How long did it take you to make these pieces?
Anywhere from 1 hour for a sketch to 8 hours or more for a full-color piece.

How does your art shape how you see the world?
I want to show the things that are quiet and beautiful in this world.

What can dragons teach us about life and art?
To appreciate the beauty of nature.

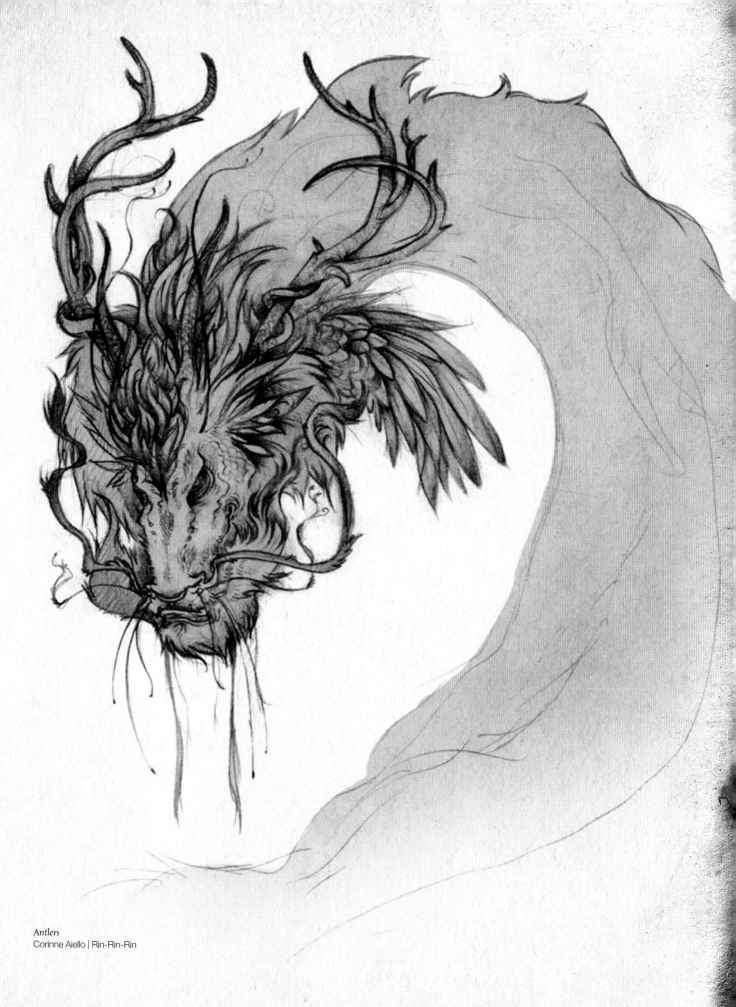

Antlers
Corinne Aiello | Rin-Rin-Rin

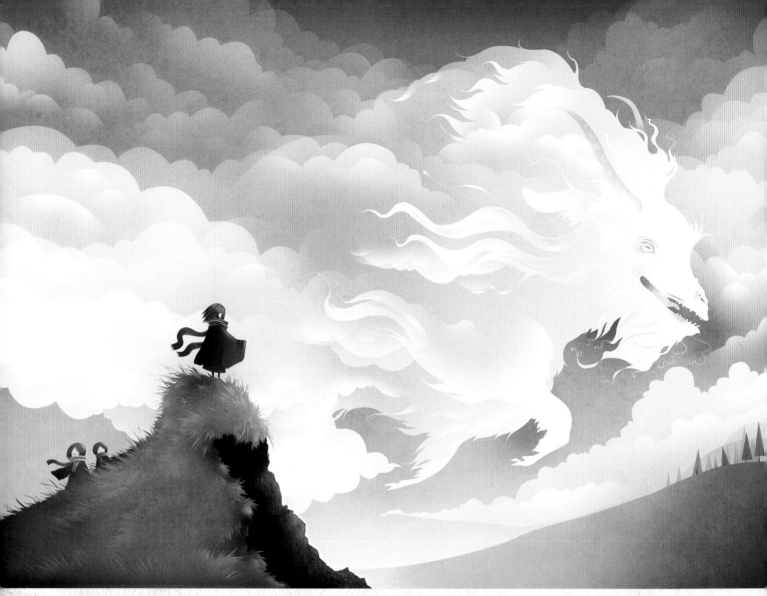

Look North
Corinne Aiello | Rin-Rin-Rin

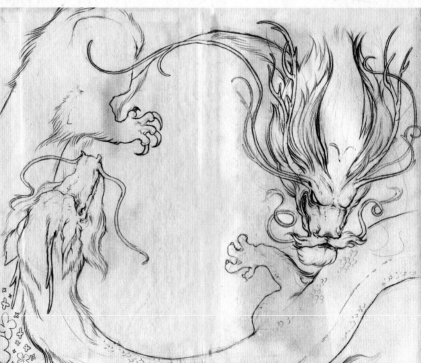

Old Book Dragons
Corinne Aiello | Rin-Rin-Rin

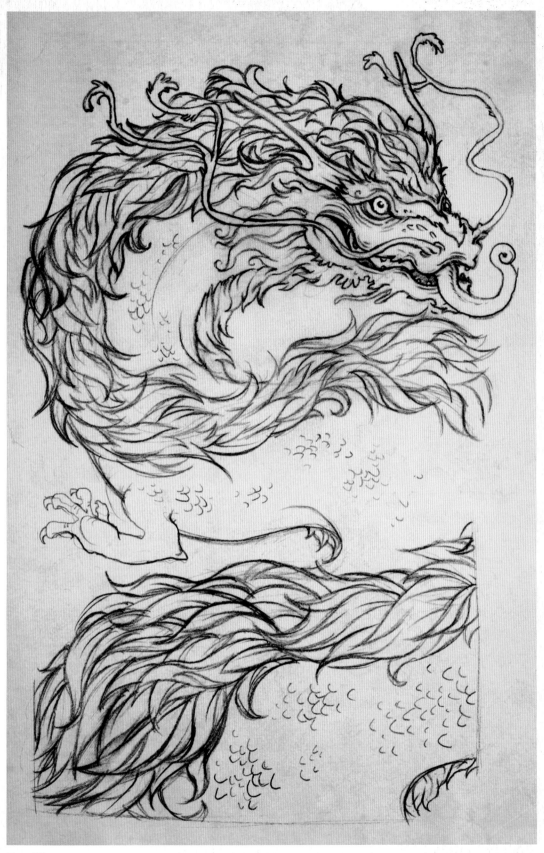

Dragon's Tongue
Corinne Aiello | Rin-Rin-Rin

Robb Mommaerts | **RobbVision**

What qualities do dragons exemplify that inspire you?
Dragons possess creativity, wisdom and strength. Their individuality is what inspires me.

What creative license do dragons provide that other subjects don't?
You can borrow features from pretty much any animal species to create dragons; they don't always have to be reptilian. Plus, dragons cover practically every culture, genre and time period.

Is there a story behind your pieces?
Rocky Mountain Smoker was actually a wedding gift for one of my oldest friends and his wife. He always loved drawing dragons and beasts. At the time, they were living in Colorado, so I picked that setting.

Do your dragons incorporate qualities of one or more other animals?
The dragons I have been drawing the past few years are more on the traditional side, the ones you typically see in literature. I like drawing them bulky and a bit lazy.

What personality traits do your dragons possess?
Mine are usually depicted as friendly and sort of cuddly, but with a slight intimidation factor. They seem to be solitary beasts that enjoy being in their home environments.

What materials did you use?
Both these pieces are rendered in watercolor.

How long did it take you to make these pieces of art?
I really did not keep track, sadly. I'm guessing *Rocky Mountain Smoker* took me a week?

How does your art shape how you see the world?
It is basically a reflection of what I wish existed, my ideal fantasy world … simple answer.

What can dragons teach us about life and art?
Always stay true to yourself, be resourceful and strive to be an individual.

profile of a
Dragon Artist

deviantART name: RobbVision

Location: Green Bay, Wisconsin

Date joined: August 19, 2007

Websites:
robbvision.com
robbvision.blogspot.com
paleo-buffet.blogspot.com

Hobbies: drawing, nature, chasing my kids, podcasts

Favorite dragon: anything from ancient Asian culture

Favorite quote: CROM!!!

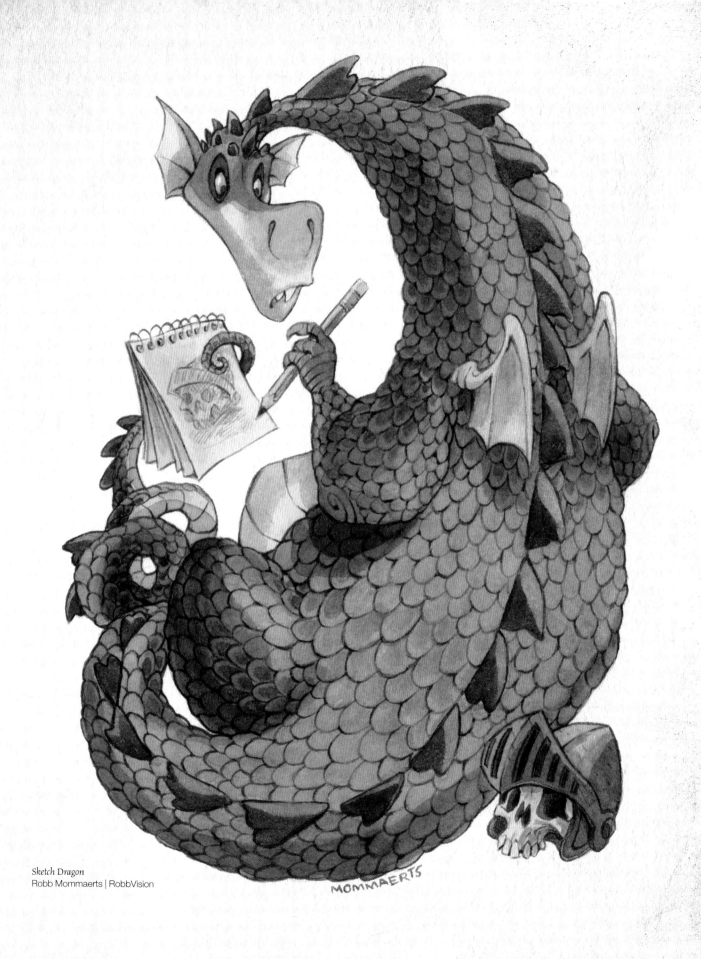

Sketch Dragon
Robb Mommaerts | RobbVision

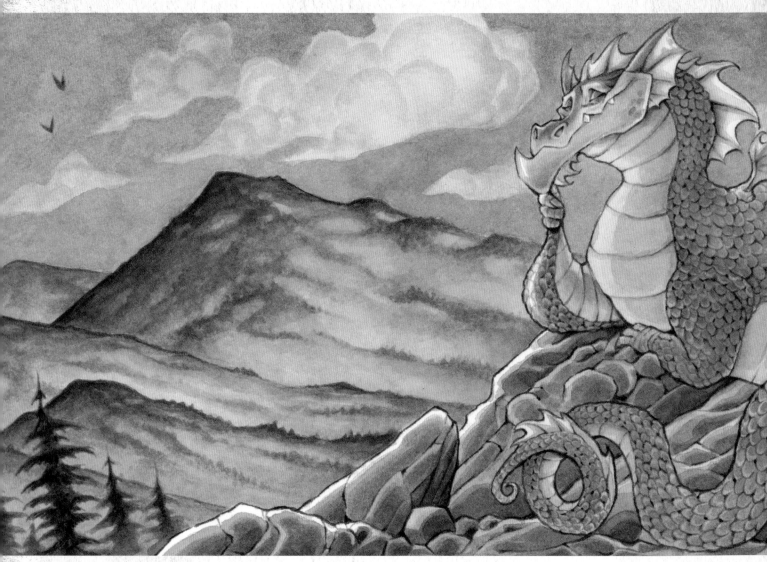

Rocky Mountain Smoker
Robb Mommaerts | RobbVision

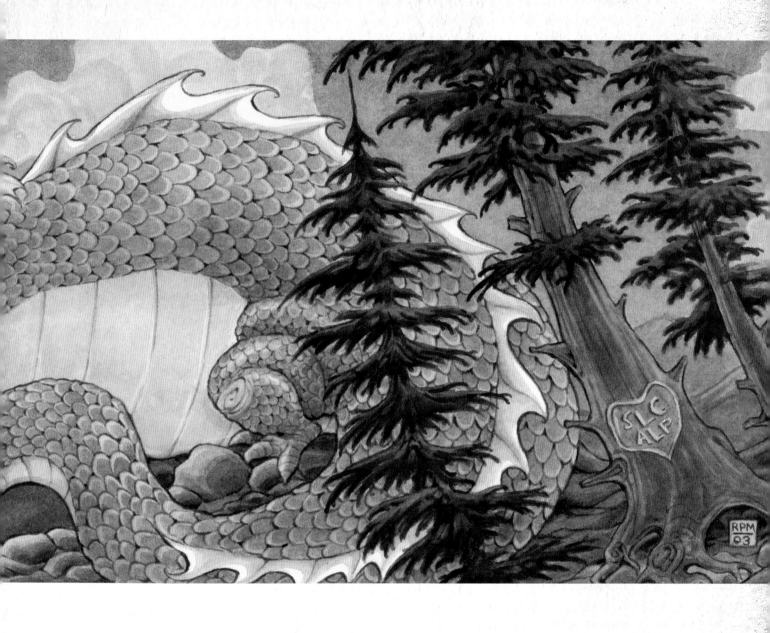

Sarah Anne Davis | **SADCAT**

What qualities do dragons exemplify that inspire you?
Dragons are powerful, magical and mysterious. They exist everywhere and can represent anything. A dragon can be wise, cunning, dangerous, protective, greedy or benevolent. They reflect our cultures and inhabit our dreams. Dragons are altogether cool.

What creative license do dragons provide that other subjects don't?
Because a dragon story can be found in just about every corner of our great big world, we as artists can take them in any direction. We're not restricted to one accepted design or one particular mythology. Two-headed dragon? Awesome! Dragons with six pairs of wings? Cool! Spider-dragon? Why not? The possibilities are endless. Creativity knows no bounds.

Is there a story behind your pieces?
I drew *Fluffy the Dragon* when I was seventeen. I've always been fascinated by mythological creatures, and in particular dragons, because I can bend them to my mood. For this particular artwork I was apparently in the mood for a pet dragon.

Don't Look Now started as a simple sketchbook doodle that earned itself some actual color. I love the idea of a friendly dragon almost as much as I enjoy a fire-breathing, knight-thrashing, berserker dragon. I imagine there's no better security system than a dragon that looms over your rooftop. Granted, you'd want to be sure it didn't end up crushing your house in the process.

Chinese Dragon—My favorite dragons lean toward the Chinese design: long and wingless, with a healthy helping of beards and mustaches. I just don't feel a dragon is really my sort of dragon until it is boasting a fine mustache.

Do your dragons incorporate qualities of one or more other animals?
Fluffy the Dragon is a mix between a horse, a rodent and maybe some variation of featherless raptor. *Don't Look Now* is not so much an animal as he is a mad scientist or possibly a wealthy, eccentric uncle.

What personality traits do your dragons possess?
Fluffy the Dragon is pretty laid back. He's comfortable enough to let a rat in a hat ride on his back. He's a little stuck up, but then what dragon isn't?

Don't Look Now is lazy, plain and simple. He's out for relaxation, pleasure and maybe a little slacking off if there's time between naps. So long as there's no running, flying or general movement involved, he's up for anything.

Chinese Dragon has already had four coffees today and the sun isn't even up yet.

What materials did you use?
Fluffy the Dragon: Prismacolor markers, colored pencils and watercolor pencils; *Don't Look Now*: Prismacolor markers, watercolor, colored pencils and a gel pen; and *Chinese Dragon*: colored pencils.

How long did it take you to make these pieces?
Fluffy the Dragon took a few hours, *Don't Look Now* took about 2 to 3 hours and *Chinese Dragon* about 1 to 2 hours.

How does your art shape how you see the world?
My art is a mixture of self-expression, fantasy and general observation. I see the world full of dragons and other magical creatures. I see fantastical places filled with people, each one of them on their own adventure. We encounter beautiful, harrowing, inspirational and downright frightening things on a daily basis. We can accept them as the drab side effects of our generally mediocre lives, or see the whimsy, thrill and discovery inherent. The world is full of art and magic.

What can dragons teach us about life and art?
When I think of a dragon, I think of something very old and very wise. I think of something that waits and contemplates and only speaks when it has something momentous to say. Dragons could teach us a thing or two about patience, learning to slow down, and reflecting on ourselves and the world around us. If we could learn to do that, our art in turn would have all the more meaning for the effort.

profile of a Dragon Artist

deviantART name: SADCAT

Location: Oakville, Ontario

Date joined: March 8, 2005

Website: sarah-davis.com

Hobbies: writing, reading, watching movies, saying inappropriate things and collecting hats

Favorite dragon: Chinese dragon

Favorite quote: God is a comedian, playing to an audience too afraid to laugh. —Voltaire

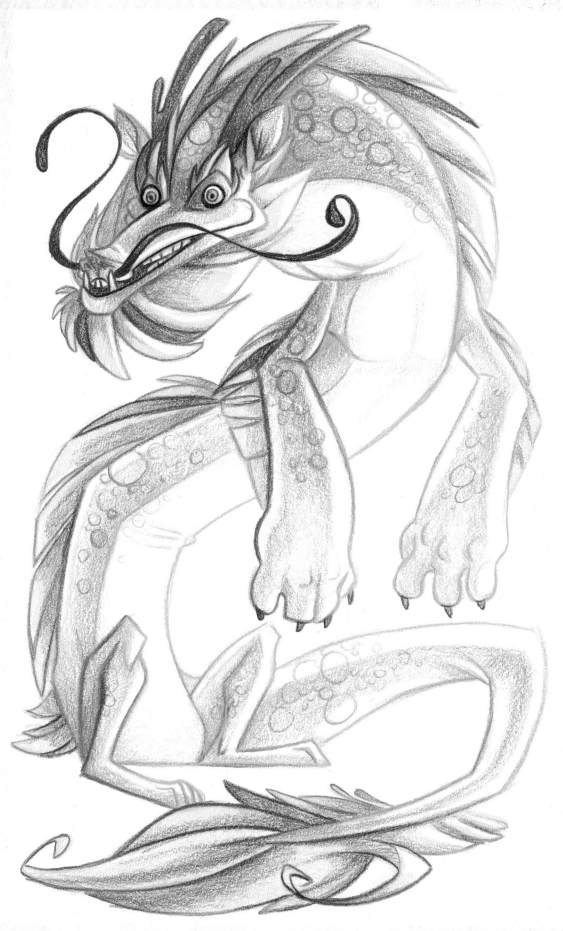

Chinese Dragon
Sarah Anne Davis | SADCAT

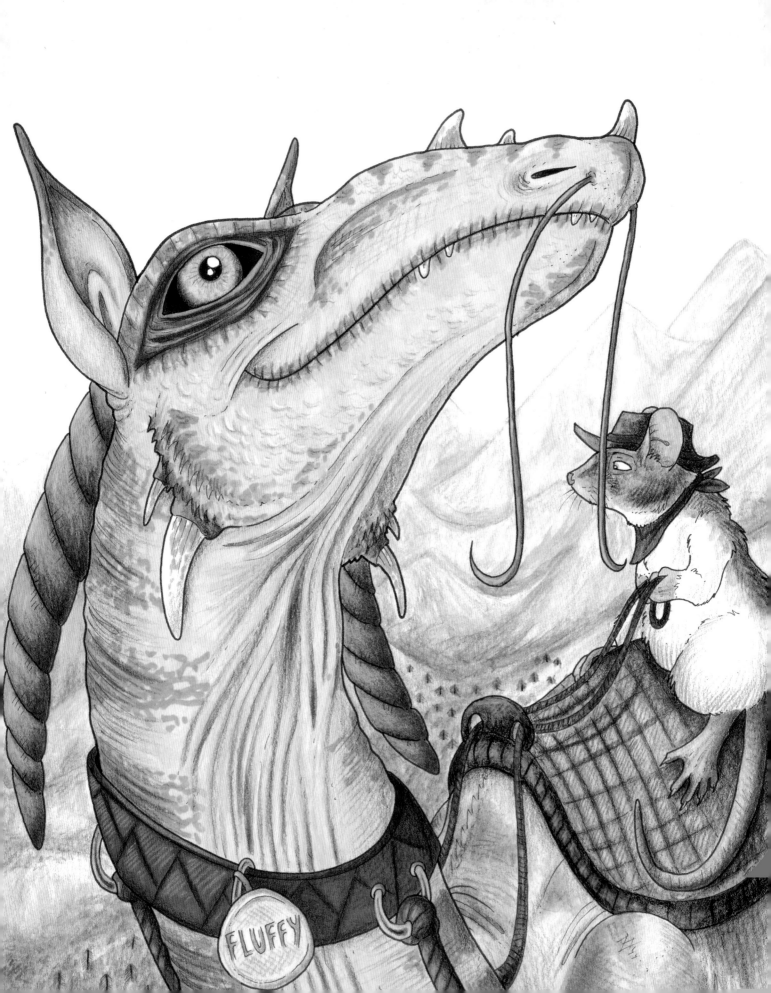

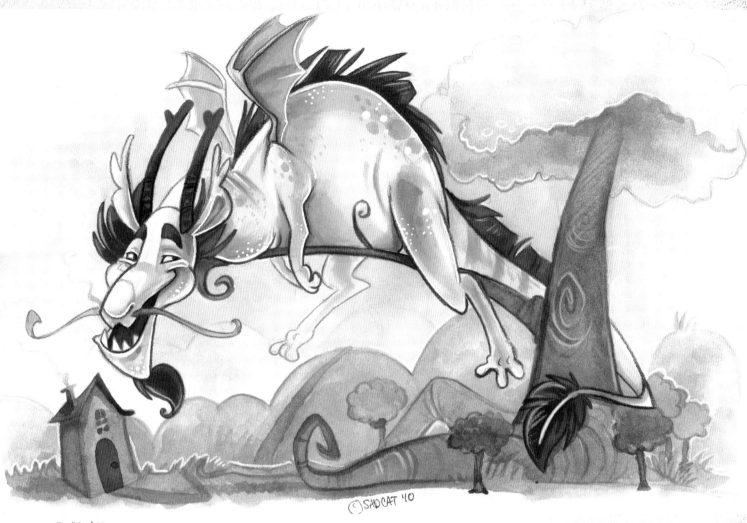

Don't Look Now
Sarah Anne Davis | SADCAT

Fluffy the Dragon
Sarah Anne Davis | SADCAT

Sandara Tang | **sandara**

What qualities do dragons exemplify that inspire you?
Their strength and power, and their myriad forms.

What creative license do dragons provide that other subjects don't?
Being creatures of fantasy, they can be designed in all shapes and colors.

Do your dragons incorporate qualities of one or more other animals?
I draw quite a variety of dragons, so yes, sometimes they do.

What personality traits do your dragons possess?
Usually power or strength.

What materials did you use to make these pieces of art?
Wacom Intuos3 and Photoshop CS3.

How long did it take you to make these pieces?
About 7 to 8 hours for my pieces.

profile of a
Dragon Artist

deviantART name: sandara

Location: Singapore

Date joined: November 29, 2003

Website: sandara.net

Hobbies: reading and drawing

Favorite dragon: Temeraire from Naomi Novik's *Temeraire* series

Firedrakes
Sandara Tang | sandara

Dragon
Sandara Tang | sandara

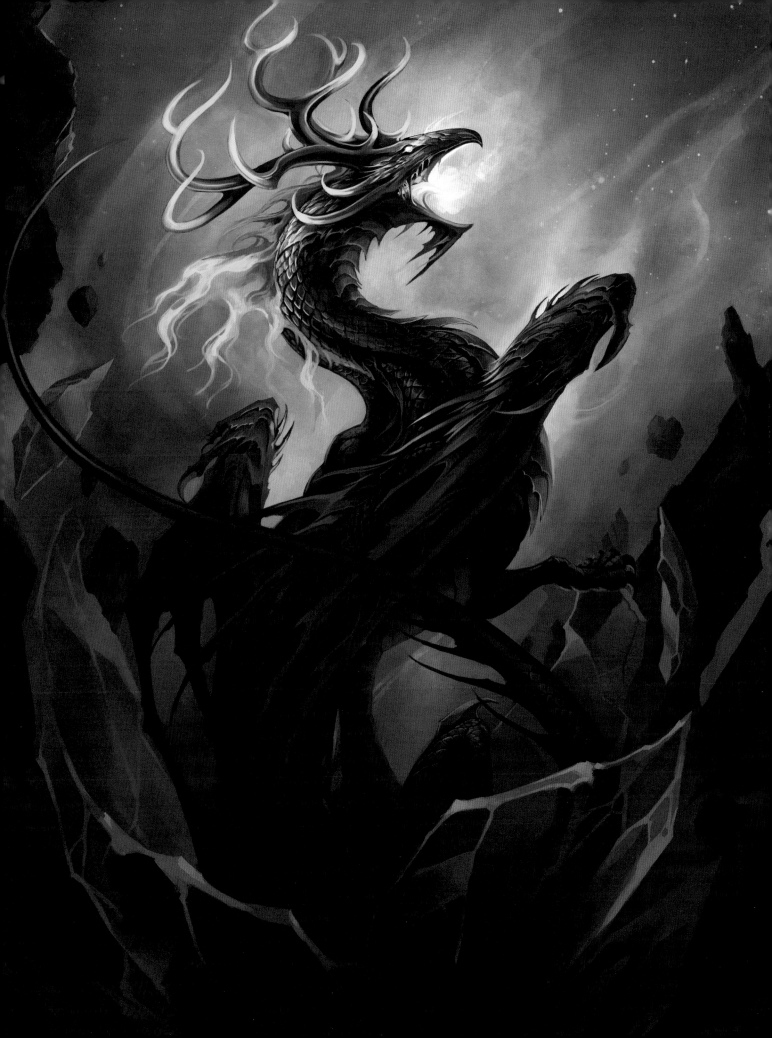

Beast
Sandara Tang | sandara

Visit http://dragonworld.impact-books.com for a free dragon demonstration

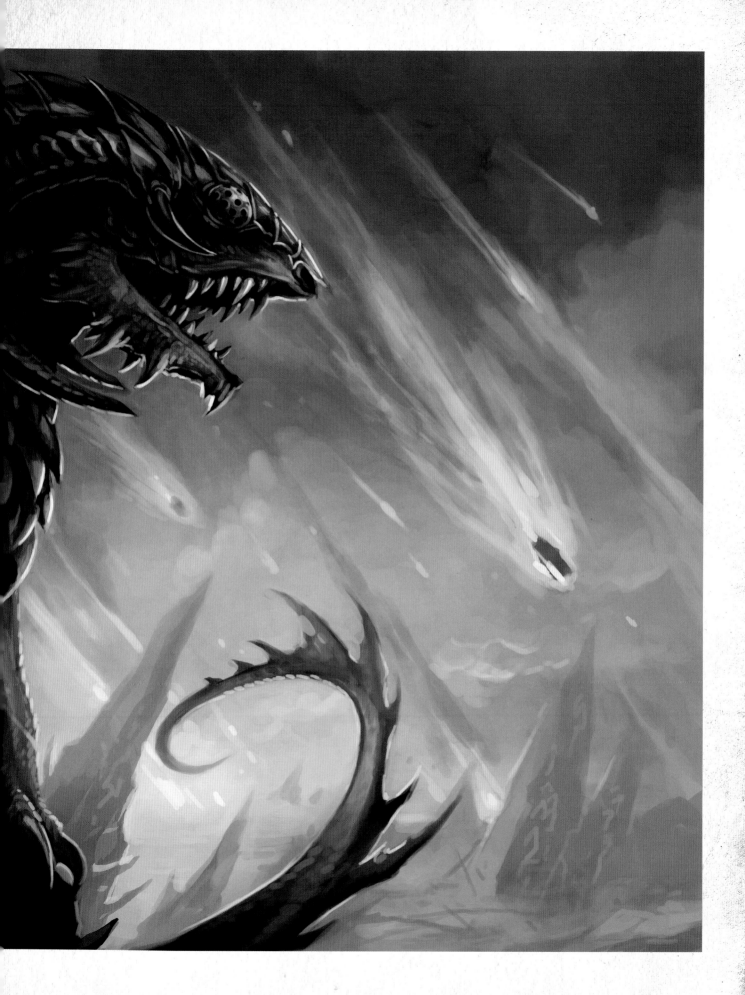

Lina Karpova | **Schur**

Is there a story behind your piece?

His name is Puff. There is a soviet fairy tale about an evil croco-dile that swallows the sun. Of course, it has a happy ending and the sun is returned to the sky. So my dragon has his own sun in a translucent crop.

Because of the dragon's good temper, the sun stays where it is, and his giant head serves as a home to the local birds.

What materials did you use to make this piece of art?

Photoshop CS4.

How long did it take you to make this piece?

A couple of days.

How does your art shape how you see the world?

I like color and color likes me. I'm doing my best to convey my feelings and mood to my watchers with the possibilities that color and light offer.

What can dragons teach us about life and art?

Dragons represent the essence of fantasy. Guardians of trea-sures and abductors of princesses, they are an embodiment of the human desire for unconstrained flight and unlimited power, wisdom and immortality. Their very existence has given the lives of fantasy heroes a little more sense.

profile of a
Dragon Artist

deviantART name: Schur

Location: Moscow, Russia

Date joined: February 21, 2009

Website: linaka.ru

Hobbies: eating tons of mandarins, drawing green fur

Favorite dragon: Fat and big!

Favorite quote: Good ... Bad ... I'm the guy with the gun. —*Army of Darkness*

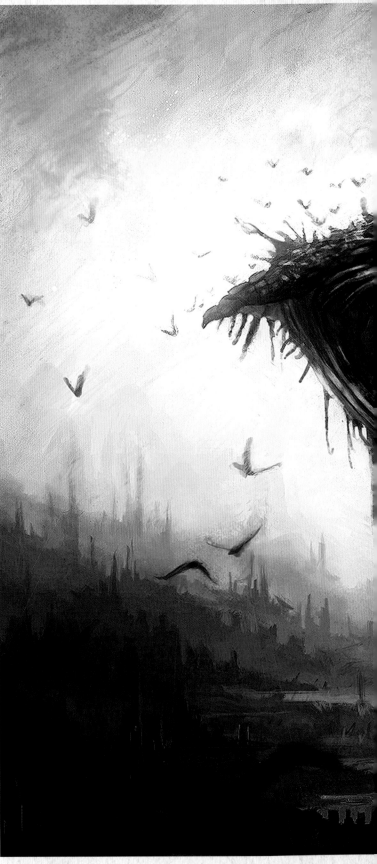

Typical Dragon
Lina Karpova | Schur

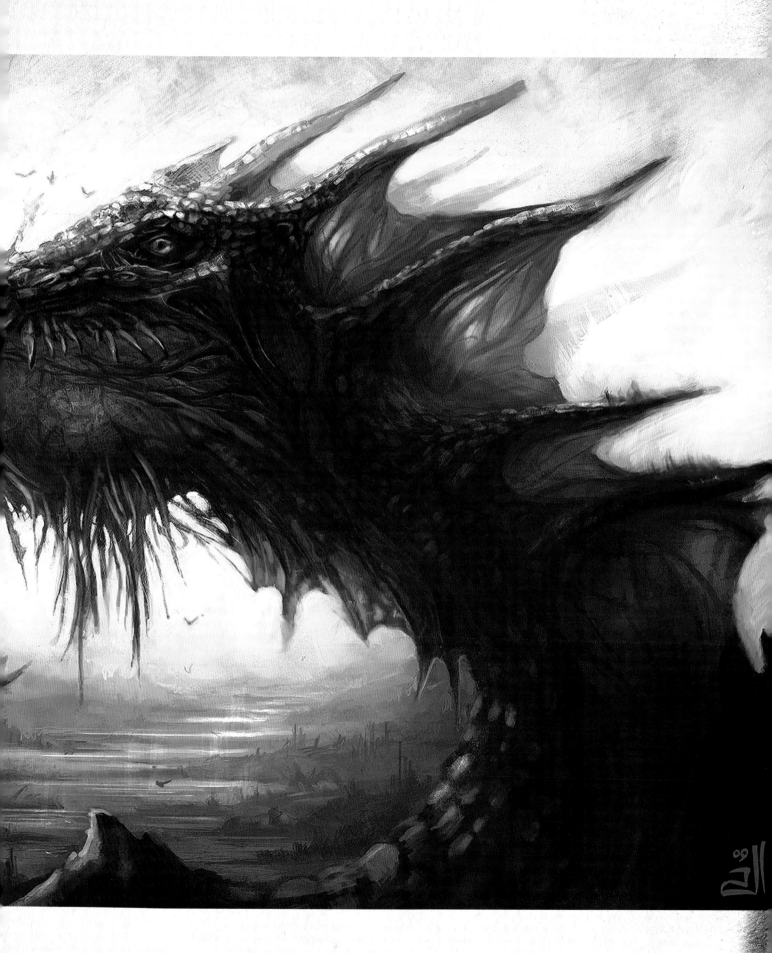

Amélie Hutt | **Smirtouille**

What qualities do dragons exemplify that inspire you?
I guess they're very old and wise creatures that were born with time and know everything about everything. They live in harmony with nature and the other younger creatures.

What creative license do dragons provide that other subjects don't?
Much freedom. And big teeth.

Is there a story behind your piece?
I've always thought my cat has dragonlike qualities. She moves her long body like it's made of water. I imagine how she'd be if she was fifteen meters long with exaggerated features—body length, teeth, ears, hair—as if she were a Chinese sort of mythical creature that flies in the sky like a snake. Of course she's a peaceful beast.

Does your dragon incorporate qualities of one or more other animals?
Norwegian forest cat.

What personality traits does your dragon possess?
Fierce and quiet at the same time.

What materials did you use to make this piece of art?
Graphic tablet and Photoshop.

How long did it take you to make this piece?
About 50 hours.

How does your art shape how you see the world?
It makes the world look mad and lyric.

What can dragons teach us about life and art?
They teach us about curiosity and nature. They also remind us that we are big dreamers.

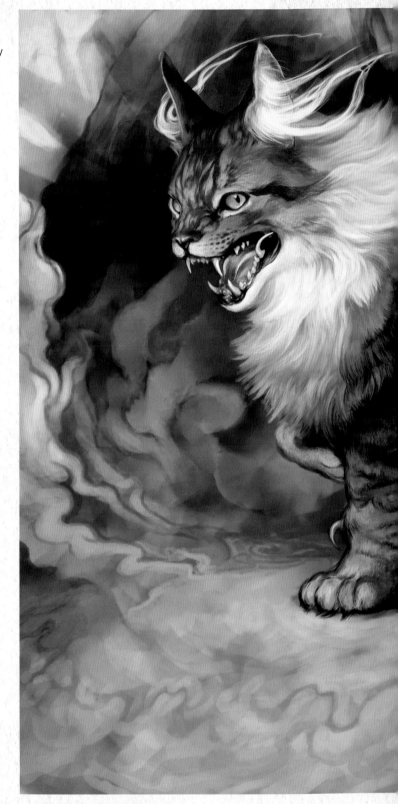

profile of a
Dragon Artist

deviantART name: Smirtouille

Location: Pittsburg, California

Hometown: Waterloo, Belgium

Date joined: May 24, 2009

Websites: smirtouille.com
smirtouille.blogspot.com

Hobbies: writing

Favorite dragon: Draco from *DragonHeart*

Favorite quote: Pourquoi faire simple quand on peut faire compliqué?

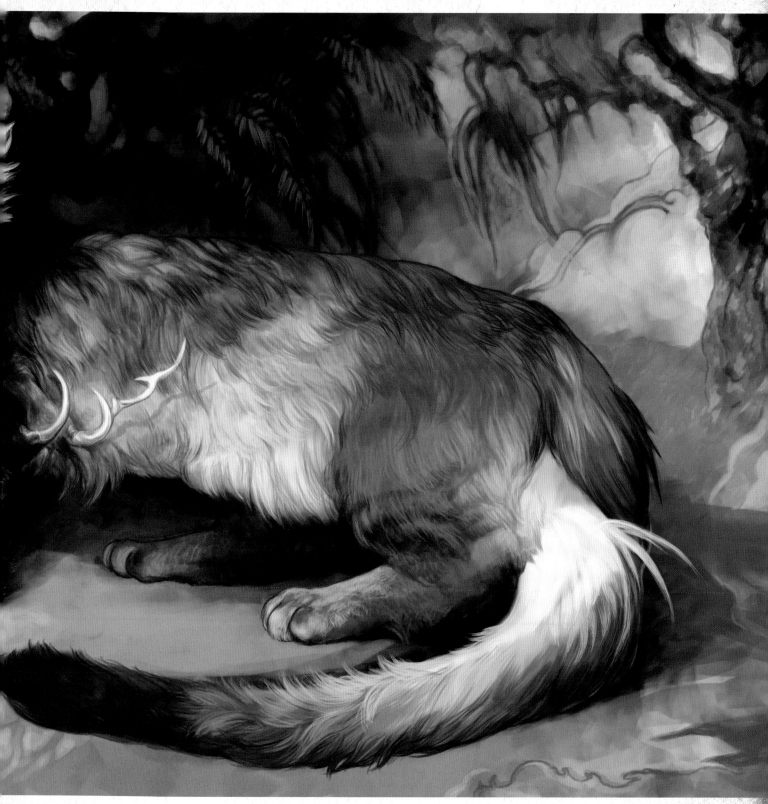

My Dragon Cat
Amélie Hutt | Smirtouille

Daniel Lundkvist | **Tyrus88**

What qualities do dragons exemplify that inspire you?
That would probably be the grace in their movement and their gift of flight.

What creative license do dragons provide that other subjects don't?
Your own imagination is the only limit for making a dragon.

Is there a story behind your piece?
I wanted to capture the fierceness of this quite evil and majestic dragon.

What personality traits does your dragon possess?
He's grumpy.

What materials did you use to make this piece of art?
Photoshop.

How long did it take you to make this piece?
About 5 to 10 hours.

How does your art shape how you see the world?
I would say that the world influences me and shapes my art. It's my creative outlet.

What can dragons teach us about life and art?
Let your imagination run wild. And also, don't play with fire.

profile of a
Dragon Artist

deviantART name: Tyrus88

Location: Gothenburg, Sweden

Date joined: August 7, 2006

Website: dlart.se

Hobbies: drawing, painting, music, movies and traveling

Favorite dragon: Working on it ...

Favorite quote: Hello world.

Black Dragon
Daniel Lundkvist | Tyrus88

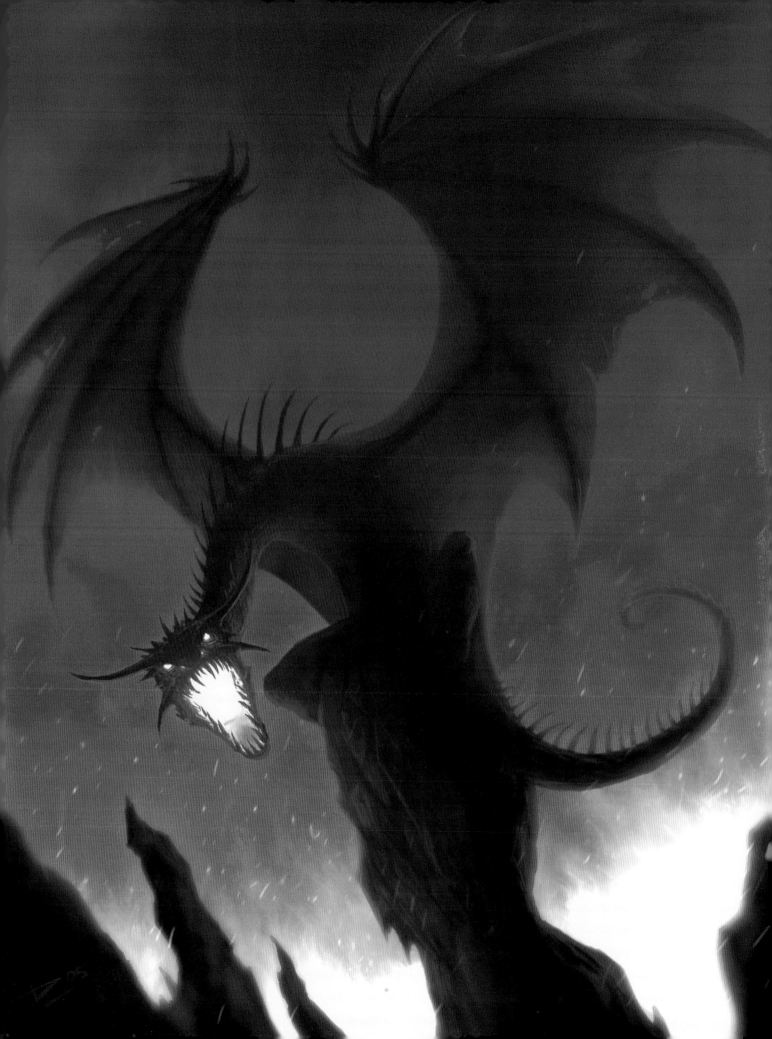

Jon Grimes | unholy-scribe

What qualities do dragons exemplify that inspire you?
The dragon is an ageless creature that appears in many sections of society. It can be good, it can be evil, and for me, it's a mystical creature of legend. A creature that everyone would like to believe did exist.

What creative license do dragons provide that other subjects don't?
Dragons, like many fantasy creatures, are based on myth and your imagination, and as such have fantastic scope for that all-important creative license.

Do your dragons incorporate qualities of one or more other animals?
Dragons can incorporate many qualities of today's animals. For me, dragons have roots in reality via the thick reptile skin we see on alligators and the wonder I think about with regards to the mighty dinosaurs.

What personality traits do your dragons possess?
Dragons can possess many traits, but I lean toward the darker side of the dragon kin, finding this easier to depict. I also like to see dragons as ageless creatures that used to fill the onlooker with fear but with a wise stare earned from hundreds of years of existence.

What materials did you use to make these pieces of art?
I've used my trusty laptop, graphics tablet and Photoshop with its fantastic range of tools.

How long did it take you to make these pieces?
I tend to work in an ad hoc way grabbing time as and when I can. Some smaller images might run off the end of my pen very easily, while other illustrations might take days to complete depending on the medium and workflow I choose.

How does your art shape how you see the world?
My art is a contrast to the normal world we see around us. A place of bizarre creatures and places of adventure to which I would like to travel. For me it shapes the world with color and adventure, above and beyond the reality of the day to day.

What can dragons teach us about life and art?
Dragons teach us about a sense of time. They come from legend and times long past, and teach us that everything is constantly changing and moving forward. The dragon itself has its place in legend—a time we all look to for inspiration and adventure. For me, it seems odd that a creature so fixed in legend and fantasy can be created and displayed with modern digital tools.

profile of a
Dragon Artist

deviantART name: unholy-scribe

Location: Devon, England

Date joined: September 18, 2008

Websites:
unholy-scribe.daportfolio.com
unholyscribe-fantasy-art.com

Hobbies: fossil hunting, metal detecting, traditional painting and drawing, online computer gaming, digital illustration

Favorite dragon: the dark evil dragons that I have yet to paint

Favorite quote: Imagination is more important than knowledge.
—Albert Einstein

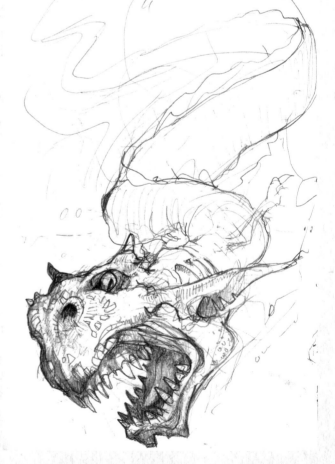

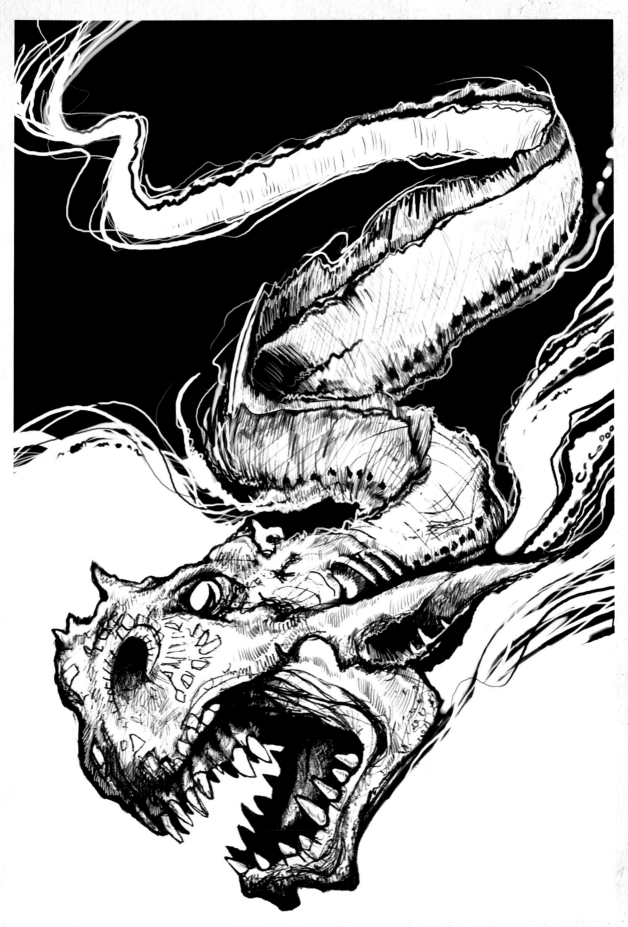

Water Dragon: Black and White
Jon Grimes | unholy-scribe

Cave Dragon
Jon Grimes | unholy-scribe

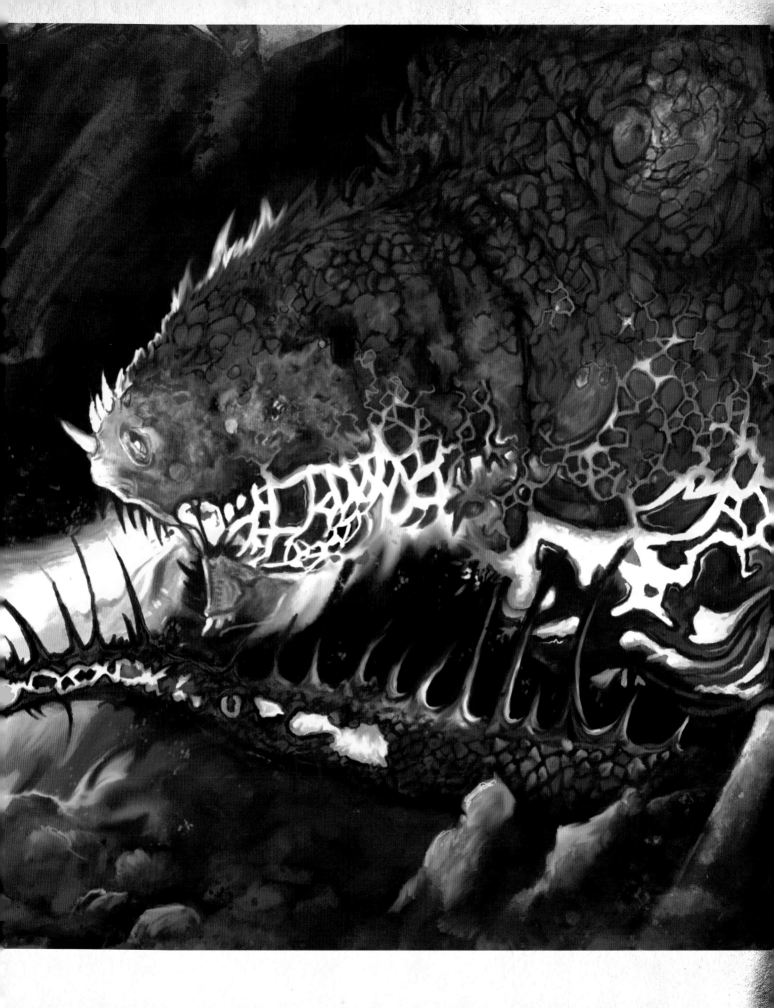

Ursula Vernon | **ursulav**

What qualities do dragons exemplify that inspire you?
Dragons have a nice built-in mythological resonance that you
don't get with most other subjects.

Is there a story behind your piece?
My only real plan with this piece was to try and tweak the notion
of knights fighting fierce dragons, which led me to hippies putting
flowers in gun barrels, and it kind of went from there.

What materials did you use to make this piece of art?
This was a very quick doodle done digitally as a warm-up sketch.

How long did it take you to make this piece?
No more than 15 or 20 minutes.

profile of a
Dragon Artist

deviantART name: ursulav

Location: North Carolina

Date joined: June 30, 2002

Websites: redwombatstudio.com
ursulavernon.com

Hobbies: gardening, video games

Favorite dragon: Smaug

Favorite quote: You can't be
afraid to make bad art.

Knight and Dragon
Ursula Vernon | ursulav

Natalia Ponce Gutiérrez | **VampirePrincess007**

profile of a
Dragon Artist

deviantART name: VampirePrincess007

Location: Valencia, Spain

Date joined: February 25, 2006

Website: nataliapg.daportfolio.com

Hobbies: listening to music, drawing, reading, diving and playing the piano

Favorite dragon: All of them?

Favorite quote: Life is far too important a thing ever to talk seriously about. —Oscar Wilde

What qualities do dragons exemplify that inspire you?
Epicness, nobility and freedom.

What creative license do dragons provide that other subjects don't?
They can be depicted in many ways—big, small, fierce, peaceful, fire/ice breathing ... you just have to let your imagination fly.

Is there a story behind your pieces?
There's a war between dragons and humans on a plain and a shaman, in front of the raging dragon monarch, casts a spell which might decide the battle result.

What personality traits do your dragons possess?
Wrathful, dominant and powerful.

What materials did you use to make these pieces of art?
Photoshop CS.

How long did it take you to make these pieces?
About 7 hours.

How does your art shape how you see the world?
Sometimes it shows a certain element of the way I see or feel, or sometimes it depicts my fears and feelings symbolically.

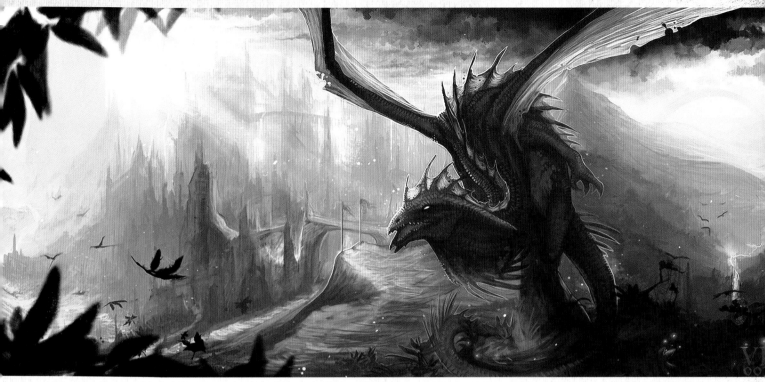

The Last Stronghold
Natalia Ponce Gutiérrez | VampirePrincess007

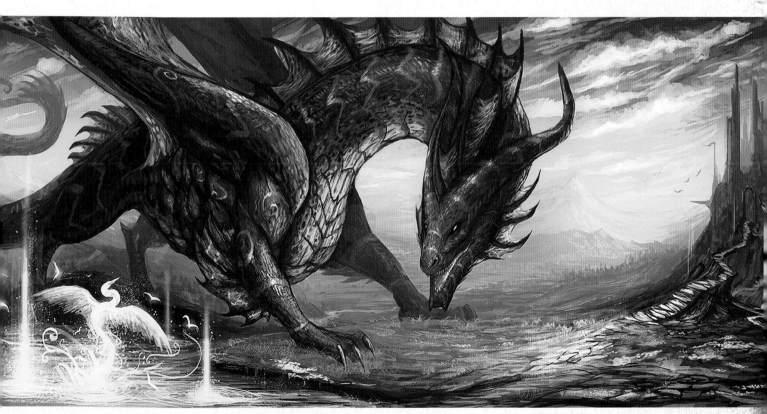

Water Spirit
Natalia Ponce Gutiérrez | VampirePrincess007

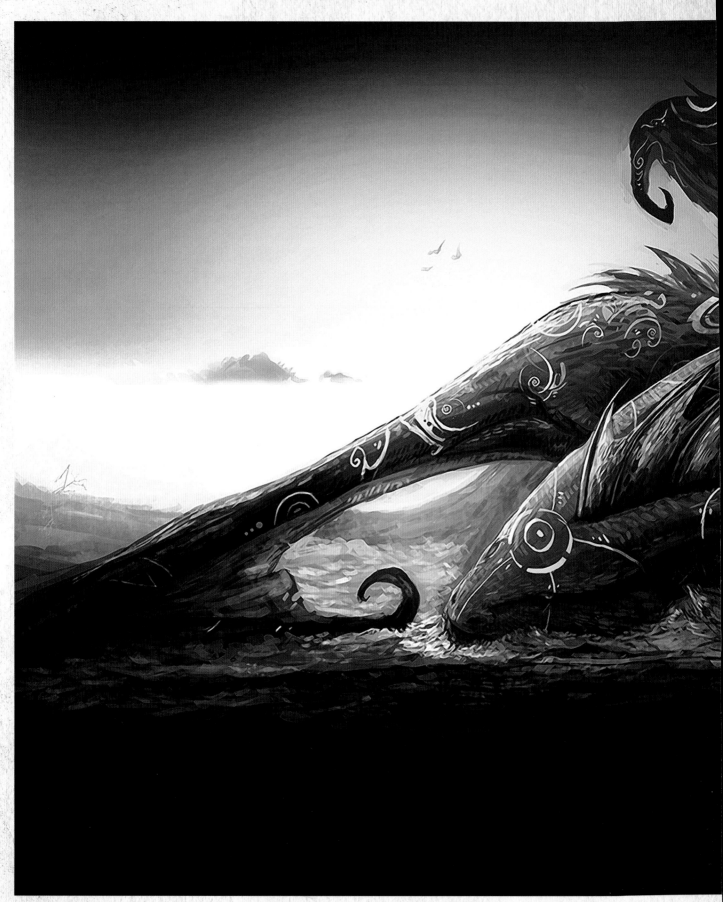

The Demise of a God
Natalia Ponce Gutiérrez | VampirePrincess007

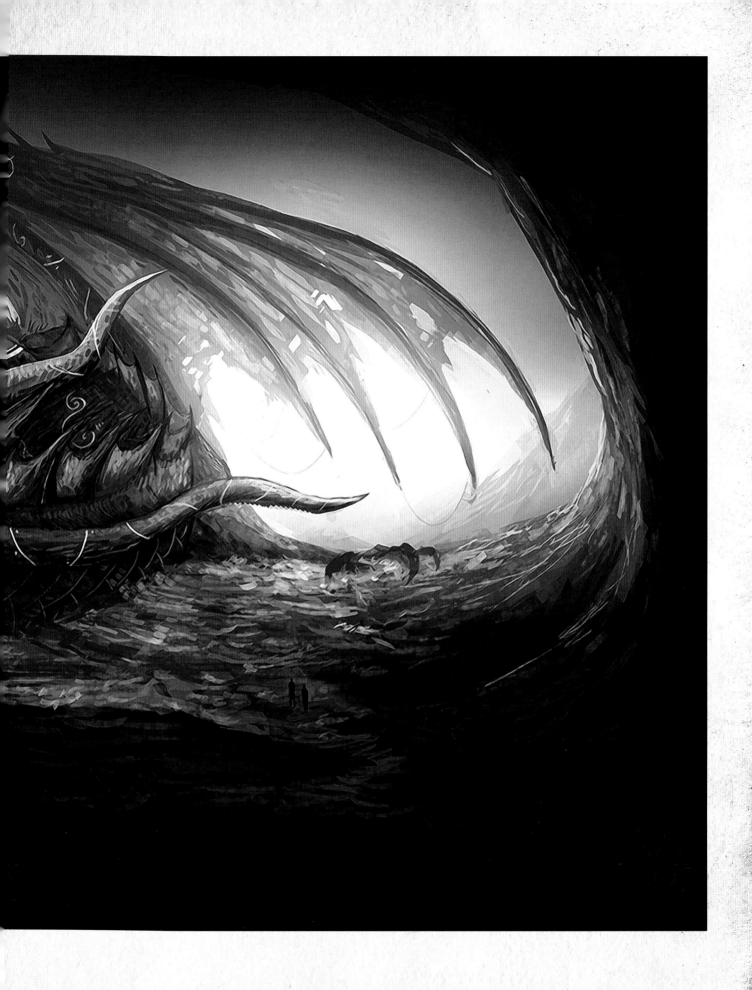

Adam Vehige | **VegasMike**

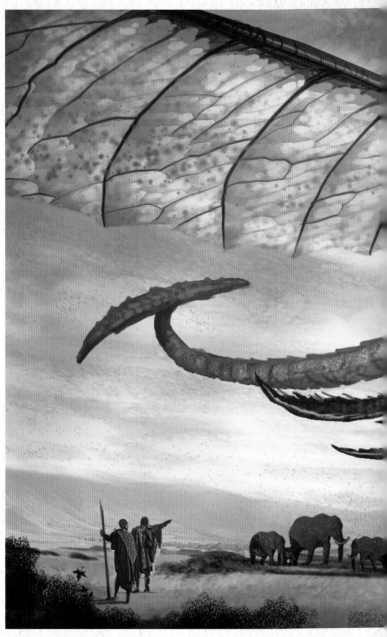

The Crab Dragon
Adam Vehige | VegasMike

What qualities do dragons exemplify that inspire you?
Terrible beauty!

What creative license do dragons provide that other subjects don't?
Creative freedom. Dragon variety can be anything you can imagine.

Is there a story behind your piece?
The Crab Dragon makes its home on Monster Island and cruises through the upper levels of the jet stream to locate its favorite prey: elephant. He plummets from above and forces the herd to scatter in fright with a low frequency roar only the elephants can hear. The dragon will then pick off the lone stragglers and come back for more until he's had his fill. The locals have reported whole herds disappearing into the belly of the beast in just under an hour. The translation of the African word *beast* is "the creature who came from above."

Does your dragon incorporate qualities of one or more other animals?
Crustacean with insectlike wings.

What personality traits does your dragon possess?
She's a bully because of her size!

What materials did you use to make this piece of art?
Wacom tablet, Photoshop and Corel Painter.

How long did it take you to make this piece?
About 6 hours.

How does your art shape how you see the world?
I try to find inspiration in everything I see.

What can dragons teach us about life and art?
Imagination and fantasy are the ultimate escape from reality.

profile of a
Dragon Artist

deviantART name: VegasMike

Location: Washington, Missouri

Date joined: October 20, 2003

Hobbies: art

Favorite dragon: Smaug

Favorite quote: Imagination is more important than knowledge.
—Albert Einstein

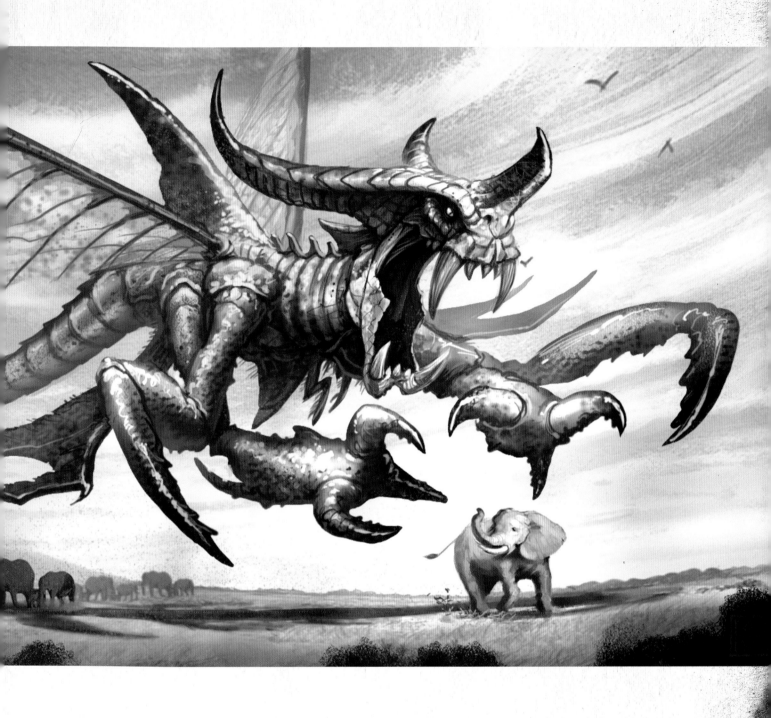

Freya Horn | **Vermin-Star**

What qualities do dragons exemplify that inspire you?
Dragons have been portrayed over the centuries by many different cultures. Their qualities can vary greatly—sometimes good, sometimes evil, intelligent or dumb, benevolent or malicious. This versatility is inspiring.

What creative license do dragons provide that other subjects don't?
Many artists enjoy creating fantasy art as its creative license is almost limitless. We all know what a unicorn is supposed to look like, but dragons are harder to define and, therefore, more open to exploration.

Is there a story behind your piece?
Dragon Brood was created a few years ago as part of a university project. I chose to illustrate characters, creatures and weapons from the fantasy novels by James Barclay. I worked in collaboration with the author who gave me detailed descriptions and feedback, and all in all it was a great experience. He really liked the dragons, too!

Do your dragons incorporate qualities of one or more other animals?
Dragons can be inspired by any creature, but these had to be true to the descriptions in the books, so they're definitely reptilian. They have the qualities of many animals: iguanas, snakes, sea horses, dinosaurs. The horny rims on the backs of their heads were inspired by ceratopsian dinosaurs.

What personality traits do your dragons possess?
The dragons here all have very different personalities, as depicted in the books. To summarize: the rusty brown one at the top is a Naik dragon. They're known for being aggressive and more bent on destruction than most dragons. The golden dragon in the middle is a Kaan dragon. This brood is the most majestic and proud of the three, and they are also archenemies of the Naik. These two are constantly battling for dominion. The small aquamarine dragon is a Veret. They are semiaquatic and far less powerful than the other two and less aggressive.

What materials did you use to make this piece of art?
The original sketches were made with pen and ink on paper. Color and textures were added in Photoshop.

How long did it take you to make this piece?
Approximately 10 hours.

How does your art shape how you see the world?
I think it's more the other way around—the world shapes my art! But art and creative expression in general affect how I see the world. I'd like to think my creations would shape someone's world in turn.

What can dragons teach us about life and art?
Dragons are a self-indulgent and free subject for artists to focus on, without the constraints that something based in reality has. We all put a bit of ourselves into dragons because they are imaginary. Therefore, I think they can teach us a lot about ourselves as individuals, and a lot about changing artistic trends in the ways they are portrayed differently through the ages.

profile of a
Dragon Artist

deviantART name: Vermin-Star

Location: Oslo, Norway

Hometown: Bedford, England

Date joined: February 20, 2006

Websites:
verticalcut.com/saintscarlet/portfolio
vermin-star.deviantart.com

Hobbies: drawing, traveling, gaming

Favorite dragon: Smaug

Favorite quote: Life isn't about finding yourself. Life is about creating yourself. —George Bernard Shaw

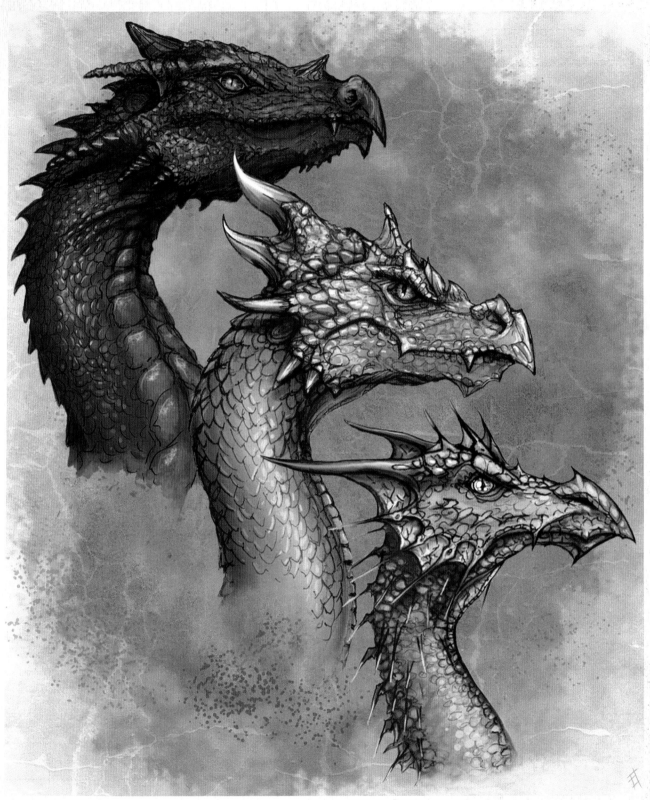

Dragon Brood
Freya Horn | Vermin-Star

Hedvig Häggman-Sund | **Vixie87**

What qualities do dragons exemplify that inspire you?
They are mystical and powerful. To me dragons symbolize strength.

What creative license do dragons provide that other subjects don't?
They spit fire and can fly. That's two cool attributes in one!

Do your dragons incorporate qualities of one or more other animals?
Goat horns.

What personality traits do your dragons possess?
Drake 2 is a grumpy but loyal guy, old and wise, but a bit bitter. Other dragons don't take him seriously, possibly because of his pink color, and that makes him mad.

What materials did you use to make this piece of art?
Pencils and Photoshop.

How long did it take you to make this piece?
About 4 to 5 hours.

What can dragons teach us about life and art?
Creativity is unlimited.

profile of a Dragon Artist

deviantART name: Vixie87

Location: Gothenburg, Sweden

Date joined: July 27, 2004

Website: vixiearts.blogspot.com

Hobbies: drawing and eating chocolate

Favorite dragon: Toothless from *How to Train Your Dragon*

Favorite quote: I want chocolate!

Skiss 20.2
Hedvig Häggman-Sund | Vixie87

Drake 2
Hedvig Häggman-Sund | Vixie87

William O'Connor | **wocstudios**

profile of a
Dragon Artist

deviantART name: wocstudios

Location: Pearl River, New York

Date joined: April 29, 2007

Website: wocstudios.com

Hobbies: travel, hiking

Favorite quote: Artists who seek perfection in everything are those who cannot attain it in anything. —Eugène Delacroix

What qualities do dragons exemplify that inspire you?
Dragons embody all that is powerful and regal. They are elegant, beautiful, ancient, wise and terrible. I think that is why they have captivated artists for centuries.

What creative license do dragons provide that other subjects don't?
Since dragons are fictional creatures, they are only limited by an artist's imagination.

What personality traits do your dragons possess?
I like to look at birds. I think they'd be a common ancestor of dragons and dinosaurs.

What materials did you use?
Pencil and digital.

How long did it take you to make these pieces?
About 20 hours.

How does your art shape how you see the world?
It doesn't. How I see the world shapes my art.

What can dragons teach us about life and art?
"The man who fights too long against dragons becomes a dragon himself." —Friedrich Nietzsche

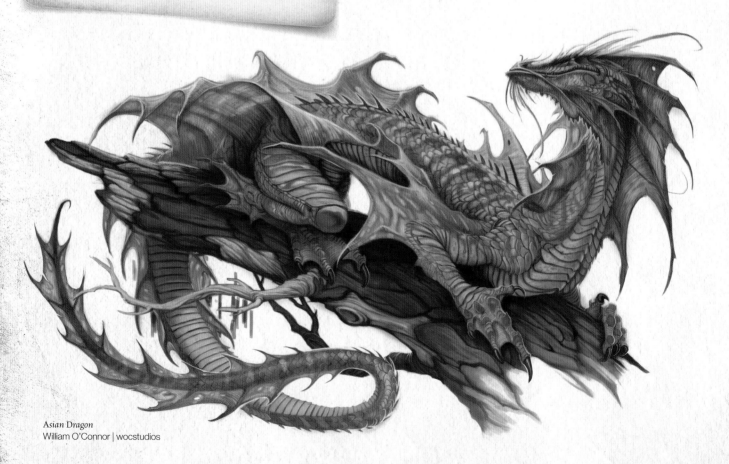

Asian Dragon
William O'Connor | wocstudios

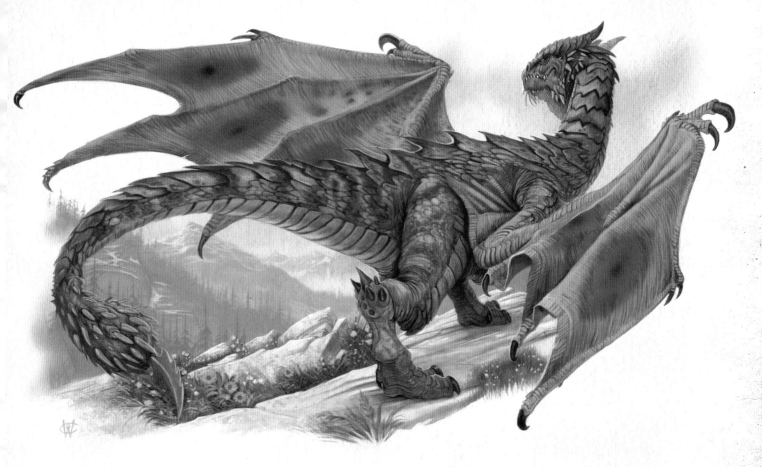

Wyvern Dragon
William O'Connor | wocstudios

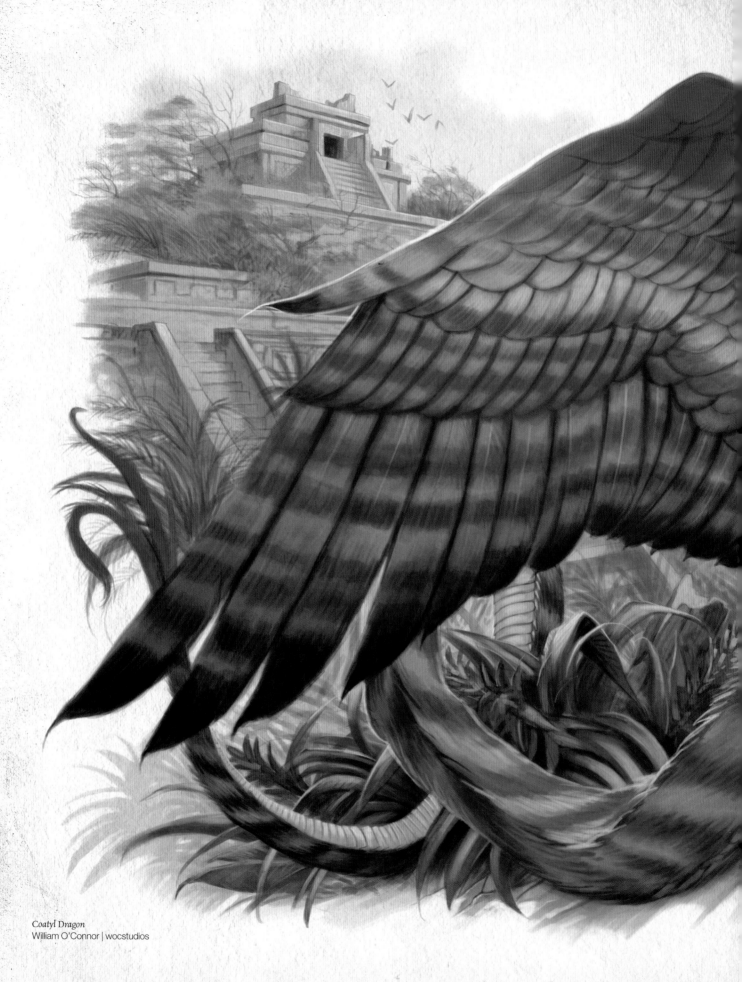

Coatyl Dragon
William O'Connor | wocstudios

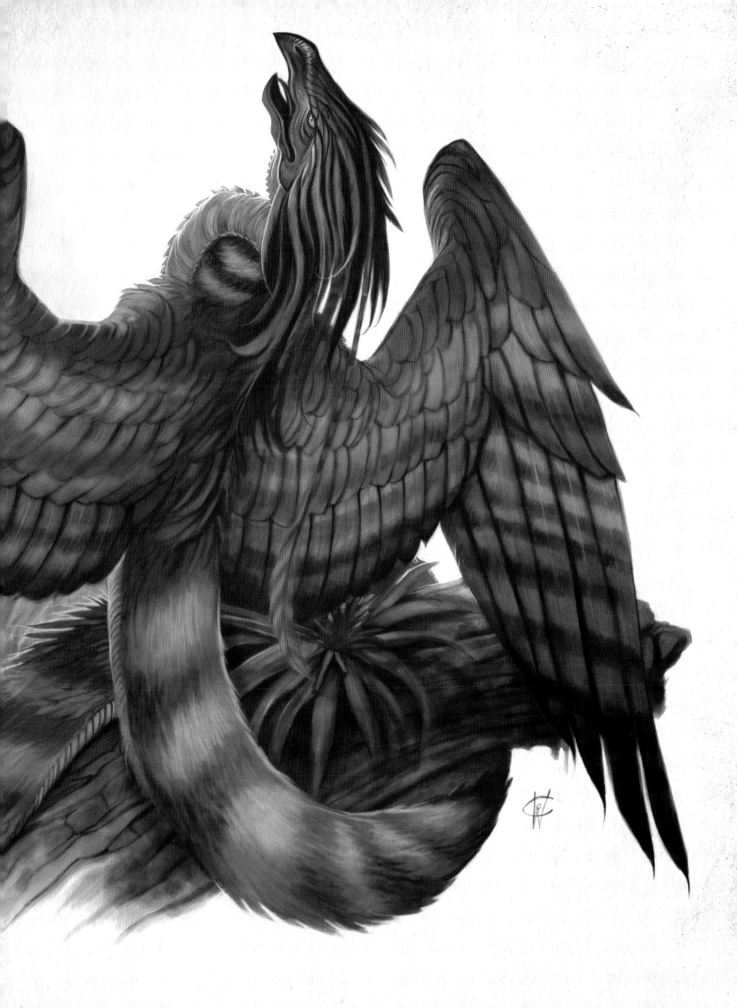

Kelsey Lakowske | **zilowar**

What qualities do dragons exemplify that inspire you?
I love the whimsical quality of dragons. Dragons have been in my doodles since I started drawing, and I think the magnificence and power we associate with them makes them an exciting subject. They're a symbol for both wisdom and strength.

What creative license do dragons provide that other subjects don't?
Dragons can trigger all sorts of imagery in different cultures—the Western and Eastern comparison is a perfect example. You can give them a personality in their very appearance, and as an artist that's one of my favorite parts.

Is there a story behind your pieces?
Both *CandyCane Dragon* and *Gingerbread Dragon* were seasonally inspired dragons. Their stories have grown and changed, so whether they came out of an oven or were poofed into existence for some great predestined quest is up to the viewer.

Do your dragons incorporate qualities of one or more other animals?
My dragons don't incorporate other animals, but they do involve edibles! Of the sweet, dessertlike sort.

What personality traits do your dragons possess?
I'd say they both have quite a sweet tooth. CandyCane Dragon is perky, inquisitive and takes frequent naps on his favorite poppyseed muffin. Gingerbread Dragon is always on a quest to find something new and sugary to inhale, and can be caught trying to eat himself.

What materials did you use to make these pieces of art?
The lines are traditional, and both were colored using Photoshop. I used a pencil and a tablet.

How long did it take you to make these pieces?
If only I knew. Probably around 3 hours.

How does your art shape how you see the world?
My art totally changes how I view the world, but it's not easy to describe how. When you look at the world artistically, then nothing is good or bad—it's taste or opinion really. Opinions vary vastly depending on our experiences and role models.

What can dragons teach us about life and art?
Dragons are what you make them! I use them to express an emotion or to convey my excitement for holidays and gingerbread ... but they can be anything. Let them make you excited about life, I suppose.

profile of a
Dragon Artist

deviantART name: zilowar
Location: Boulder, Colorado
Date joined: June 29, 2005
Websites: antlerink.tk
zilowar.livejournal.com
Hobbies: art, snakes, beasties and running
Favorite dragon: *Peanut Butter & Jelly Dragon*
Favorite quote: Hope is the only bee that makes honey without flowers.
—Robert Green Ingersoll

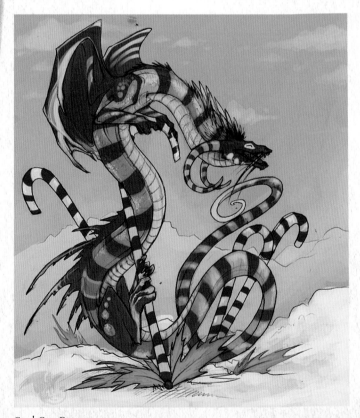

CandyCane Dragon
Kelsey Lakowske | zilowar

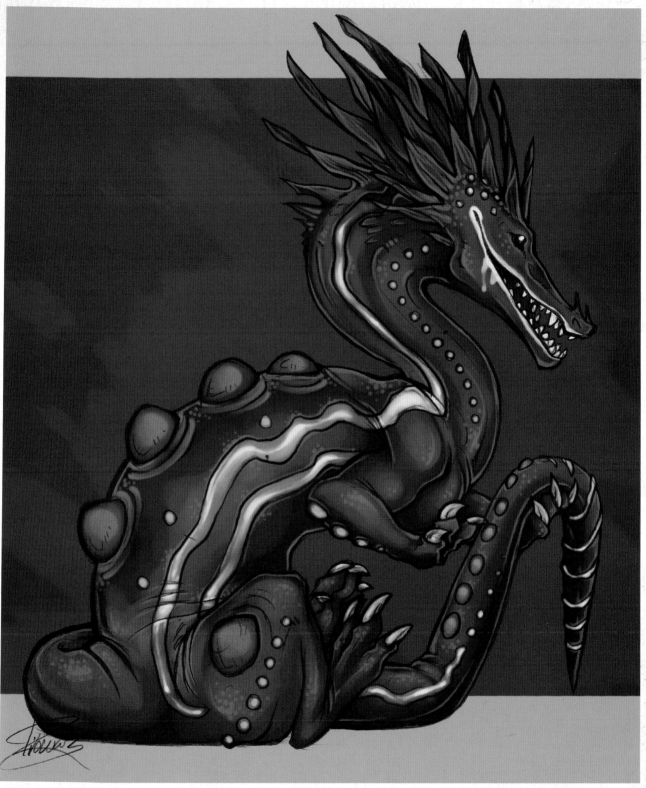

Gingerbread Dragon
Kelsey Lakowske | zilowar

Contributors

KEI ACEDERA
dA: imaginism
e: info@imaginismstudios.com
w: imaginismstudios.com

CORINNE AIELLO
dA: Rin-Rin-Rin
e: rinaiello@gmail.com
w: rinaiello.com
w: navi-rin.blogspot.com

KEREM BEYIT
dA: kerembeyit
a: Avrupa Evleri, Macaristan Blok No.
 2, Konutkent Mahallesi, 2431, Cadde,
 06810 Cayyolu, Ankara, Turkey
p: +90 532 701 4575
e: kerembeyit@hotmail.com
w: theartofkerembeyit.com

JUAN CALLE
dA: Onikaizer
a: Calle 127-A #51-A-90 Int 3.
 Apto. 412, Bogotá, Colombia
p: (571) 610 6145 253 0607
e: cristobal.calle@gmail.com
w: juancalle.com
w: liberumdonum.com

BOBBY CHIU
dA: imaginism
e: info@imaginismstudios.com
w: www.imaginismstudios.com

JULIA CHUBAROVA
dA: AlviaAlcedo
e: alviaalcedo@mail.ru

EMMY CICIEREGA
dA: B1nd1
w: emmycic.livejournal.com
w: emmyc.com

GINGER COOLEY
dA: cooley
a: P.O. Box 212301, Anchorage, AK
 99521
e: iamcooley@gmail.com
w: iamcooley.com

MELITA CURPHY
dA: missmonster
e: missmonstermel@gmail.com
w: missmonster.com

ALYSSA T. DAVIS
dA: KaiserFlames
p: (717) 343 3349
e: worentiger@gmail.com

ISABELLE L. DAVIS
dA: drakhenliche
e: drakhen@necrodragonart.com
w: necrodragonart.com
w: daemonslayers.net

SARAH ANNE DAVIS
dA: SADCAT
e: sadcat@sarah-davis.com
w: sadcat.artworkfolio.com
w: sarah-davis.com

THANAPHAN DECHBOON
dA: jengslizer
a: 277 Shukumvit 93 Bangjak,
 Bangkok, Thailand 10260
p: (+66) 85 904 1495
e: jeng_slizer@hotmail.com
w: happydrawing.com
w: jengslizer.cghub.com

ALICE DUKE
dA: melora
e: alice.naomi.duke@gmail.com
w: aliceduke.com
w: alicedraws.blogspot.com

COLLETTE J. ELLIS
dA: purpleglovez
p: 07888 001 181
e: purpleglovez@hotmail.com
w: collettejellis.blogspot.com

CARLOS EULEFÍ
dA: Kaek
a: Díaz Sagredo 750 Quinta Normal,
 Santiago, Chile
p: (562) 724 3219
e: countallamistakeo@gmail.com
w: kaeks.blogspot.com

JON GRIMES
dA: unholy-scribe
p: 07955 513013
e: unholy.scribe@gmail.com
e: jon-grimes@hotmail.com
w: unholy-scribe.daportfolio.com
w: unholyscribe-fantasy-art.com

NATALIA PONCE GUTIÉRREZ
dA: VampirePrincess007
e: natalpg@yahoo.es
w: nataliapg.daportfolio.com

HEDVIG HÄGGMAN-SUND
dA: Vixie87
e: hedvighs@gmail.com
w: vixiearts.blogspot.com

ASHLEY HALL
dA: Badhead-Gadroon
e: badhead_gadroon@aazari.com
w: www.aazari.com/Badhead_Gadroon

MAURICIO HERRERA
dA: el-grimlock
a: Nilo dto. 2 Colonia Claveria, Azcapo
 tzalco, Mexico DF, Mexico
p: +52 (55) 50 12 52 78
e: mauroxherrera@gmail.com
w: berserker-comics.com/foro/index.php

FREYA HORN
dA: Vermin-Star
e: saintscarlet@hotmail.com
w: verticalcut.com/saintscarlet/portfolio

AMÉLIE HUTT
dA: Smirtouille
e: smirtouille@gmail.com
w: smirtouille.com
w: smirtouille.blogspot.com

SARAH JAFFE
dA: klar
e: pallues@gmail.com

LINA KARPOVA
dA: Schur
a: 132-7/2 Rogova St., Moscow, Russia
 123098
p: +7 (903) 715 10 07
e: 4@linaka.ru
w: linaka.ru

K. "KEZ" LACZIN
dA: Kezrek
e: kezrek@gmail.com
w: kezrek.com

KELSEY LAKOWSKE
dA: zilowar
e: zilowar@hotmail.com
w: antlerink.tk
w: zilowar.livejournal.com

STEPHANIE PUI-MUN LAW
dA: puimun
e: stephlaw@shadowscapes.com
w: shadowscapes.com
w: facebook.com/shadowscapes
w: shadowscapes-stephanielaw.
 blogspot.com

KENDRICK LIM
dA: kunkka
w: imaginaryfs.com

DANIEL LUNDKVIST
dA: Tyrus88
e: contact@dlart.se
w: dlart.se

VICTORIA MADERNA
dA: entdroid
e: hi@victoriamaderna.com
w: victoriamaderna.com

KATARZYNA MARCINKOWSKA
dA: grzanka
e: redtail@wp.pl

EDUARD MIRICA
dA: eduardmirica
e: eduardmirica@yahoo.com

ROBB MOMMAERTS
dA: RobbVision
e: robb@robbvision.com
w: robbvision.com
w: robbvision.blogspot.com
w: paleo-buffet.blogspot.com

STEFANIE MORIN
dA: psycho-kitty
e: stefaniemorin@gmail.com
w: stefm.net
w: stefm.blogspot.com

WILLIAM O'CONNOR
dA: wocstudios
e: woconnor@wocstudios.com
w: wocstudios.com

MICHELLE PARKER
dA: Mparker
w: knotwyrks.com

JIM PAVELEC
dA: Genethoq
a: 1445 S. Kenilworth Ave, Berwyn, IL
 60402
e: genethoq@gmail.com
w: jimpavelec.com
w: inkbloomadventure.com

JESSICA PEFFER
dA: neondragon
w: neondragonart.com
w: neondragon.livejournal.com

NICOLÁS ALEJANDRO PEÑA
dA: Amisgaudi
p: +52 (686) 147 3443
e: amisgaudi@gmail.com
w: amisgaudi.blogspot.com
w: amisgaudi.daportfolio.com
w: amisgaudi.cghub.com

AARON POCOCK
dA: aaronpocock
e: kat_aaron@hotmail.com
w: pocockart.com
w: aaronpocock.wordpress.com

KAITLIN REID
dA: Flying-Fox
e: kitfoxyfire@gmail.com
w: sunsetdragon.com
w: sunsetdragon.blogspot.com

TIAGO DA SILVA
dA: Grafik
p: +351 282 080 566
e: tmds77@hotmail.com

JOHN STAUB
dA: dustsplat
e: oro_jay@yahoo.com
w: dustsplat.carbonmade.com
w: dustsplat.blogspot.com

E.J. SU
dA: EJ-Su
e: ejsu28@gmail.com
w: protodepot.com
w: ejsouffle.blogspot.com

SANDARA TANG
dA: sandara
w: sandara.net

ADAM VEHIGE
dA: VegasMike
e: adamvehige@hotmail.com

URSULA VERNON
dA: ursulav
e: ursulav@metalandmagic.com
w: ursulavernon.com
w: redwombatstudio.com

CHUCK WADEY
dA: chuckwadey
e: chuck@chuckwadey.com
w: chuckwadey.com

Index

Other fine IMPACT Books are available from your favorite bookstore, art supply store or online supplier. Visit our website at www.fwmedia.com.

15 14 13 12 11 5 4 3 2 1

DISTRIBUTED IN CANADA BY FRASER DIRECT
100 Armstrong Avenue
Georgetown, ON, Canada L7G 5S4
Tel: (905) 877-4411

DISTRIBUTED IN THE U.K. AND EUROPE BY
F&W MEDIA INTERNATIONAL, LTD
Brunel House, Newton Abbot, Devon, TQ12 4PU, England
Tel: (+44) 1626 323200, Fax: (+44) 1626 323319
Email: enquiries@fwmedia.com

DISTRIBUTED IN AUSTRALIA BY CAPRICORN LINK
P.O. Box 704, S. Windsor NSW, 2756 Australia
Tel: (02) 4577-3555

Production edited by Sarah Laichas
Designed by Guy Kelly
Production coordinated by Mark Griffin

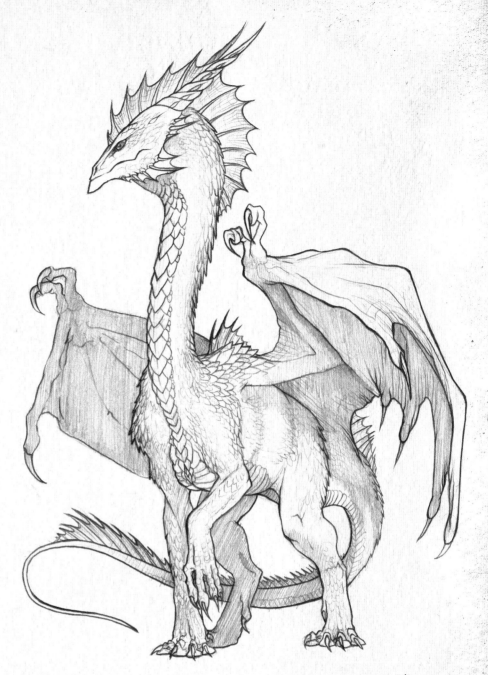

Crystal Dragon
Alyssa T. Davis | KaiserFlames

Metric Conversion Chart

To convert	to	multiply by
Inches	Centimeters	2.54
Centimeters	Inches	0.4
Feet	Centimeters	30.5
Centimeters	Feet	0.03
Yards	Meters	0.9
Meters	Yards	1.1